# Stars in My Eyes

# Stars in My Eyes

*Don Bachardy*

The University of Wisconsin Press

The University of Wisconsin Press
2537 Daniels Street
Madison, Wisconsin 53718

3 Henrietta Street
London WC2E 8LU, England

1    3    5    4    2

Printed in the United States of America

Library of Congress Cataloging-in-Publication Data

Bachardy, Don, 1934—
Stars in my eyes / Don Bachardy.
272 pp.          cm.

ISBN 0-299-16730-5 (alk. paper)
1. Motion picture actors and actresses Anecdotes.    I. Title.
PN1998.2.B318          2000
791.43'028'0922-dc21          99-6741

*To James T. White*

# Contents

# Illustrations

# Stars in My Eyes

# Introduction

The act of recording, whether by writing, drawing, or painting, not only helps me to understand and digest my experience, but because of the attention that recording demands, makes the experience itself more indelible. Since I am used to working every day and each of my pictures is dated as well as signed by its subject, my work as an artist amounts to a kind of pictorial diary.

I lived with Christopher Isherwood from 1953 (when I was eighteen and he was forty-eight) until his death in 1986. By his own example, Chris confirmed my instinctive urge to record. (In my early childhood I was already drawing—even then all of my pictures were of people—and in my early teens I kept a primitive kind of written diary.) Chris helped me see that many artists of all kinds are essentially creating a record of their own experiences. With Chris's encouragement and support, emotional as well as financial, I gained enough confidence in my talent to become a dedicated full-time artist.

Besides Chris, the other major influence on my life, which is at the root of this book, is my early and enduring love of movies. By the time I was five they were already an obsession. I'm convinced that my interest in looking at people came directly from gazing, when I was very young and impressionable, at closeups of movie actors several hundred times larger than life. Some of my earliest memories are of drawings I did from photographs of these actors in magazines, and I continued this practice for many years. The precise but naive renderings I did in my teens sharpened the accuracy of my eye, so that when I started art school at twenty-two and first began drawing regularly from a live model, my work advanced quickly.

The written accounts of sittings gathered in this book are culled from my diaries. At Chris's urging I began to keep a written diary in our first year together, and despite frequent lapses I have continued ever since. The original accounts were often hastily written, and I have, therefore, tidied and edited them for easier reading. Since Chris was largely responsible for my being a diarist, as well as an artist, and since we were intimately bound up in our life together, he appears often in these pages. His age and distinguished reputation, combined with my youth and enthusiasm, made us a dynamic duo. He provided access to many of my celebrity sitters, and with his prestigious support to back me up, my requests to them for sittings were more difficult to refuse.

The experience of a sitting, of being alone with another person while looking intently at him or her, often for several hours, is like no other I know. That experience is the real subject of my work. A sitting is also a true collaboration. The energy I get from my sitter helps me with my work. That's why, when I finish a picture, I ask my sitter to sign and date it.

Working from life is to me much preferable to working by myself from a photograph, as many portrait artists do nowadays, because that approach would deprive me of both the numen and the company of my sitter. Moreover, the content of a photograph is predigested. The translation of three dimensions into two has already been accomplished, so the artist is denied that delicate challenge. Even if the photograph is taken by the artist himself, it is at best a record of an experience both shared with and reliant on a camera. For me the introduction of a camera to a sitting would basically alter and dilute the experience. And making art from second-hand experience seems to me a synthetic process which, according to my standards anyway, must produce synthetic results.

For more than thirty-five years I have obeyed my early, instinctive urge to complete each work I do in a single sitting. The departure

of my sitter is like the breaking of a spell. I never alter any detail of the work I've done once the sitting has ended. Even if, on the next day at exactly the same hour, I were to resume work with the same sitter dressed in the same clothes, not only would my sitter be different in some minor or major way, but so would I. It would be impossible for us to recapture our respective moods from a previous sitting. On a new day, when very likely the light, too, has changed, my natural inclination is always to make a fresh start on a new picture, to record that day's different combinations of moods and light. To try to re-create those of a previous day seems to me false and futile.

Working strictly from life invites all kinds of hazards. Because I depend on the stillness of my sitter, a restless, uncooperative one can sometimes make insurmountable obstacles for me. A sitter's restlessness may have many causes: a natural resistance to being scrutinized; shyness or some other expression of insecurity; or boredom, which often leads to sleepiness, the commonest of the difficulties that beset any artist who depends on a sitter. And, if that sitter lacks physical or mental stamina, the length and tedium of a sitting can lead to restlessness and eventually to sheer exhaustion, of both artist and subject. My keen concentration on the sitter gives me access to his moods. When he is bored, I am in danger of becoming bored myself. Yawns are contagious.

During a sitting I am constantly under some kind of time pressure, since even the most cooperative of sitters must inevitably run out of time or become exhausted. I never know for sure that I will be able to finish a picture, and that doubt creates anxiety. I also worry, particularly if the picture is going well, that I might spoil it before it is finished.

The ways a drawing or painting can be spoiled during its execution are many and varied. At my first sitting with Robert Mapplethorpe, I was doing a pen and ink wash drawing and had nearly completed his head when suddenly a large, dark drop of ink wash slipped

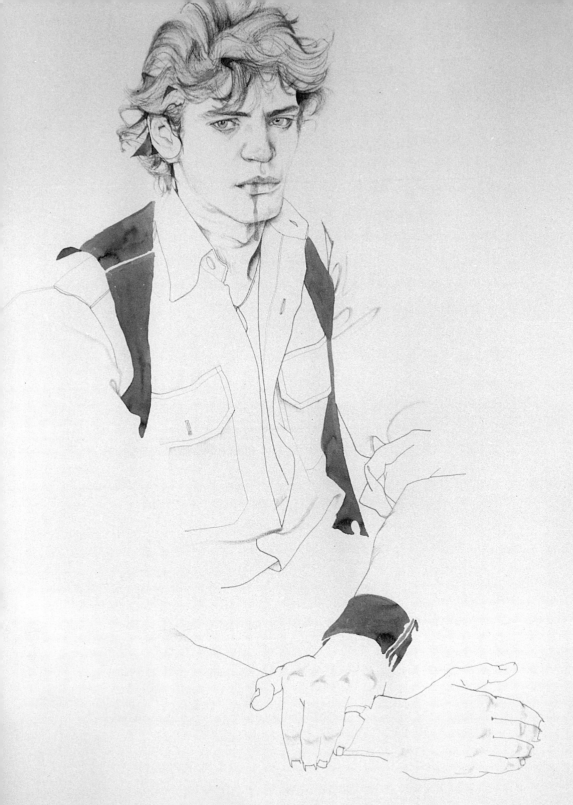

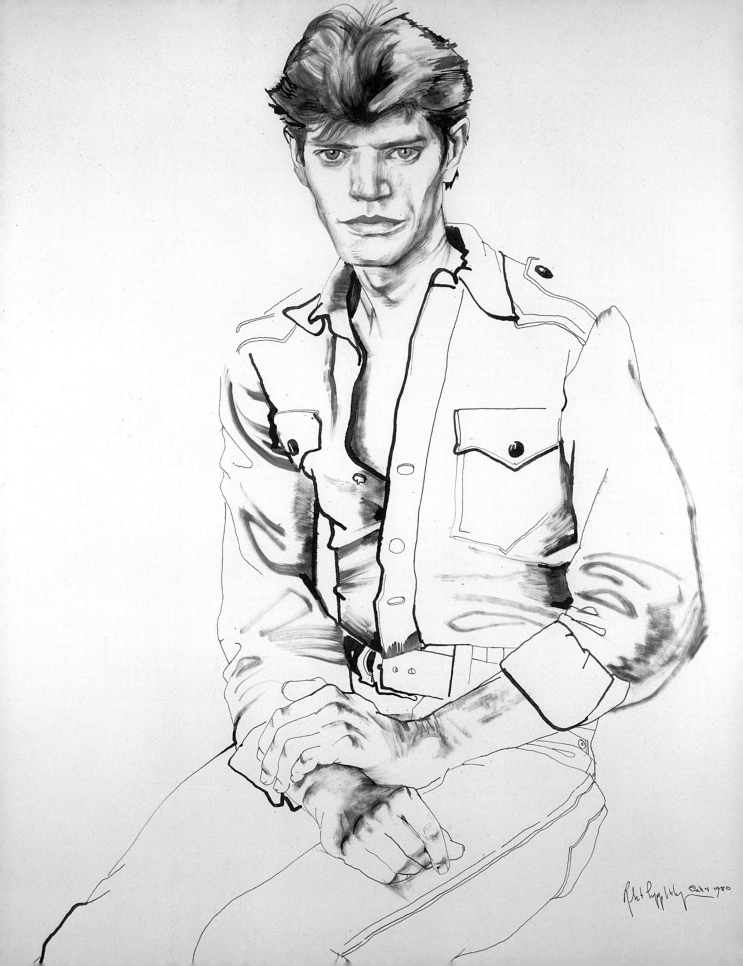

off my pen and landed on the drawing at the corner of his mouth. There was no way to remove the drop, and though I was convinced that I had ruined the drawing, I went on to finish it anyway. I did another drawing of him in a second sitting that we were both pleased with, but when it came time for him to choose one of the two drawings for himself, he chose the one with the ink stain because it suggested to him blood drooling from the mouth of a vampire!

My fear of spoiling a drawing or painting, particularly if it is going well, sometimes forces me into a paralyzing tightness. Even if I maintain looseness and work freely, I might still blunder in some last-minute detail, or just continue working too long. In the execution of any drawing or painting, the decision to finish is perhaps the most crucial. I've wrecked countless pictures by adding some irrelevant detail in the last seconds of work. Occasionally I have been forced to stop by the sudden departure of the sitter and only discovered later that, had I worked a few seconds longer, I would surely have ruined the picture.

I work as directly as possible and never do any kind of preliminary drawing or sketch. In an ink drawing mistakes are unalterable, but even when I worked with pencil I seldom used an eraser. Because time is precious, I learned early to eliminate unnecessary and time-consuming procedures, such as underdrawings and erasures, and made up my mind to get it right the first time. Taking chances creates more excitement.

I believe that, at least under close inspection, the look and style of a drawing or painting reveals the circumstances and methods of its execution. The breakneck speed that working from life often demands can give the drawing or painting a rawness or an unfinished look disturbing to some. To hide these telltale effects of a live confrontation seems to me wrong. On occasion, they should be flaunted. If a drawing or painting is done spontaneously, it should look spontaneous.

The faces I make while I'm working have provoked smiles and sometimes outright laughter from my sitter. Gradually I've come to

realize that these moues are an unconscious expression of my instinctive urge to identify with another person. Twisting my own face into expressions that make me feel more like the possessor of the face I am trying to record enables me, as in a self-portrait, to reproduce a likeness from within as well as without. (I don't enjoying doing self-portraits because they rob me of one of the greatest pleasures a sitting can offer: that of forgetting myself and slipping into another's personality so completely that I sometimes lose my self-awareness for several minutes at a time.)

I can't do any kind of satisfactory picture of someone I consciously dislike. Negative or judgmental feelings block my intuitive access to the sitter, and the process of my instinctive identification won't function. In a way my sittings are similar to one-night stands, but during daylight hours and without physical contact. Any expression of love or sexuality is transmitted by sublimation to the drawing or painting itself.

I prefer not to talk while I'm working, but I will if necessary to encourage or pacify a sitter who cannot bear the experience without talking. Since my best concentration is devoted to the work, my mouth is on its own. Hours later I may recall remarks of mine during a sitting and be startled by their unguarded indiscretion. My best sitter, if he must talk, is a monologist who can keep going with little or no input from me, and my most troublesome one a scintillating talker who demands and deserves my verbal participation.

My work with well-known people is only a small percentage of my total output, but I tend to write more about those sittings because they are much more likely to be demanding, even frustrating. I am often under pressure from insufficient working time and a variety of obstacles, including my own awe of the sitter. The anxiety and tension of a difficult sitting also make the experience more vivid, so there is more to write about. And, when a difficult sitting has caused me dissatisfaction with my work, writing about the experience helps to com-

pensate for any sense of failure I might feel, and it forces me to pinpoint the causes of that failure so that my next attempt may be more successful. If I didn't have time to write a full account of a sitting soon afterward, I made notes of my impressions and snippets of dialogue to refer to later. Sometimes an account took several hours to write; that of my sitting with Ginger Rogers took days.

I also tended to write more about my sittings with movie actors if the sitter had been one I'd loved in movies when I was a child, such as Bette Davis, Alice Faye, Henry Fonda, Paulette Goddard, Laurence Olivier, Ginger Rogers, or Barbara Stanwyck. My eye-to-eye physical confrontation with an actor whose image had permeated my childhood was profound, making me wonder if my childish infatuation had had a causal power, and, because of it, destiny had decreed that we should one day meet.

One's karma can be terrifying as well as instructive. My audacity in asking celebrities to sit could evaporate when the sitting occurred, leaving me shy and nearly speechless. On several occasions I can remember picking up my pencil to make the first strokes onto the daunting expanse of drawing paper and finding that my hand trembled uncontrollably. But the fierce necessity of proving myself and justifying the expenditure of my distinguished subject's time made me persevere. And, if the sitting went well, my sense of accomplishment, even triumph, was exhilarating.

My sittings with some of the movie star legends of my youth often occurred twenty or thirty years after my initial exposure to them. I keenly felt the injustice of rewarding their generosity in sitting for me, an unknown, fledgling artist, with a version of themselves which they would almost certainly think unflattering, and maybe cruel or even sadistic. But how to reconcile, for instance, the vigorous, handsome image of the Henry Fonda of my youth with the gaunt grimness of the stiff, red-eyed man of seventy-four who was sitting before me? Or the

heavily painted and surgically altered face of Alice Faye with the actress who had first enchanted me nearly forty years earlier in her big-eyed, fleshy youth. The effects of age on these faces I knew so well neither shocked nor dismayed me. On the contrary, I was fascinated by every alteration in their appearance and sometimes rendered the lines, sags, pouches, and blotches of age too accurately for my subjects' comfort.

Working from life imposes an uncomfortable obligation on me. A portrait photographer can develop his pictures in private, edit out those he doesn't like, and choose a time when he feels most confident to show his work to its subject. In contrast, I must show my picture to my sitter immediately after finishing it, when, often without any objective opinion of it myself, I am at my most vulnerable. Wounded vanity has led more than one sitter to implore me to destroy a just-completed picture. On the occasions when my work has gone well, I still have a natural inclination, after such extended and intense confrontation, to escape even my most sympathetic sitters. To have to defend and protect my work from an irate one when I am dazed and drained taxes me to the limit.

The written accounts of the sittings in this book are, along with the paintings and drawings that resulted from them, arranged chronologically. The originals of all of the drawings reproduced in this book (with the exception of that of Linda Ronstadt, which is 24 by 19 inches) are 29 by 23 inches.

In many ways I am now very different from the artist and person I was in 1973, the year of the earliest work in this collection, and my work has been steadily changing, too. In the late seventies I switched from pencil and ink wash to strictly ink drawings, first with pen and brush (Irwin Shaw, Iris Murdoch, Henry Fonda, William Wyler, Vincente Minnelli, Laurence Olivier), then with brush only (Allen Ginsberg II, Helmut Newton). My ever-increasing volume of work in color naturally affected my drawing. Its precision of the early 1970s

gradually gave way to a freer, brushier style, and in the early 1980s I changed to wash drawings with black acrylic paint (Jerry Brown I and II). By 1983, the year of the latest work in this collection, I was spending more than half of my studio time painting, and by the end of the decade I was working in color exclusively.

After many years of making pictures of people, I still haven't found another subject as varied and challenging. But even when a painting or drawing of mine is well executed, if it's not also an accurate likeness, I can't really care for it. A likeness is subtle and indefinable. Some good artists lack the knack for it, and some mediocre ones don't. A portraitist is obliged to prove his possession of this knack by exhibiting pictures of well-known, recognizable subjects. Otherwise the majority of people will not be able to judge a likeness. But even if I don't know the subject of another portraitist's work, I can *feel* whether the likeness is firm.

Though I've been lucky enough to work with many well-known people in my time, since my early years at art school and continuing into the present I have willingly taken on anyone who had the time, patience, and inclination to sit for me. As a result, I have drawings and paintings of just about everybody I have known in the past forty years, including the most casual friends. Even if I have known someone many years, I feel that I don't really know what that person looks like until we've done a sitting. And often a first sitting is merely an appetizer. Over the years I have worked repeatedly with certain people and made a series of drawings and paintings of each, sometimes stretching over more than thirty years. In such a series one can observe the effects wrought by time and experience both on my subject and on my work as an artist.

Chris was my handiest and, therefore, most frequent subject. My first drawing of him was done in 1953, a few weeks after we began to live together. It is doubly significant to me because it is also my first

drawing from life. I did countless drawings and paintings of Chris over the next thirty-three years. In the last six months of his life, he was my only subject. I drew him almost every day and sometimes did as many as a dozen drawings in a single session. On the morning he died, I spontaneously decided to spend the rest of the day drawing his corpse, so he was both my first life subject and my first death subject. Since we worked together so often, he was also my most challenging subject. To find a fresh way to present him, some new approach I hadn't yet tried, or to discover some unrevealed detail of him, whether physical or psychological, was a persistent and seemingly endless quest of mine until his death put an end to it. Because he knew well my often-told saga of the joys and frustrations I suffered because of my need to work from life, he was my most cooperative subject, even on his deathbed.

An unexpected reward for my persistence in working with Chris was the comfort I received from my pictures of him after he was no longer there to sit for me. While I was doing those pictures, it had never occurred to me that they would serve and soothe me one day as an intimate record of the many long hours we'd spent alone together. Those works began with my birth as an artist and include everything from nudes to death drawings, from five-minute studies to drawing or painting sessions that took more than three hours to execute, without a break for artist or sitter. They encompass the full range of my work as an artist and for me represent my best effort.

I am gratified if I think I have done good work, but I never feel that I can take full credit for my best pictures because I don't know how I did them. I am like a medium receiving messages from one realm and conveying them to another. Some truth and energy from my sitter pass through me on the way to my paper or canvas. Since the confrontation between my sitter and me is the subject of my pictures, I do know that the more involved I become in that experience, the better my work is

likely to be. I don't believe that good art is ever the product of boredom. So I want to enjoy total absorption in the work and have the best time possible while I am doing it. If the results aren't satisfactory, at least I have enjoyed myself. "Work for the work itself, not the fruits thereof" is a Vedantic teaching I learned very early from Chris. He taught me all the truths I value most.

# Bette Davis

On the first day of November, I spent nearly eight hours alone with Bette Davis in her house in Connecticut. Ten days earlier (21 October), she, Chris, and I had been guests at a dinner party at Roddy McDowall's house, where, after asking her to sit for me, I showed her a catalogue of a recent exhibition of my work. She turned the pages without comment until she paused to inspect a drawing of Margaret Leighton. Though I had seen her and Leighton in the original 1962 production of *The Night of the Iguana,* I had forgotten that they had worked together. "You've drawn Maggie," she said. I sensed from the tone of her remark that her professional rivalry with Leighton still flourished. I knew then that I'd hooked her.

Since both Davis and I were going east the following week, she gave me her telephone number in Connecticut. I called her when I got to New York. We agreed on a date for a sitting and a noon train from Grand Central Station, which would get me to Weston shortly after one. The train was on time, but at the station I was told that it might be fifteen minutes before a cab was available. "You're very considerate to let me know," Davis said, as though my telephoning about the delay was an uncommon courtesy. She surprised me further by adding that she was fixing lunch for me. "Yankee corn chowder or a broiled steak?" (Bette Davis anxious to serve the right meal to me!) I guessed that she had put the chowder first because it was her choice, and her tagging it with "Yankee" might be a test of my American mettle, so I chose the chowder.

As I was paying the cab driver in front of her house, she came out onto the porch to greet me. She was wearing a cornflower-blue

wool turtleneck, blue and yellow plaid trousers, and blue socks on her shoeless feet, and she looked little and brightly painted in the gray, overcast daylight. Perhaps because of her shortness, or because of her thinning hair, I noticed the firm shape of her skull.

Once we were inside the house, she offered me a drink and I declined. Then she immediately sat me at a table by a window and told me to start on the salad she placed before me. After the salad came the corn chowder, more for me than for her, and, though she was still standing up preparing things, she insisted that I start before it got cold. She seemed pleased when I praised the chowder, but not until she had delivered a cloth-covered basket of toast to the table did she finally sit down. I wondered if she would notice that both of the place-mats were wrong side up, with the tags showing. (She didn't.)

I wasn't hungry, and the thick soup was made from canned corn, but I agreed to a second helping despite my concern about getting the sitting started. I also worried that I was too tired (from a late Hallow-een party the night before) to do my best work.

To establish a transition from meal to work, I pretended to be curious about a small painting on a nearby wall and got up from the table to inspect it. Perhaps because it was crammed with furniture, her small, neat house felt miniature when I stood up, and the ceiling seemed too low. The amateurish, overrendered painting—sent to her by a fan, she told me—was done from a photograph of her in *All About Eve.* "The best portrait ever done of me," Davis asserted, unaware, I think, of the challenge she was posing.

We were still uncomfortably respectful of each other, and we both seemed to dread our imminent confrontation, but I was deter-mined to get started. I chose for my drawing bench two of the chairs from the table we'd just left and put them seat-to-seat in the middle of her living room. Then I chose a wooden chair with arms for her, and placed it before a large window, which looked out onto a narrow river near the back of the house. As soon as she sat down, I began to

work. My head-on view of her face was satisfactory except for her eyes, which looked away from mine and instantly became fixed and glassy. I didn't dare to ask her to look directly at me because, when I began to peer into her face, I saw her intense shyness and uncertainty. She hides her vulnerability with an outward show of strength and independence, but I suspect that if anyone made the mistake of cowering before her, she would be merciless, like a true bully. A few days later, a friend asked me if she was as implacable as he had heard, and I answered: "No, but she'd like to be. She imagines implacability and character are the same thing."

The first fifteen minutes of the sitting were tense for us both. Mysteriously, she managed to be restless *and* rigid. Catching the stiffness of her body, my drawing hand sweated onto the glossy-smooth surface of my paper. The tension was relieved when she asked if she could smoke, and—much more emphatically than I'd intended—I greeted her request with a startling "YES!"

As my drawing progressed, I worried that it might be unflattering. So I was glad, once I'd finished, that Davis tactfully waited to be invited to look at it. But I didn't invite her; instead, I asked if I could do a second drawing. She answered, "Why not?" She then complained that the chair I'd put her in was uncomfortable and proposed an enormous chaise, which, she informed me, had been custom-made for her. The chaise was far from any window or the already-scant afternoon light, and it was too big to move. It was so deep and long that it dwarfed the two chairs I was using as a drawing bench. Now the only available light came from a stationary lamp, lighting Davis from behind and casting over my drawing, as I worked, a dark shadow from my hand. To compensate for the difficult working conditions, I asked Davis to look at me while I drew her eyes.

Once I had begun the second drawing, we became more relaxed with each other. I was feeling the full effect of several cups of coffee and marveled at my circumstances: I was alone with Bette Davis in her

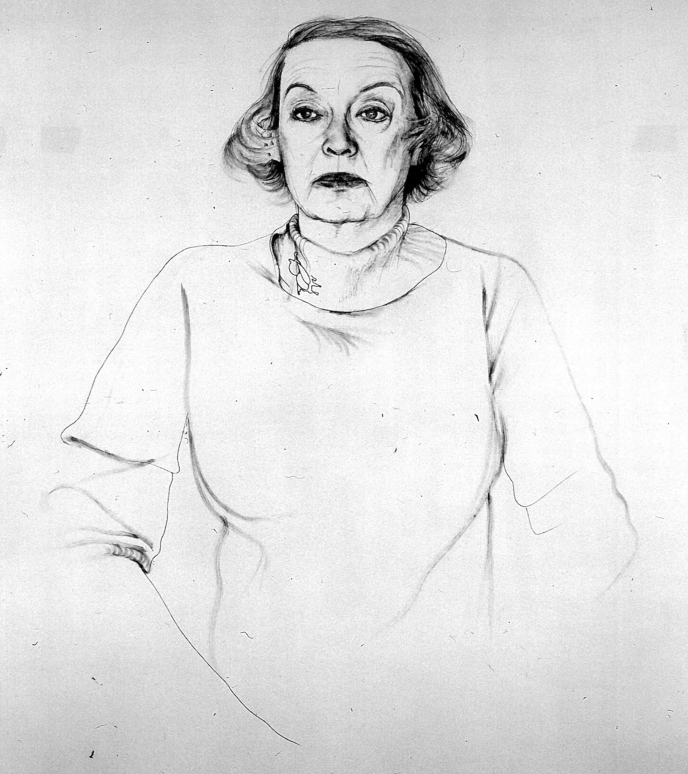

Bette Davis
November 1, 1973

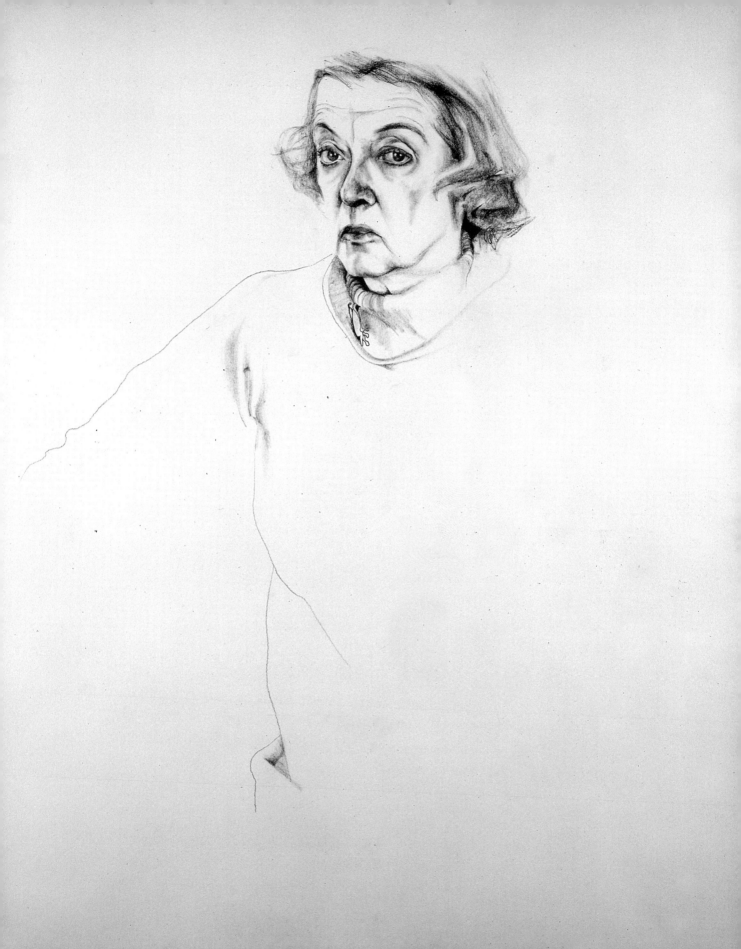

house in Connecticut! And not only were my eyes fixed on her battered face, but those baleful eyes of hers were fixed on *me*! In spite of the bad light and her fidgeting, which steadily increased as she grew more relaxed, I gloried in every detail of her.

When I'd completed the drawing, she stood up and, without waiting to be invited, moved behind me to look at it over my shoulder. "That's me all right," she declared with only a faint note of reserve in her praise. She then gasped in mock exhaustion when I proposed another drawing, but I knew she was going to agree before I asked. She liked my fanatical appetite for her, my whole attention devoted to her, a veritable trance of looking and recording. "But only," she insisted, "if I can have a drink."

Returning to the giant chaise with her scotch, she spilled some of it precisely where she'd been sitting. "I'm glad you saw me do that," she said, gesturing at the wet stain, "otherwise you might think I'd been incontinent." We both laughed at the idea of Bette Davis peeing while sitting for her portrait.

Now we were easy with each other, but the drink destroyed what was left of her concentration. She talked more, and her head moved continually. My confident determination turned to frenzy, and I found myself uncharacteristically erasing and re-drawing. I knew then that my concentration was shot, too.

As I gradually lost control of my drawing, it became a sad, almost mournful version of her. "Now you've done it," she declared, when I finally stopped working and she got up to inspect what I'd done. "That's the best." Davis believes that loneliness is the price of her talent and fame (her autobiography is called *The Lonely Life*), and she also, I suspect, equates a sad appearance with wisdom and greatness. She seemed proud of her sad look.

She assumed that her generous praise for my third drawing gave her license to attack the second. She now called it "cruel" and refused to sign it. But she signed the third and even the tentative first drawing.

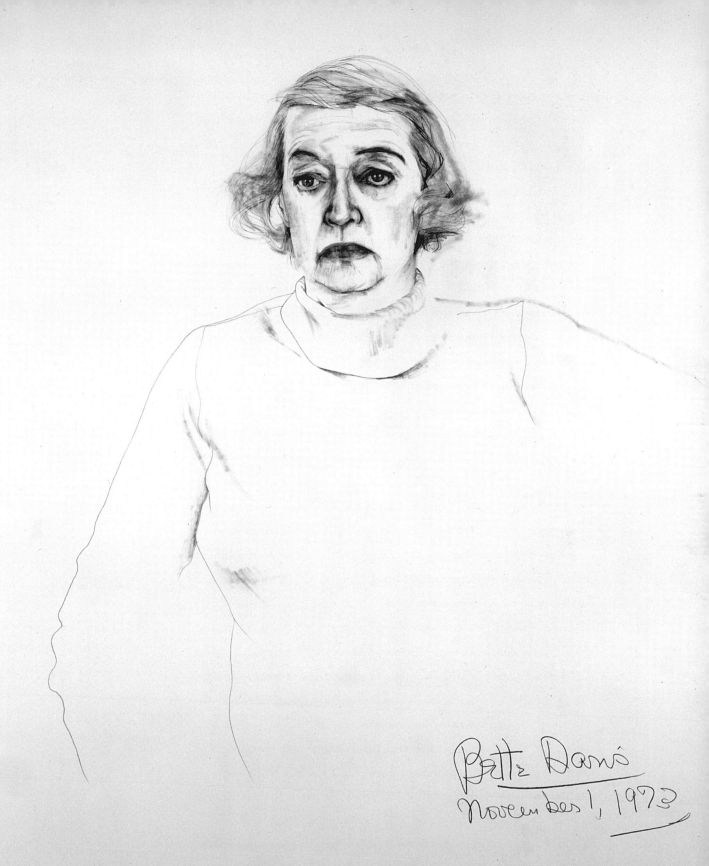

Bette Davis
November 1, 1973

22

I guessed that her accusation of cruelty resulted from my accurate treatment of her jawline, which could have been even more explicit.

"If I let you do another," Davis had stipulated before I started the third drawing, "I can't let you get back onto the train without your supper. But because of the short notice, the meal will be humble—chicken pot pies from the freezer." She then cried, "Thank God for Mr. Stouffer!" I couldn't help wondering about the broiled steak I was offered for my lunch, but I kept silent.

After she put two frozen pies into the oven, Davis opened a can of beets, which she emptied into a saucepan. Putting the saucepan over a high flame, she boiled its contents for a good half hour. Again, I kept silent.

"Now *you* must have a drink," she announced. I needed one, too. I hadn't tasted hard liquor in many months, but I asked for straight vodka on the rocks. It tasted good. She refreshed her drink several times, and, though its effect on her was discernible, she could hold her liquor. Drink eased her shyness, and it also brought out her susceptibility to self-pity. She complained of loneliness but cited her own perversity as the cause. She was often too impatient to endure having other people around her, and she sent them away, only to find that she was lonely again. Narrowing her eyes and fixing them on a slim white cat sleeping on a kitchen chair, she exclaimed: "I *never* thought I'd wind up with a cat!"

"Aries must be first," she repeated, having asserted it several times during the afternoon. "We're hell to live with because we have to be on top! Taurus is strong, too," she allowed, graciously including me, "we're both strong." She was smoking nonstop now, and, as in so many of her movies, she imparted to the smoke seeping out of her mouth a peculiar sensuousness. Then, fastening her eyes onto mine, she launched into a series of tales about Gary Merrill's manic-depressive fits.

More drink brought out the little old lady in Davis. Her balance

became precarious, and she seemed to lag behind her own driving energy. With her feet more firmly planted on the floor, her gestures became looser and her efforts in the kitchen less precise. Soaking up her increasingly intimate disclosures, I was still, after more than five hours with her, astonished to have her all to myself. Despite her advancing age, she's still Bette Davis—overwhelmingly so. I'd imagined that in her movies she exaggerated herself for the camera. Now I realized she was keeping herself down!

## 3 December 1973, Santa Monica

Bette Davis arrived in Los Angeles last Thursday around four in the afternoon. I telephoned her at six to invite her to dinner at our house, as I had promised her that I would, and also to set up a second sitting, which she had promised me. I expected the same friendliness she had shown me when I telephoned her in Connecticut to thank her for our previous drawing session and the two meals she had cooked for me, but I got a surprise. "I can't have dinner with you and your friend. I'm only here for a few days. I go to Phoenix on Wednesday." After a slight pause she continued: "You know, I was very good to you. *Too* good. I sat for three drawings. That's very hard work. I was exhausted, and I had a stiff neck for days. I think I spoiled you. You get one hour this time. That's all. *One hour,* and I mean it!"

I guessed that she'd had several drinks during her plane flight and maybe more afterward, but I also wondered if I had offended her by the note, addressed to "Dear Bette," which I'd sent with a copy of Quentin Bell's biography of Virginia Woolf because we had spoken about Woolf during our sitting. Davis didn't even mention the book. However, we made a date for Tuesday afternoon at two. "One hour," she repeated, "and that's *all.*"

I'd just come from the Chateau Marmont, where I'd had a drawing session with Myrna Loy five hours long! Not a word from Myrna

about exhaustion or spoiling me. And we had had a three-and-a-half-hour session the week before.

[The day after this journal entry I did have a second sitting with Davis. She was staying with a friend in his house on North Orlando Avenue in West Hollywood. I arrived promptly at two o'clock and found her alone, ready and waiting for me. The living room where we worked was flooded with north light from a large overhead window, a welcome contrast to Davis's dark Connecticut house. I only regretted that there wasn't time to paint her in full color. The vivid pinks and blues in the plaid of her wool suit were outdone only by the blue eyeshadow on her eyelids and the vivid magenta crimson of her painted lips.

Instead of the grumpy disciplinarian that I was expecting and dreading, Davis was again the unalarming, compliant version of herself I had known in Connecticut. But I wasn't tempted to challenge her decree. I fully intended to keep my drawing time to an hour and started work a few minutes after my arrival.

I knew that this was my last chance with her. Because of the time pressure, I kept my drawing simple and was determined not to worry about a flattering likeness. But the uncompromising face that gradually formed on the paper scared me. I foresaw myself rebuked by a furious Davis and sent away with an unsigned drawing.

By the time the hour was up, I had finished her head and could have left the drawing at that. Davis, however, had noticed that I was working feverishly, and, when we were within a few minutes of the time limit, she suddenly spoke, "I'm not going to throw you out if you aren't finished on time." I thanked her for her lenience and continued working.

When I announced a few minutes later that I was finished, Davis rose from her chair and stood behind me to see what I'd done. Dread of her fury made me afraid to turn around. During the agonizing

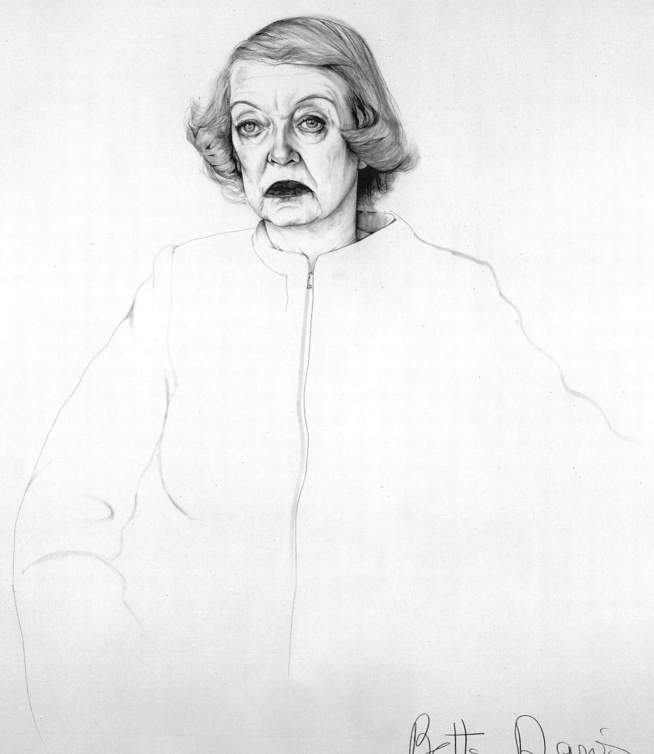

Bette Davis

December 4, 1973

pause that followed, I half-expected a wallop on the back of my head accompanied by accusations of treachery.

"Yup," she finally said, "that's the old bag."

I already knew that this was the best of my four drawings of Davis. My admiration for her unflinching approval of it was almost as great as my relief that the sitting had gone well.

We never met again. I sent her a photograph of the drawing and called her in Connecticut a few weeks later to ask her permission to reproduce the drawing as a poster for an upcoming exhibition of my work at the New York Cultural Center. "I'd be honored" were her last words to me.]

# Myrna Loy

*21 November 1973, Santa Monica*

Yesterday I drew Myrna Loy in her apartment at the Chateau Marmont.

Whatever topic you are discussing with her, Myrna sorts out the pros and cons and weighs each carefully before deciding on her own opinion. Though you may think that you are having a conversation with her, she is really talking aloud to herself. The effect, a charming, wistful vagueness, is the same as that of her screen personality but emphasized by her age, her physical bigness, her untragic aloneness. She is quite cheerfully keeping herself company, just in case you might not really be there.

As soon as I arrived she began to talk, one thought leading to the next in a way that left me little chance to suggest that we begin work. Myrna is shy with people she doesn't know well but, unwilling to give in to her shyness, tries to talk herself out of it. Even while she extolled the prosaic virtues of the Chemex coffee-maker with which she made coffee for me, I was easily lulled by the charm of her voice and her idiosyncratic phrasing of words.

When at last we started work, her shyness made her restless and therefore difficult to draw. She was considerably calmer and quieter during the second drawing, and when she drifted from her established position, often corrected herself.

As though to assist me in my work, she told me that the multi-colored print of her dress was based on a classic Chinese design of a passion flower and that her light pinkish-orange hair is "much too short." "He went too far," she said of the hairdresser who had recently given her a permanent. Later, when criticizing one of my drawings,

27

or rather, while talking herself into liking it, she blamed her short hair for what looked to her like too much breadth of cheek and too little neck. Though she gently pressured me to enlarge the eyes, she could not blame their size on the length of her hair.

I resisted her persuasion because the smallness of her clear, pale eyes is one of her most distinctive characteristics. "I drew your eyes by daylight," I explained, "but if I re-draw them now, when the daylight is gone and they're reflecting only artificial light, they won't match the rest of the drawing." If she was not altogether convinced by my devious explanation, she accepted the firmness of my tone.

Yesterday I was especially aware of her bigness. Yet, perhaps because she was once a dancer, her slow movements have a strange grace. She does not move with a flowing continuity of action, but rather in separate lifts, as if she were a statue moved by an inner will that changes her placement in a room without altering her solid form. She mentioned her legs, which are big and, even when she loses weight, do not get any smaller. Instead, she told me, the weight loss only makes her face look "gaunt and older." "I'd rather my face looked good and my figure—well, I've got a little—," she patted her stomach and made an as-you-can-see gesture, "which I should do something about. I stopped smoking last year and my appetite increased immediately. Food tastes so *good* now."

## 3 December 1973

I had another long, fascinating sitting with Myrna this afternoon. Despite her considerate and patient cooperation, the sitting was a maximum effort for me. I've begun to think Myrna is one of the most difficult subjects I've ever tackled. A combination of many subtle elements, her face is distinct yet elusive; and it changes every instant. Her eyebrows and eyelids rise and descend continually, while her mouth adjusts and readjusts itself in quite another rhythm. Though her up-

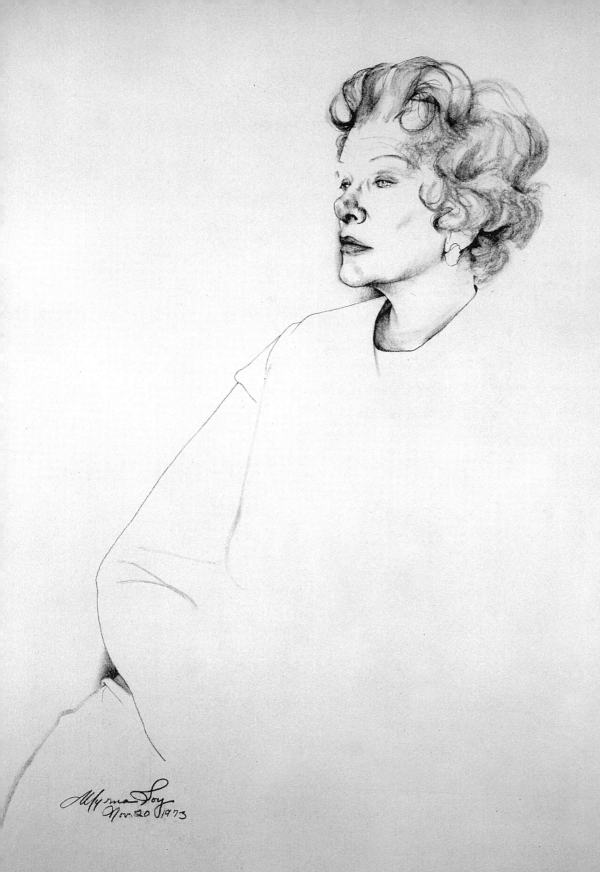

Myrna Loy
Nov. 20 1973

per and lower lip are ideally balanced in size and weight, her mouth, perhaps because of the very perfection of its shape, is somehow indefinable. Her nose, sometimes small and pert, can suddenly seem like a mountain in the landscape of her features. And while her face expresses her extensive range of delicate moods, she too is continually moving. Her slight, almost imperceptible movements are difficult to notice and impossible to arrest.

There is a firm fondness between us. I know that she both likes me and enjoys the sittings. "Your eyes are so alive," she told me, "there's such vitality in you." She often reassured me about time, too: "Take as long as you like. I'm in no hurry. I haven't anything else to do."

When we got onto the subject of husbands who find it hard to put up with the success of their more famous wives, she recalled a warning she gave to her fourth husband before their marriage: "I'm very famous you know. I'm *world*-famous." She lowered the register of her voice for an aside: "And that's not like me at all." Resuming her former tone, she continued: "But it didn't help. He didn't understand what I was saying. After we were married, when the first photographer appeared, he just couldn't handle it."

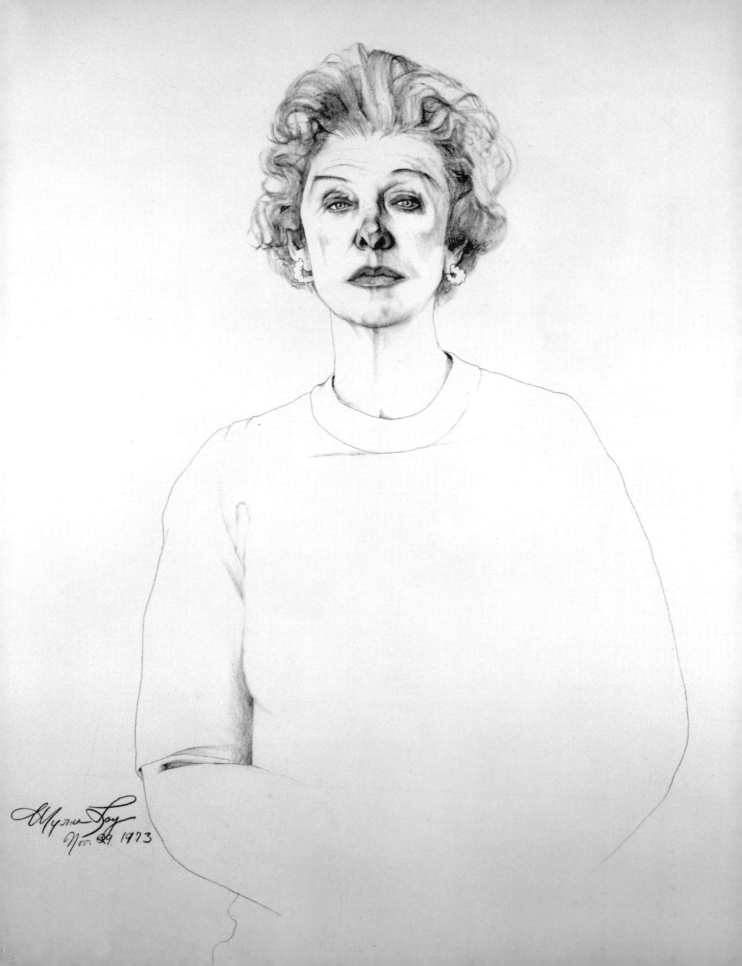

# Paulette Goddard

*13 November 1973, New York*

I spent this afternoon drawing Paulette Goddard in the luxury apartment she leases on the thirty-fourth floor of the Ritz Tower. There are dramatic views of New York from every window, even the windows of both bathrooms, as Paulette herself noted, one of which has a southern and the other a northern exposure. Paulette is proud of her apartment. She excused the absence of a Degas drawing, which, she told me, is at the Metropolitan Museum getting "de-foxed." "Why is it called 'foxed'?" she asked. "Because," I ventured, "the mildew spots, if not checked, will grow fur."

Paulette herself was considerably foxed, but with a superior kind—white fox. A fox fur and a trim, sleeveless white jacket of the same lightweight silk jersey as her dress and trimmed in white fox were laid out on the sofa at the ready, along with a full-length white mink coat "for sitting on." Before going to bed last night she had decided to wear white today, so that for her clothes I would have "only simple lines." "That's a consideration," I told her truthfully, "no other sitter of mine has ever offered." She had also decided to dispense with a necklace and even said, if I chose, to ignore the diamond clips glittering at her ears. Without diamonds, I thought to myself, Paulette would not seem quite herself.

The simplicity of Paulette's white dress and minimal jewelry were welcome. But she had envisioned herself being drawn with her white fox slung over her shoulder, so that instead of the tedium of drawing a busy patterned dress and elaborate jewelry, I faced the daunting challenge of drawing a dead animal with long fur. My dismay was only briefly lightened when I noticed that the clear blue eyes of the fox

(which, she told me, she had specifically chosen) were very like Paulette's own eyes. The sparkling effect of hers is a mirage which vanishes when you look into them. They are cool and blank, without energy and depth, and even their contours seem flat rather than rounded. Her articulate eyebrows and the restless, crepey skin around her eyelids move continually, but her eyes remain jelled.

Paulette is well organized. In addition to carefully planning her costume, she had ordered a corned-beef sandwich, which arrived soon after I did. We took a break in mid-sitting and shared the sandwich. "I've given you the bigger half," she pointed out. Two "high-energy" cookies were also on the tray, both for me, and a mug of coffee—everything simple, neat, thought out in advance.

While we ate she talked about Erich [Maria Remarque, her last husband]: "He was Cancer, a cautious crab. One step forward, nine steps back. I used to tell him so. After he died, I got all of his things, his personal things, into one bag. Not even a large bag. Just a bag. That's all we leave."

Not long after saying this, she got a telephone call telling her that Remarque's play, *Full Circle,* was going to close at the end of the week. "I don't feel anything," she said to me as she put down the phone. "It doesn't mean a thing to me." But then she remembered that a newspaperman was coming to interview her that afternoon at five about the production. "What'll I say to him? I can't tell him it means nothing to me. What'll I say?" More for the sake of making sound rather than giving advice—her question was rhetorical, and I knew that she didn't need me to tell her what to say—I offered: "Why not tell him you've taken a philosophical view of the situation?" "Oh, I can't tell him that," she said. "I have no philosophy." Her reply was quick, unemphatic, a simple fact which couldn't be denied.

About the autobiography she was considering but is now against: "I've given endless interviews and never told anything about myself. Why start now?"

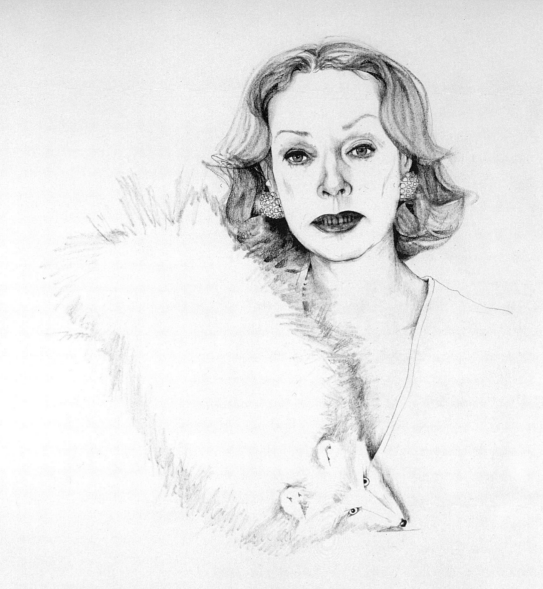

Paulette Goddard
Nov. 13. '73.

Before we resumed work, Paulette told me about the large skin cancer that was removed from her forehead just over her right eyebrow. There is a barely perceptible mark where it had been. She felt a bond with me when I told her of the incipient skin cancers, caused, like hers, from overexposure to the sun, that I'd had removed from my face some months before.

My drawing took a long time. Paulette is not easy to pin down, in life or on paper. Her whole presence bristles with energy. This afternoon she managed to contain it much better than at our first sittings a few years ago. Then her restlessness had been a real problem for me. As she herself knows instinctively, she is diminished by repose. Her natural energy has no outlet, and, with her animated personality in check, her face becomes indistinct, as though age had blurred it.

Neither of us was satisfied with my drawing. Its static, stilted quality seemed to have jarred her face out of a likeness. I'd had trouble, too, with her ever-changing mouth and had finally drawn it half open with some teeth showing. She compared the teeth in the drawing to rows of corn on a corncob. "Cornteeth!" she laughingly dubbed them.

When I suggested doing another drawing, she hesitated, half-agreed, then said she couldn't sit so long, maybe half an hour. She had not planned to sit for two drawings and was bothered by confrontation with the unexpected. When I relented, she was visibly relieved. "I was starting to get sick," she said, "just at the thought of it."

# Alice Faye

*17 October 1974, Santa Monica*

"You must have caught Bette Davis on a bad day." Those were almost the first words Alice Faye said to me yesterday when at two-thirty I arrived at her Shubert Theatre dressing room. She was referring to the drawing of Davis in the catalogue for my show at the New York Cultural Center. When I told her that Davis had preferred that drawing to earlier, more flattering ones I'd done of her, Faye made no comment, but the look on her face conveyed that she thought Davis must be crazy. "That mouth!" she then said, making a gesture in the air with her index finger to describe the downward curve of the Davis mouth and bugging her eyes in mock horror. "I *will* have approval of what you do today, won't I?" Her rhetorical question, a dubious blend of aggression and retreat, is typical of her style in dealing with people.

Faye obstinately sees herself as vulnerable, and indeed she is, because she has no finesse, no dexterity. She avoids any kind of demands on her time because she is unable to say no gracefully and can only put on the brakes full-stop. But something contradictory in her nature, a kind of masochistic vanity, invites the coaxers and pleaders who, like me, sense her susceptibility to adulation.

"But of course you must approve anything I do," I assured her, wondering if I could manage *any* kind of drawing of her, flattering or not.

I was invited to set up my drawing bench in a small, gray, windowless room which connected with her dressing room. It was fixed up like a reception room, and there was even a big bowl of popcorn. Faye's hairdresser, Jerry Masarone, told me that the popcorn is freshly made in her dressing room every matinee day to sustain her through

two shows. "It's a good binder, too," he said, and then added, with an upward roll of his eyes, "for diarrhea of the road."

Also in the room were several cushions covered with needlepoint designs (executed, I later learned, by Faye herself) in glaring colors; two stuffed figures, one of Mickey Mouse and the other of Minnie; a small, yellow, lace-trimmed pillow with the embroidered words "God Bless Alice"; and a blanket in more harsh colors, which Jerry had crocheted as a birthday present to her.

Faye makes a fetish out of birthdays and gives a cake to each member of the company, high or low, who is having one. Later in the day a middle-aged stagehand came to her dressing room to deliver a speech of thanks. His description of his joyful discovery of Faye's cake the day before closed with the words: "You're a wonderful lady." I was reminded of a similar scene in several of Faye's movies. In one of them, *The Great American Broadcast,* Faye leaves the microphone after a song number and goes into the wings, where an admiring Cesar Romero waits for her. "Darling, you were wonderful," he tells her. "Thank you," says a complacent Faye, her wonderfulness accepted without question.

And so it was last evening in her dressing room. The participants in the ritual knew their parts perfectly. Both star-goddess and mother-bountiful, Faye graciously received homage for her lofty beneficence without any suggestion that she was playing a part. She has no glint of humor about herself, and takes seriously the servile acts of flattery and gratitude from those around her. She is like a sponge soaked to capacity with liquid blandishment.

I, too, was playing a role, that of admirer with pencil, waiting patiently for the stretches of the show during which Faye was not onstage. Returning to her dressing room, she would modestly shut the door to the adjoining room, where I waited, and change into her next costume, then appear unto me as she closed off behind her the flurry of attendants. With only the sound of the live performance onstage

being piped into the room, we were alone, and, during those few minutes while she sat mutely waiting for her next cue, I drew her.

The unflattering gray shadows cast by the fluorescent light fixture over our heads added to the gloom of our sealed room. It could have been a storm cellar, and the filtered sound of the ongoing performance intermittently drowned by squalls of applause or laughter from the audience was like the noise of a storm heard from its still center.

To temper my anxiety, I reminded myself that I had asked for this encounter with Faye—begged for it, in fact. And, since I'd waited nearly a year, I was, as much as possible, prepared for it. Determined not to fail as I had in that first sitting the previous November, when I was too rattled and respectful to dare anything which might alarm her, I boldly asked Faye to look right at me. Surprised and relieved that she did what I asked with equanimity, I began to draw those eyes I knew so well from my childhood. I still recognized them, despite the pouches and crepey wrinkles in the skin surrounding them and an unnatural tautness which, pulling down each lower lid, exposed its pale inner ledge.

Defying discrepancies between my mental image of Faye and her present state, I had the strange feeling that, at least partly, I was drawing her eyes from memory. I was not deterred by their bright blue eyeshadow and stiff spiky eyelashes, and by the thick, dusty brown pencilling of her eyebrows—her left one irretrievably arched in the classic Faye look as though already frozen for posterity.

Despite our eye contact and my undisclosed childhood obsession with her, Alice Faye and I were uncrossable miles apart. For a few minutes only our orbits interlooped, and I received the dim glow of her darshan—dim because so little of her was with me. She doesn't understand what I'm doing, nor does she want to. We are separated by all of her flattering attendants and coaxing manipulators, who, if allowed to persist with their wily indulgence, will anesthetize and eventually deaden their prey. I was drawing the shell of Alice Faye, searching

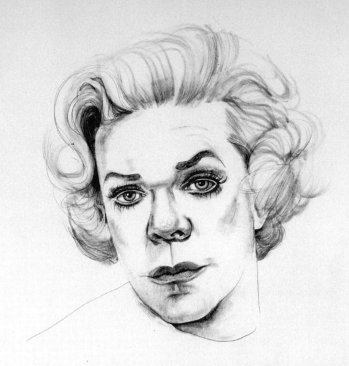

vainly through layers of deadness for a sign of something still glim-mering within. Yet, those layers are steeped in her essence and rich with meaning. Shells tell much about their original inhabitants.

It amazed me to think that the semiconscious creature I sat so close to, and peered at so intently, was in fact, to some extent anyway, the same creature who was the subject of those thousands of clippings I endlessly pored over when young. The same creature who, years ago in other dressing rooms, looked into reassuring mirrors, or into cam-eras on vast sets, was now looking at me—or rather, *toward* me. I have little sense that Faye was actually seeing me. Her gaze gradually drifted away from my eyes to some point above or beside my head. Later, as Jerry was putting her hair up in rollers for the evening performance, I noticed that she put on glasses to read the newspaper, so perhaps she hadn't been able to see me clearly. But basically she was not interested in me. I was just part of a routine she had endured countless times.

Not that such routines seemed to bore her. On the contrary, filling her ego as needlepoint fills her time, they apparently reassured her. Just as the needlepoint is part of the routine of being a middle-aged woman, so the noblesse oblige is part of the routine of being a star; and she performs both routines with the same dulled attention.

Once set in motion, the routine of being a star can overshadow the stardom that engenders it. Now, it is the routine that makes Faye feel like a star, and it puts her whole attitude to herself as a performer into reverse. The other evening Harry Rigby [the producer of *Good News*, the show she was starring in, who helped persuade Faye to sit for me] laughed when I told him that Faye is guarding the wrong door. She puts her energy and effort into her public image and, obstinately protecting her rigidity, calcifies anything creative in her with stale repetition.

According to Jerry, Michael Kidd, the latest director of the show, came to her with one new line, and, because of her instinctive resistance, she took days to learn it. Jerry claimed that without his con-

stant nagging and encouragement, she might not have managed it at all. He had stood in the wings at every performance with the new line written in big letters on a card, to jog Faye's memory just before she went onstage. And in my many telephone calls to her, she had put off my request for a sitting with complaints about all the demands on her due to last-minute changes in the show. "That's what we're told is show business," I had sympathized. "Well, if that's what it is," she had responded, "I don't want any part of it."

On the other hand, she makes herself absurdly vulnerable to her fans. She allows me to draw her at the wrong time and in the wrong place. And according to Jerry she lets autograph seekers boss her around. He mimics them telling her: "No, not *there, here!*" Faye apologizes to them and then obediently signs where she's told.

Soon after the matinee performance was over, Jerry reset Faye's hair and redid her makeup for the second show. Through the open doorway of the small adjoining room where I was, I had a view of her left profile and could sometimes see part of her face reflected in the mirror of the dressing table. She had so little sense of my presence, she was unaware that I was observing her closely. Jerry parted her hair into sections, then wetted each section with a setting liquid before rolling it onto large rollers which eventually stuck out all over her head. He twisted the short hair at the back of her neck into small pincurls. She has her hair washed only every other day, but likes to have it done from scratch for each performance, a kind of perfectionism that is apparently reserved for the theater, since Jerry told me he has to argue with her to get her to wear makeup and eyelashes when she goes out to parties or dinner. She doesn't like to be bothered.

As Jerry did her hair, Faye chewed gum and skimmed the social pages of the *Herald-Examiner*, making desultory comments. "I wonder what the rich people are doing right now—," she speculated. "Just getting into a big limousine to go out for cocktails somewhere. *That's* the life."

Jerry sprayed the structure of rollers and pincurls on her head and then, dipping his fingers into a pot of dark red cream, dabbed a red mark high onto her left cheek and smeared it down and in with a massaging motion. She stared vacantly at her face in the mirror while his supple fingers expertly attached a row of false eyelashes under her left eye.

"Oh, I didn't know you were there," she said to me when she stood up to be led by Jerry to the dryer. She was not the least concerned that I had been watching her. Her crown of rollers made her look absurdly top-heavy, like a Mardi Gras figure with a giant papier-mâché head. The harsh reddish-orange and sky blue of her fresh makeup added to the garish effect.

"Might I move my drawing bench into the dressing room?" I asked. "If I wouldn't be too much in the way, it would be easier to draw by the bright light from your dressing table." "Whatever you'd like," she answered, taking my presence for granted again. To occupy her while she sat under the dryer, she picked up a nearly completed square of needlepoint, its crude design of a rose and its leaves rendered in strident red, yellow, and green. A much more elaborate design in a smaller stitch, of a beach scene with several figures, stood on a table nearby. Though Faye had finished three-quarters, she had abandoned it, Jerry told me, because the smallness of the work had begun to hurt her eyes.

While I was moving my drawing equipment into the brighter room, I was able to examine Faye's dressing table. Several snapshots of herself were inserted around the mirror's frame, most of them taken by fans and sent to her. Faye is smiling in all of them. She is with Maureen Stapleton in one, and in another only her smiling mouth looms above the centered image of a white curly-haired dog. Among the telegrams attached to the wall by the mirror was one from Eleanor Powell beginning: "ILLNESS PREVENTS ME—."

While Faye was under the dryer, Jerry took me on a tour of the

theater's dressing and wardrobe rooms. When we got back I resumed my position behind Faye and watched as Jerry undid the rollers and pincurls and brushed with heavy strokes the thick, lackluster ash-blond hair, teasing it on top and then smoothing over the tangled mound. I inspected her profile: the blunt, turned-up nose larger in her face than I'd remembered; the long, long upper lip imposing itself on the lower one with a dangerous-looking overhang; the lumpy jaw-line, where many folds of skin gathered whenever she turned her head; the loose, mottled skin of her upper arms, which quivered as she rubbed a thick cream into her hands.

When Faye returned from her first entrance in the evening show and sat again in front of me, I started work on a second drawing without informing her that I'd put away the first. Since her costume was different each time she sat for me and I was obliged to concentrate on just her head, I chose a more direct full-face view.

We were into our third six- to twelve-minute stint on the second drawing when suddenly she roused herself from her placid state to announce without altering the bland stare of her eyes: "Oh, I think I'm getting tired. I *am* getting tired." Then, raising her voice but not changing the expression on her face, she called to her black dresser, Mrs. Giles: "*Marjorie!* I'm tired."

I had her eyes and nose drawn, but only part of her mouth and chin. Confident of the drawing so far, I was afraid, when she started suggesting my coming back another time, that I was going to lose her. "Could you come tomorrow night?" she asked. "Yes," I answered and heard myself the hesitation in my voice, the note of dread at the prospect of another day of similar stress.

When Faye returned from another appearance onstage, Marjorie helped her onto a slanting board and, leaving her upside down on it, turned out the lights and herded Jerry and me into the reception room. "She's not as young as she used to be," warned Marjorie after closing the door. She was preparing me, if necessary, for a quick dis-

patch. Somebody knocked on the dressing room door, and I heard Faye's voice from the darkened room tell whoever it was to try the next door, behind which Marjorie, Jerry, and I waited for our next cues.

Faye sat for me again during the intermission, and I was able to finish the head of the second drawing. She watched my progress in the reflection of the dressing table mirror, and when she saw the face of the drawing nearing completion, she began signaling the end of the sitting.

She quickly agreed to sign the drawing and had already written "For Don" before I realized that she was automatically performing her usual autograph: "Always, Alice Faye." "Just your name and the date on the other one," I suggested to her, another fan giving her orders. She showed no sign of regretting the first inscription, said nothing about there being two drawings, and made no comment on the drawings themselves. It was Marjorie who whispered to me a few minutes later: "Miss Faye is pleased."

More as an afterthought, Faye eventually said of the second drawing that it brought out what she called "my resemblance to Lauren Bacall." Rather than betray my surprise or contradict her, I answered: "But your eyes are much bigger than hers." This visibly pleased her.

Increasingly anxious to be rid of me, Faye was almost hustling me now. In her haste, her smock fell open and exposed a complex of attachments dangling from the body stocking that tightly enveloped her thin body. She seemed unconcerned about what I might see under her smock, but I was moved into the reception room again while she changed into her next costume. Then, in a flurry of thank yous and some mechanical words about the "honor" I had bestowed on her, she was saying a rushed goodbye as she hurried out of the dressing room in her second-act white fur coat.

Before leaving the theater I stood backstage to watch her "I Want To Be Bad" number. There was something stiff about her movements, as though she were unoiled, and her voice was so low that it was barely

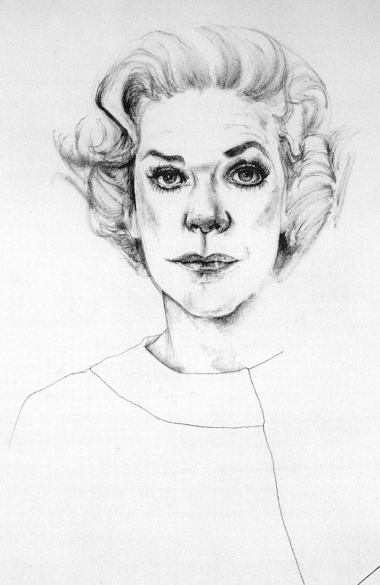

For Don —
Alice
Alice Faye
Oct 16 / 1974

audible from the wings. In the profile view I had of her, the bright lights cast deep, dark shadows on her face and highlighted her heavily veined hands. She exited the stage without noticing me and went directly to the man in charge of lighting cues. "What are you doing to me?" she asked, like a victim to her torturer. I gathered that her spotlight had not followed her throughout the number, but no temperamental fireworks, no bitchy edge to her voice. She was not angry or even impatient, just a sad, uncomprehending animal pleading for kindness and good will.

As I said to Chris when I got home that night, for me the whole sitting had been purely symbolic. My drawings of her have little of the character in her face that interests me. But even if I'd had an ideal, sustained sitting, Faye would never have sanctioned the drawing that such a sitting would have produced. My achievement was to be with her, to experience her for an entire afternoon. And that I did, intensely.

# Ruby Keeler

*1 November 1974, Santa Monica*

Yesterday I drove down to Laguna Beach to meet and draw Ruby Kee-
ler. Her house is part of a new and expensive housing development
called Irvine Cove and, neither the grandest nor the humblest, has
at least a narrow slice of sea view. The house below hers with actual
beach frontage is for sale at $875,000. "That's almost a million
dollars," said Keeler with amazement, "but of course that's only
what they're asking. Probably," she added ironically, "they'd take
$800,000."

She explained that the man who owns the house offered to show
it to her that morning, just in case she has—she then wryly mimicked
him—"friends who might be interested." "We could look at it if you'd
like?" she asked. Despite my worry that a house-visit would interfere
with our sitting, I acquiesced, but she must have noted my lack of en-
thusiasm because, when the owner interrupted us in the middle of our
drawing session, she told him without consulting me that she couldn't
get away. He had anyway seen us at work through her living room win-
dow. "Another time," they agreed.

Keeler was wearing a one-piece dress made of white leather with
a cream-colored leather belt and dainty shoes which matched her belt.
The patterned silk scarf around her neck combined light blues and
grays on a dark blue ground traversed by a single stripe of red. Her
torso is solid and chunky-looking without being flabby, her legs slen-
der and shapely, and her feet squarely placed on the floor. She has
neither grace nor fluidity and, in her leather outfit, looked rather like
a small piece of luggage, a soft leather bag fully packed but not bulging.
You could almost fit her under your seat on an airplane. Her solidity,

too, suggests a passive object to be picked up and put down, and her firm, compact head could be pressed down into her shoulders for more streamlined carrying.

Though her complexion is leathery, too, and wrinkled, she still looks exactly like Ruby Keeler. Nothing has been misplaced. Her forehead is furrowed as though by the strain of maintaining her wide-eyed, ingenuous expression. Many little lines run into her red-painted lips, which have no distinct outline or shape and seem often to be verging on a wan smile. Her dimly seeing eyes afford no view of her interior, nor any hint of emotion. They are an opaque grayish-blue with yellowed, bloodshot whites. Their lower lids are somewhat pulled-down and, exposing more red, give her head a look like an old turtle's. And her shoulders encroach on her head like a turtle's protective shell, so that, rather than scurry away if danger threatened, she could pull in her head and become impregnable. Self-reliance suits her.

Keeler has a good-natured, unruffled, almost country-folk charm, inspired more, I surmise, by her friendly kindness than by any natural spontaneity. Without phony grandeur or any pretense that she hadn't been waiting for my arrival, she greeted me from the front door as I was getting out of my car. She is highly organized, and her day's events are well planned.

Her organization is evident in her house, too. Neat as though it were on display in a store window, its accent is on cheerfulness, with its bright yellow wall-to-wall carpet as clean as though it had been laid the day before. Armchairs are covered in blue and green plaid; the sofa is white and spotless. Avoiding character or heart, the house and its glossy furnishings stress a firm, positive will to endure. If Ruby Keeler died tomorrow, the house might continue indefinitely without a change in the slightest detail.

"I don't know why you want to do this," said Keeler to me, "but I'm flattered that you do." Her modesty is not feigned. She really

didn't know why I wanted to draw her. Not thinking of herself as a star or unusual in any way, she believes that she was just lucky enough to be around when some good movies were being made.

I had assumed that she would take for granted my admiration for her as a fan and could think of nothing more I could say to explain my request for a sitting. She might have misunderstood or even been offended if I had told her of my constant curiosity about the discrepancies between reality and illusion. And I was afraid to admit to her the kind of information I wanted: Is she as likable off-screen as she is in her movies? How has age changed her, psychologically as well as physically? Is she stupid or bright? Cheerful and optimistic, or resigned, or bitter and resentful? How much of the Ruby Keeler in those movies of forty years ago is still recognizable in her face, body, movement, and behavior?

No, I couldn't be candid. And I was still feeling awkward with her after only a few minutes of polite talk, and also experiencing my familiar dread when beginning a sitting with anyone I've not met before. But, rather than admit my discomfort, I tried to reassure her: "I thought you were wonderful in *No, No, Nanette.*" My words sounded hollow and perfunctory, partly because they were ill-timed, but largely because they were not necessary. She had not been hinting for praise or encouragement and so was in no way receptive to it. I forget just what it was she did or said, but she succinctly managed to convey to me that I shouldn't feel obliged to praise her.

Keeler knows exactly why she did the show and why she was a success in it. Rather than a star or even a modest performer, she is a phenomenon. Though not defensive about herself, her realistic attitude is unyielding, and she will listen to nothing contrary to it. I'm sure she has received more than a whiff of her reputation as a well-meaning but hopeless no-talent, as, at best, a sympathetic joke. Determined to have no illusions about herself or to accept those that others might have about her, she has used her reputation, good or bad, to

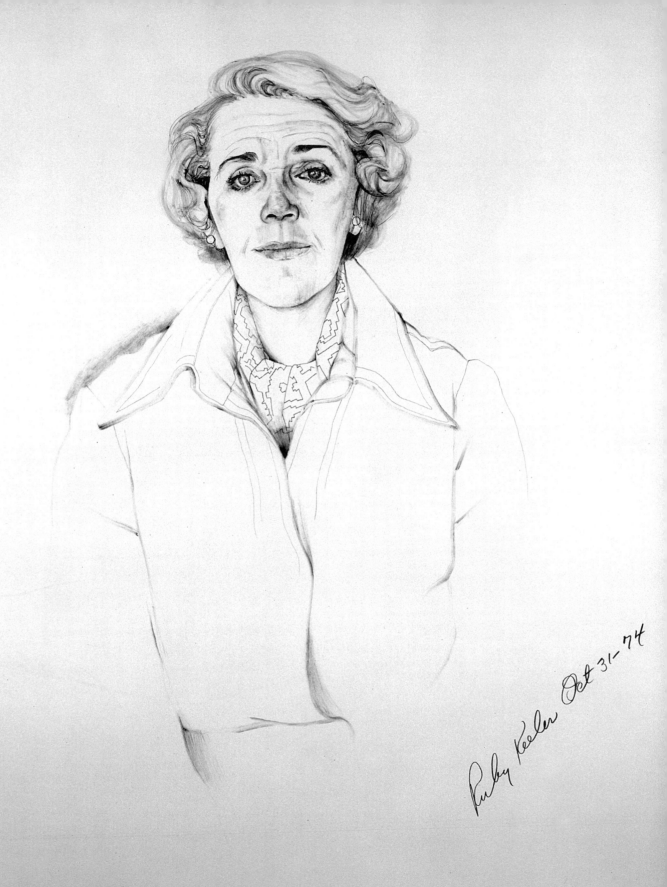

Ruby Keeler Oct 31-74

Bachardy

her own advantage. Her comeback was motivated by nothing either sentimental or self-deluding.

The strength of her onstage presence is exactly her friendliness and modest lack of pretension, which encourage an audience, if not to cheer, at least to sing and dance along with her. But I knew she didn't want to hear any of this. She already knows it. So I decided, rather than try to right the wrong of my clumsy praise, to begin work as quickly as possible. But, because I was truly liking her and enjoying drawing her, about half an hour into the sitting I did say: "You are marvelous to draw."

Again, without the equipment for accepting such a statement, she sincerely did not know what I meant. Though obviously I was drawing with appetite, how *could* my statement be serious? If she were the least bit paranoid, she might have concluded that I was putting her on. And how could I explain what I meant? My fascination with her red, saturated eyes, her furrowed brow and angular eyebrows, her lined lips? She was being very cooperative, too, and looked me in the eye almost unflinchingly. Unconvinced by my encouragement, however, she examined me as though still vaguely wondering: Why?

Soon after the sitting a friend asked what she is like, and I spontaneously answered: "She's that rare thing for a woman of her age, especially one with a show business history, a *happy* woman." She does convey peace and contentment. Her aura is one of genuine wholesomeness. And yet, looking at my drawings later, I see in them much anxiety and pain, and a sad perplexity. She herself was not shocked by the drawings, unflattering though they are, and saw that they are like her. Contrary to most sitters, she did not object to the sadness in them or even refer to it. However, she did remark, only faintly critical, on the pulled-down eyes in the first drawing and the "exaggerated bump" I'd put on her nose in the second.

For me, the second drawing misses almost completely. She had not expected to sit for two drawings and, though trying to be a good

sport, was restless and bored throughout the second. Because she repeatedly changed the angle of her head, I finally had to redraw her left eye completely. Now the second drawing seems less like her, but the first is good, and has an inner as well as an outer likeness.

"I never wanted to be a star," she said when I asked about her moviemaking days. "I just wanted to be one of the group, working along with the others." Wasn't it grueling work filming the big Busby Berkeley production numbers? "The filming itself was done very quickly. There were weeks of rehearsal, which were difficult, but once the filming began, it went quickly. He had it all in his head and always knew what he wanted, and he was right there with the camera, seeing personally to every detail." What is it like for you seeing these films today? "I like seeing again all the people I used to work with, the old friends I don't see any more. A lot of the scenes I can't remember doing. And I look at that girl as though it were somebody else. I say to myself: she was nice and thin. Not bad looking either." Do you still see anybody from the old days, anyone from the business? "Claire Trevor lives down here now, though I haven't seen her in a while. She was very good in pictures."

Keeler's family is her great concern and support. One of her daughters had given birth three weeks before to a son, another of several grandchildren for Keeler. He is named Michael Keeler Hall. Framed in a plain cardboard folder and sent by the hospital, a photograph of him taken shortly after his birth arrived in the mail while I was with Keeler. Guessing the envelope's contents, she eagerly tore it open and, holding the photograph in both hands, pored over it as though it could provide her with some secret of life.

She opened the folder wide and stood it on the kitchen window sill over the faucets and sink. Still she studied it. Then she went into a long, halting, sometimes almost inarticulate description of the difficulties of the delivery due to her daughter's rare blood type. She repeated several times how the doctor had "forced the labor." In imi-

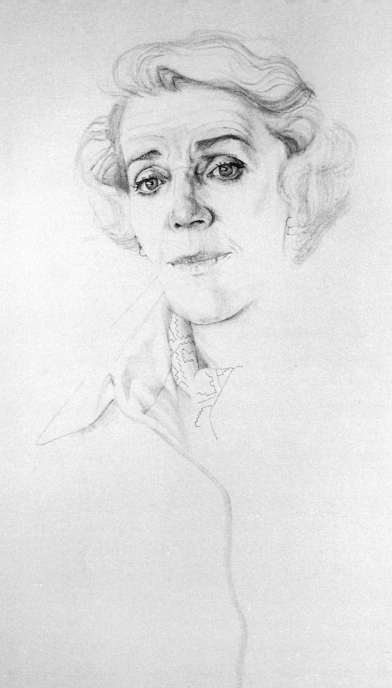

Ruby Keeler Oct 31-74

tation of his "taking the baby," her hands made clumsy, animal-like gestures. I got the impression that she spoke of such matters against her finer instincts. She was forcing herself to face openly the unsightly rigors of birth because they are a natural, essential part of life. She told of tests requiring the tapping of the fluid in the uterus of her pregnant daughter in order to find out the proper time to, again, "force the labor" and "take the baby."

She led me to a wall in the breakfast room with lots of photographs of her two sons and two daughters, all beautiful and wholesome-looking. When I commented on their handsomeness, she accepted the remark without giving any credit to herself. She, too, looked closely at the photographs and seemed pleased, but there was also something objective and dispassionate about her inspection, as though she were wondering: What does it all mean?

# Ginger Rogers

On Monday I drove to Palm Springs to draw Ginger Rogers.

In December we had met briefly in Chicago, where Rogers was appearing in a touring company of *Forty Carats.* On her night off she had gone to a performance of a Feydeau play, *13 rue de l'Amour,* in which Leslie Caron and Louis Jourdan were starring. Chris and I were also seeing the play that night and at intermission were summoned by the producer, David Lonn, to his office, where Rogers, attended by several courtiers she had brought with her, was already holding court. In spite of the dim light in the office, she was wearing large dark glasses. She was heavily made-up and looked voluptuous in a rich tan cashmere dress with a thick blond fur coat draped over her shoulders.

When we were introduced, she spoke with a stagy-grand accent, "We nearly collided in the lobby last night." I was surprised that she remembered me. Leslie was staying at the same hotel as Rogers, and Chris and I had been waiting for her to come downstairs and out to dinner with us when Rogers entered from the street. She was muffled in a black and gray plaid coat with a black snood over her hair and high shiny black boots on her feet. She wore dark glasses then, too, but despite her wrapped and goggled disguise and her unexpected presence in a strange city I'd never visited before, I knew it was Ginger Rogers. She crossed from the hotel desk to the elevator and, when she passed, gave me a casual smile, probably because I was so obviously staring.

Something flirtatious in her manner at our first meeting encouraged me, even months later, to get her number from Harry Rigby [producer of the theater revival of *Good News* who was considering her

for a television version of the show] and dare to call her house in Palm Springs. Identifying myself as "the man who nearly collided with you in Chicago," I then praised her appearance in an interview for a CBS television show a few nights before. "One never knows about these things," she replied, clearly pleased by my praise. I then broached the subject of a possible sitting with her and asked for her address so that I could send her a catalogue of my work.

During the next week I called her three times before she finally collected her mail from her post office box. At first she stressed the importance of her "recuperation period" and her "desperate need for rest after months of exhausting performances," but before long she agreed to a sitting date ten days off.

She then launched into the longest, most detailed directions for finding anything that I have ever received. I could not stop her. The long-distance charges were mounting, and Chris was waiting in his workroom to resume work with me on the script of *The Beautiful and Damned,* but on and on she droned with her instructions. After a seemingly endless account of one route to her house ("the road meanders" was a much-repeated phrase), she then embarked on "an alternate approach" which took just as long to narrate. I began to think that either she was demented or this was subtle punishment for my impudent request for an audience.

Taking her alternate approach last Monday, I arrived about twelve-thirty in the afternoon without the least trouble. The way was as clear and simple as could be, and once I entered the complex of expensive ranch-style tract houses, there were several markers with the name Rogers clearly painted on them. A cretin could have found his way to her.

I parked near some oleander trees, also noted in her directions, which grew beside a garage with the number of her house painted on its door. Entering through a wire fence gate next to the garage, I realized I'd come in the back way. With my drawing board and equipment

bag, I stood peering into a U-shaped wooden house with its windows shaded from the bright desert sun by an overhanging roof. A rectangular pool nearly filled the small space behind the house, and some plastic furniture—ornate orange chairs and two plain white tables—was placed on a patch of parched grass between the house and the pool.

I could see no one in the house but heard movements from within. A thin, long-headed woman with liverish brown spots on her sallow face and a bandana on her head opened a sliding glass door to let me in. She called me "Mr. Bachardy" and, leading me into a white-carpeted living room which squarely faced the pool, informed me that Miss Rogers had "gotten behind" but would be with me soon.

A round white plastic table that looked like a mate to those outdoors took up a lot of space in the living room. Its size was emphasized by its slipping piles of magazines and copies of the *Christian Science Monitor* and the *Los Angeles Times.* Stacks of opened and unopened mail overflowed from it onto the floor and nearby chairs. The sprawl of magazines, newspapers, and mail reached across the room to engulf a large cocktail table and a long white curved sofa. The table was already overloaded with ashtrays and assorted giftshop figurines, and the sofa with several pillows in harsh bright colors.

On the telephone Rogers had been hesitant to let me see the "unsettled" state of her house and explained that, though she'd owned the house two years, she'd spent very little time in it. This clutter, however, was well beyond a temporary unpacked state. It expressed the uncertain mind of one who, unable to decide what is and is not of value, clings to everything.

Two armless upholstered chairs turned their backs on the littered sofa to confront a switched-off television set and a nearby fireplace. On the mantlepiece stood a silver-framed 8 by 10 color photograph of Rogers's mother and a small silver frame with a black and white photograph of Rogers curtsying to a smiling Queen Elizabeth II. Herb Alpert and Tom Jones stand by in shadowed, stony indifference while

a brightly lit Rogers shines in white fur and white, puffed-up hair. She is in mid-curtsy but sneaking a coy, girlish look at Her Majesty. The effort to fix the queen with her eyes while keeping her head lowered showed in the taut strings of Rogers's distended neck.

Opposite the mantelpiece and silhouetted by reflected light from the swimming pool stood a curlicue wrought-iron stand. Among its several shelves of giftshop items, such as turquoise glass bottles and ceramic animals, was a bust of Rogers's mother with a hairstyle from the forties and a smile plumping her cheeks. Sculpted by her daughter, I learned later, largely from photographs but also from "a few impatient sittings," the smaller-than-life-size bust (it had "shrunk," Rogers said) rested on a black ebony slab. As though to fit the slab, both shoulders of the otherwise fairly competent piece had been cruelly sliced off.

Stacks of boxes, papers, and unopened movers' cartons spilled out of a connecting room that led to Rogers's bedroom and dressing room. I imagined these rooms in a disorder defying description because later, when fetching from them items to show me, Rogers was careful not to let me follow her.

From this interior I was never to see, Rogers finally emerged. She apologized for keeping me waiting and blamed her lateness on incoming telephone calls. Though she hadn't yet finished preparing herself, she assured me that she had purposely not put on makeup so that I could see and draw her face "as it really is."

Rogers's idea of no makeup must be judged by her own standards. Her lips were enlarged by a thick coating of glossy magenta-pink paint, her eyes lined with heavy black, her eyelids bright sky blue, and her eyebrows pencilled in a rich orange-brown. The ends of her eyebrows nearest her nose were turned up, the right one more than the left, in that familiar look, like a perplexed frown, she initiated in the mid-forties.

To Rogers no makeup probably means no foundation or pan-

cake, because her complexion was quite exposed. Shiny and mottled, it betrays her age more than anything else in her face. Large discolored splotches, like freckles united on a rampage, must be the result of too much sun, as is the dark redness of her nose.

Perhaps because Rogers's forceful on-screen personality suggests a taller woman than she is, my first sight of her by daylight surprised me. She seemed shorter as well as broader than I expected. Perhaps I was more aware of the full, curvaceous body she has acquired in middle age because her white turtleneck sweater and snug-fitting white trousers accentuated her rounded breasts and padded hips. She also wore a bulky jacket of a stiff fabric patterned with bright turquoise dots on a field of dark blue, which, tightly cinched at the waist so that it flared out, gave her a dumpy look. Open at both ends, her battered pink and gold wedgies revealed thick, gnarled toenails and crusty heels. Her unpolished fingernails, thick and yellowish, too, are like beaks that transform each finger into a crotchety old bird.

Her long blond hair reaches to her shoulders and, dry and stiff, is thinned, especially in back, by broken ends. Later, as I peered through a window at her while she stood in the sun talking to the tall, dark young man who'd come to fix her air-conditioning system, her hair looked like a wig of thatch. Even the young man stared at her intently, almost apprehensively, as though she might bite. I wondered if he knows who she is and, if so, if her distinguished past means anything to him. Or does he regard her as just another painted old bag in sunglasses with a superior manner and more money than he has? His round young face betrayed nothing more than his effort to look natural face to face with this unnatural creature.

I later decided that he was safer not knowing who she was when Rogers told me about a woman who stopped her in a market and, after asking Rogers if she was who she thought she was, told her she didn't look at all like she'd expected her to look. "Then how did she know who you are?" I asked. "I wish I'd thought of that," answered Rogers,

62

still rankled. Her eyes were narrowed and her mouth snarly. "I suppose you want to know what Fred Astaire is doing?" Rogers quoted herself, replaying the scene in the market for me. "Well, he doesn't report to me everything he does." Her voice then took on a savage, cutting edge: "We don't live in each other's pocket."

To fill the silence which followed her tale of outrage, Rogers and I, still shy of each other but, as "professionals," determined not to show it, searched for conversation. "You see what I mean about being unsettled," she said, indicating the room. "What I need is three or four brothers." Later, talking on the telephone with a friend, she altered her requirements for getting the house in order to "two Nubian slaves."

To help me to set up for work, Rogers pulled the round plastic table into a corner and, after drawing the white, openwork curtains farther apart, found suitable straight-back chairs without arms, one for me and the other to support my drawing board. Once we'd chosen a chair for her, she left me to put on her eyelashes, in her mind something essential rather than mere makeup. "They really are necessary," she explained, "they give that extra something."

A few minutes later Rogers returned to the living room with her eyelashes in place. Jutting out in all directions from around her bright little eyes, the primitive black prongs, like rows of spiders' legs, were both protective and threatening, and alluring too, even provocative.

When I began to draw her, she was restless at first and varied the angle of her head so that I had difficulty keeping her features correctly aligned in my drawing. I had to ask her to adjust the position of her head several times.

The telephone rang in the middle of the drawing, and Rogers got up without any attempt to prepare me, as she did throughout the sitting whenever she was tired or thought of something to attend to. Her telephone conversation lasted for fifteen minutes and was about a deal in which she and her caller were involved. Rogers was concerned

that, whether or not the deal went through, there should be "some-thing warm between us." She repeated the phrase several times in a voice that sounded almost menacing.

"I'm not going to look until you say I can," Rogers said to me as she sat down again, "I'm being good." Her considerate but uncon-vincing reticence worried me enough that I never showed her the first drawing. When she asked to see it shortly before I left, I sneaked a look at it, thought it disturbed-looking, and told her it was no good. Unexpectedly, I now like it the best of my three drawings of her. It shows her vulnerable side, before its stronger, dominating counter-part had established control over me.

During the second drawing Rogers decided that music would make sitting easier for her, so I encouraged the idea. She retrieved from the junk-filled room leading to the rest of the house a big, shiny portable radio in a clear-plastic cover and plugged the radio's cord into an electrical socket. When the radio wouldn't work, she blamed her cruel, demanding show business career, as though her radio had died of loneliness.

Resorting to the television set, she knew of a station which in the daytime played only music. "Not the kind of music we might have chosen to listen to," she commented as the first stale strains of Muzak enveloped us. But soon she was humming and eventually sing-ing along, in particular to Anthony Newley's "Who Can I Turn To?" Knowing that the song was written by "that talented British composer" whose name, like his lyrics, escaped her, she augmented the few lyrics she knew with spontaneously invented, quite banal ones of her own and, not just idly but with mounting emphasis and feeling, sang them over and over again. I continued to work throughout her performance while she, singing but maintaining the eye contact I'd asked for when I started to draw her, showed not a hint of self-consciousness, or con-cern for my concentration, or any apprehension about the impression she was making on me.

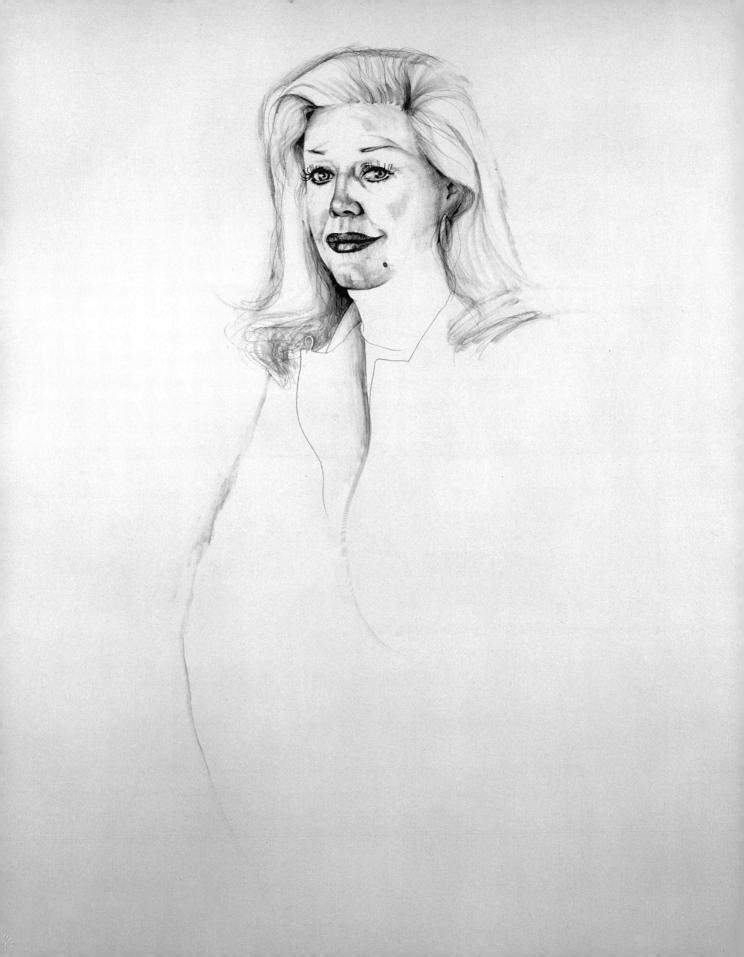

The afternoon wore on, and the television station changed from its Muzak and static abstract visual pattern to a live show with news and bits of commentary. Since the set was directly behind Rogers, she had to turn away from me to look at the screen. To her credit, she did so only twice, but her reactions to what she heard were always clearly visible as well as audible. Though in full approval of a test demonstration of the emergency warning signal ("a good thing," she muttered ominously), she was quickly indignant at an item about the new fad of wearing "earth shoes" and declared them "silly and dangerous" and "fit only for long-haired people who've never had proper shoes on their feet." I didn't admit that I have two pair because I knew that, if provoked, she might easily get riled enough to take a stand, and, perhaps forced into an argument, I would be unable to concentrate on my drawing.

Introduced as a guest on the television show, a Christian minister soon imposed a minute of meditation on death and the meaningless, transitory nature of worldly things. It was the only time in all the hours I spent with her that Rogers was flummoxed. Because the minister was "a man of God," she dared not voice her impotent outrage, but the dynamo inside her suddenly failed. The lights in her eyes dimmed, her face melted into gloom, and the zest in her whole body evaporated. A humming and contented creature a moment before, she oozed misery. For several moments all that could warm her was what I imagined to be an occasional spark of resentment, as though she were saying to herself: How *dare* he mention such things!

Another distraction while I worked was afforded by her dog, a shaggy, seedy-looking Puli. On my arrival he had greeted me with the housekeeper and quite ignored her order not to stand up with his front paws on my trousers. Impressed that I knew the dog's breed, Rogers told me that in this country they're usually called "terry poos." She praised his brightness and said he was the only dog she had ever known to sleep on his back with his paws in the air. Once while I was

drawing, she directed my attention to him. Lying on his back halfway under her chair and showing his grayish-white underbelly with his genitals swathed in what looked like a tangled mass of spider webbing, his pose implied something sordid, almost lewd. I wondered if Rogers had got the same impression as I because, after a moment of awkward silence, we simultaneously resumed work without further comment.

Two or three times during the afternoon the dog indulged in a barking spree. Jealous of my demand on Rogers's attention, he directed loud, shrill barks to her at close range. Without reacting or making any attempt to quiet him, she sat motionless and impervious, her eyes fixed on me, the perpetual upward pull at the corners of her mouth never relaxing for an instant. The dog's barking even seemed to give her pleasure, like a renewal of clamor for her favors, the louder the better.

Halfway through the second drawing I sensed that Rogers's energy was flagging. Keeping the major part of my concentration on my drawing, I attempted to revive her with conversation and unwisely asked: "You haven't done any stage musicals in a long while, have you?"

Since the single most imposing object in the room with us was a full-length, life-size painting of Rogers in *Hello, Dolly,* my goof was inexcusable (and my failure until now to mention the painting here is strange). Because the painting includes a tall stand of feathers on top of her head, it seemed even bigger than its large size, and its color further magnified its impact. (The background as well as her dress, headgear, and long gloves are painted a nasty bright red.) But, despite the crudeness of even its minor details (the mingling of the red of the background with the red of her gloves is intended to camouflage the amateurish drawing of her gloved hands), the face in the painting does bear an identifiable likeness to Rogers.

"Yes," she replied coldly to my question and, after a long theatrical pause, added, "I have." Her voice now had the same sharp edge

with which she'd punished the woman in the market. "Two years in *Hello, Dolly*," she intoned like a severe judge conferring a prison sentence. As though for bad behavior, she concluded with: "And ten months in the London production of *Mame*." "Of course, *of course*," I gulped, and let the subject drop.

I had even seen her in *Hello, Dolly*, so my mistake was all the more inexplicable. How, I wondered, could I have forgotten her curtain call in front of the entire, glaring cast of the show, when, approaching the footlights, Rogers had presumed to thank the audience for so many years of devoted admiration of her, as if the applause had been for her alone.

Rogers and I were both mute for a long while before, nearing completion of the second drawing, I cautiously asked if I might "wash my hands." She not only led the way but came right into the bathroom with me. When she got inside she excused herself as she removed a note taped to the mirror of the medicine cabinet and explained: "I leave messages to myself all over the house." Then, as though expecting me to need a lot, she said: "Let me see if there's enough paper." Checking the ample roll of toilet paper, she gave it her approval and bade me to indulge myself.

Her decision to be "good" had lasted through the second drawing. Though she had sat much stiller for it than she had for the first, I'd made the mistake of drawing her left eye slightly too far from her nose. This flaw, however, is the only one which escaped her. "The mouth looks too big," she began and soon changed to: "The mouth *is* too big." Gaining momentum, she continued: "Why do you put color into my nose and not my cheeks?" (I realized from this remark that she favors that peculiar flushed shine on her cheeks, certainly one of the key features of the Ginger Rogers look.) Referring to my drawing of the glimpse of earring beyond the far side of her face, she said: "It looks like part of my face." This criticism, to me unjustified and irrel-

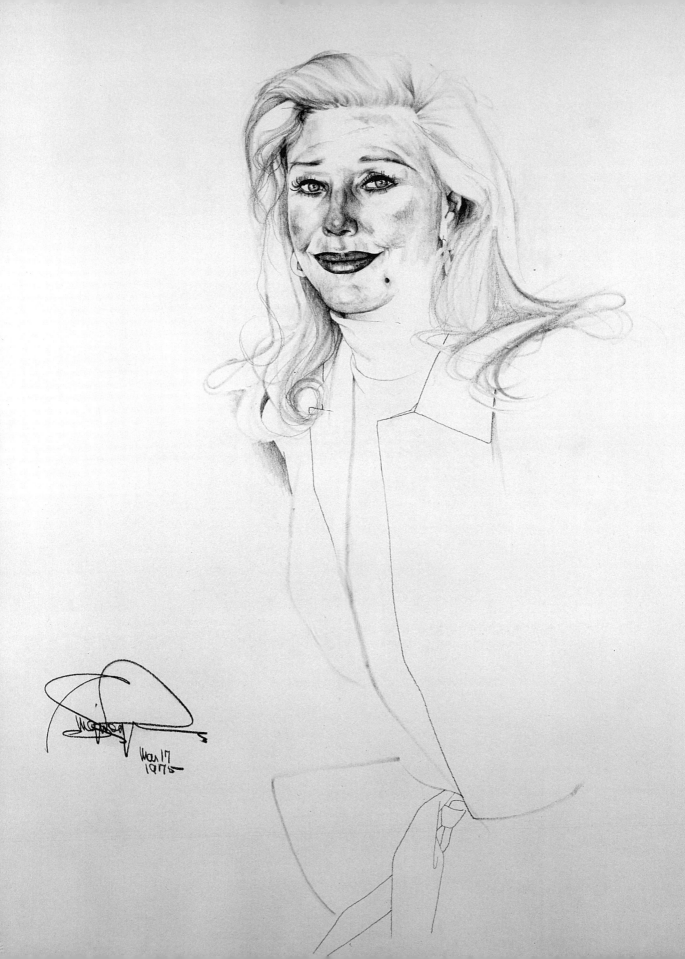

Mar 17
1975

evant, she would not abandon until I had lightened the drawing of the earring with my kneaded eraser so that it looked more like part of her hair. (When I got home that night, I drew in the earring again, following exactly the ghost of the original line and giving it its full earlier weight.)

Then we got to the real issue. "Why do you draw my eyes so pale, and so *small?*" (I had commented while drawing her eyes that they had so much vitality, such sparkle and life. "How nice of you to say that" had been her pleased response.) Resisting her increasing pressure to darken and enlarge the eyes, I said it was impossible for me to be objective about the drawing while still so involved with the actual doing of it. But I assured her that, even if I had mistakenly drawn her eyes too pale and small, I certainly didn't see them that way. "Then why," she stated rather than asked, her voice taking on its fiercest battle tone of the day, "do you draw me with eyes like peas!" Her enunciation of "peas" seethed with bitter loathing.

Had I touched on some deep trauma? In her early days in Hollywood had a cameraman told her that her eyes are too small and too close together? Partly to save my drawing from her fury and partly to get her to sit for another, I told her it would be easier to do a new "correct" drawing than to tamper with a structural fault in one already completed.

Perhaps wondering for a moment whether an extended audience might not in some way diminish her grandeur, Rogers was silent for a moment before she granted my request. The outrage to her eyes, by no means forgotten and still making her cross and sulky, was postponed for later consideration, but I was definitely on probation.

Despite my determination, the third drawing was difficult to do, and my tiredness made me work slowly. The daylight was beginning to fade, too, and Rogers was in her full domination. She had learned from the previous two drawings how to lead me. Her smile was cast in iron, and

the earlier vitality in her eyes was replaced by a glazed stare of hypnotizing willpower.

Once, midway through the drawing, without a hint in her expression of what was coming, she suddenly got up. "My back is getting tired," she announced and disappeared for a long ten minutes. When she reappeared, without even a perfunctory "May I?" she went straight to my drawing. Bending toward it with her head close to mine, she took a long, steady look. Without a word, she walked away and disappeared again into the havoc of her inner quarters, from which, for all I knew, she might never return. She did return, however, and, still without a word and with no apparent effort, resumed her pose and her smile as though she had never left them.

In the half-light of dusk, I at last finished the third drawing. Again, the cheeks were not dark enough for her, and the mouth too large. She also complained that, because of my vague treatment of her sweater's neck, its bulky folds could be mistaken for her own neck. (I had intentionally kept the neck area vague rather than draw the wattle under her chin that the turtleneck's upward push accentuated.)

Though Rogers's eye is unsophisticated, it is sharp, and her method of criticism the most effective I have ever dealt with. She spoke, not as an actress and a woman in defense of her ego and her vanity, but as a fellow draughtsman as dedicated as I to the search for truth and clarity. She had returned from her recent break grasping a round hand-mirror about the size of her palm, and, matching in its reflection the angle of her head in my drawing, she studied her mouth intently. Without a trace of self-consciousness, she then deftly reproduced the same fixed smile she'd given me and openly compared its undeniable reality in her mirror with the highly suspect invention on my drawing paper.

Finally, like no other sitter in the many years of my professional experience, she turned her back on my drawing and, holding up her little mirror and carefully positioning herself, tilted her head back,

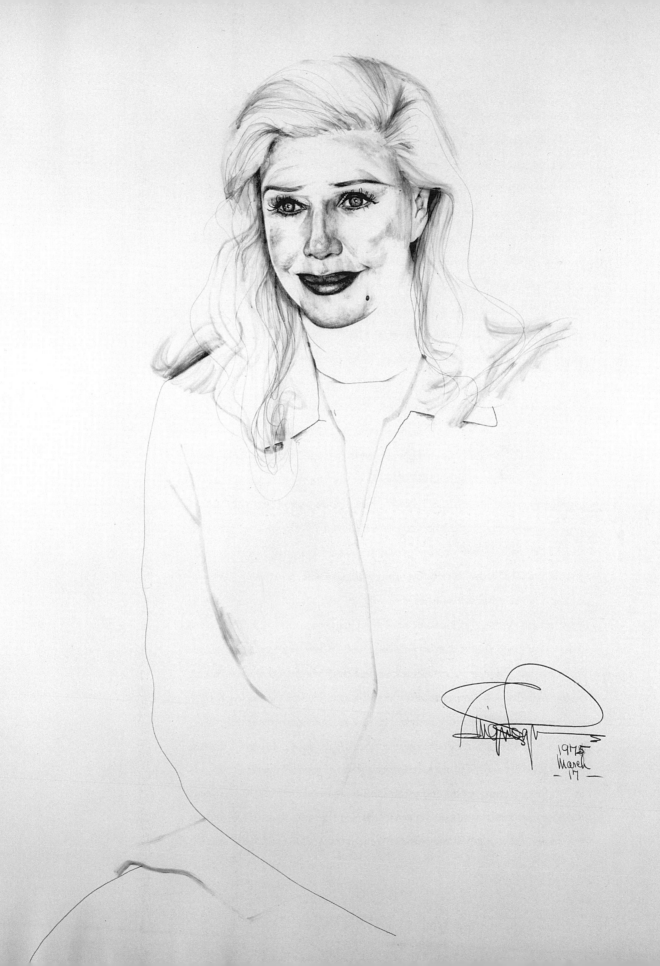

1975
March
-17-

narrowed her eyes, and checked in the mirror's reflection the accuracy of my drawing. Since her long, silent appraisal produced neither accusation nor praise, I took advantage of what I hoped was a mood of mild concession and asked if she would sign and date the drawing.

Bearing down with intense purpose on the frail lead of my pencil, she swirled her large, intricate emblem. When the lead broke in mid-signature, I gave her another pencil, which she used as fiercely as the first, making repeated flourishes of loops and curls before finally driving it home. Decisive, indelible, her mark was made. It is, like Ginger Rogers herself, ornate and self-enveloped, an end in itself.

There was nearly an hour and a half between the finishing of the third drawing and my departure from her house at eight o'clock. In more than seven hours with her, I never got even a glimpse of her mother, nor did I hear the faintest noise to suggest her presence in the house, yet she is there, unmistakably—in the photographs on the mantelpiece, the bust on the wrought-iron stand and the continual references to her on the lips of her daughter. She was not only undeniably there; she was, like "Rebecca," the virtual mistress of the house. And Rogers, in spite of her age, painted face, and dominating personality, is curiously like a little girl, willful and sometimes belligerent but always a profoundly loving daughter. Indeed, I suspect that her mother is the great love of her life.

Rogers brought me a selection of photographs of her mother from a close-at-hand niche (perhaps they lined her mirror), some from fifteen years ago she told me, a few more recent color ones taken by her, and one of them together at a public occasion. In spite of their familiarity to her, Rogers pored over them, her head intimately close to mine as she shared her greatest treasure with me. "Isn't that the most adorable face." Her questions have no question marks.

Peeking out from the photographs with a decisive merriment that portends danger, the little wizened face of her mother is that of

a malignant pixie. Her full cheeks squeeze her eyes into slits, and, twisted into a masklike grin, her firm little mouth looks meant for bites that, like a gila monster's, would embed septic teeth to fester in one's flesh. But she is Mother Triumphant, the maker and leader of Rogers's life, its source of light and strength. But soon that sun must go out. Without a doting mother's constant care, can her daughter's powerful, consuming ego sustain itself on its own?

It was Rogers's ego that prompted her to sit for me, to substitute, for the cameras that no longer choose to inspect her continually, a pair of devouring eyes as eager to feast on her as she is to be feasted upon. She met their gaze with more voluptuous delight than any of my other sitters. Her response to being the sole object of my attention, to that intrusive "peering" which Virginia Woolf in her journal so objected to, was profound, and almost purely sensual. She beamed her eyes at mine, not so much seeing me as feeling my scan, and, throbbing with a luxury of fulfillment, she proffered me her mouth. Shiny and wet with paint, it balanced itself between the disciplined tension of a perpetual smile and the relaxation of unqualified surrender. As feminine and dewy as an adolescent girl in the heat of sexual awakening, she flowered and came to fruit in the warmth of my greedy stare.

It was late dusk now, and Rogers, seeing a pink and blue sky through the sliding glass window, suddenly exclaimed: "Just look at that!" She pulled the glass door open and, flowing into the open air, gestured girlishly to the sky above. "Look at that *color!* Have you ever seen anything like it!" Another of her statements masquerading as a question, it didn't require any response from me, but I dutifully followed her outside and tried to reflect her actressy communion with nature's glory. Insufficiently inspired or just plain tired, I only felt awkward with her under the open sky.

## 13 November 1975

Ginger Rogers sat for me a second time on Tuesday, 4 November, in a house in Beverly Hills (724 North Bedford Drive) she'd rented temporarily to facilitate rehearsals for her nightclub act.

I had come to the house for the first time on the previous Wednesday. She had peeked out of the small, grilled window in the front door and, upon recognizing me, let out a horrified moan to signal that she had forgotten our date. The door was opened, and I stood on the threshold as Rogers, small in flat shoes but bulky in heavy black knit sweater over a black turtleneck and black pants, writhed in mock anguish at her lapse of memory. "I've been so busy, rehearsing every day, doing so many things. And look at me!" she wailed. This time she really was wearing no makeup at all, not even lipstick, though her parched, raw-looking lips were glossy with a thick lubricant. "I was going to have my hair done for you," she continued, gesturing with a long brittle strand of faded yellow-orange hair. "Just *look* at me!" she commanded. But behind her feigned horror hid a glimmer of defiant pride, a belief that, even without makeup, she was *still* fascinating. And she was—to me anyway.

Though certain that she wasn't going to let herself be drawn that day, I told her that I thought she looked fine. As I said those words, however, I shuddered at the thought of her reaction to even a halfway truthful version of the leatheriness and mottled colors of her sun-baked complexion. Without lashes and defined by neither eyeliner nor mascara, her small, bleached eyes had a non-seeing quality, as though unable to focus. (I, however, knew otherwise!)

While Rogers and I talked in the vestibule, her new secretary, a tall, thin, red-haired young woman who yessed Rogers with a smarmy professionalism, stood by ready either to close the door in my face or spread herself ruglike at my feet. Then a man arrived who said he was delivering a bed. The secretary explained that he must first, as was

"promised," take away "the old bed." Perhaps to spare me the heart-rending sight of the banishment of her poor old bed, Rogers led me through the hall out to the rear garden, where I extracted from a portfolio I'd brought with me the first of the three drawings I'd done of her seven months before. Though I hadn't shown it to her at the time, I had since come to like it best of the three and foolishly hoped that, in her apologetic mood, she might agree to sign it. But I had forgotten the full strength of her unrelenting will to rule by her own immutable standards. In short, the upper lip was, as in the other drawings, "too long." I saw no possibility of persuading her, and by then beds were foremost in her mind. We made a date for the following week, and she saw me out with a repetition of her gracious apologies.

Rogers kept me waiting only a few minutes on the following Tuesday. The heavy eye makeup and the big, wet, magenta-pink mouth were already in place, but her hair, which she'd just washed, was damp and lank. "In your drawing, of course," she said confidently, "you'll be able to curl it for me."

To help me "to understand" her face, before we started she gave me a lecture on the "calibrations" of its proportions: three horizontal fingers from hairline to top of eyebrows, three more from top of eyebrows to bottom of nose, one finger from bottom of nose to top of upper lip, one more for upper *and* lower lip, and two fingers from bottom of lower lip to end of chin. Demonstrating these measurements for me kindergarten-style, she fingered herself with patient deliberateness.

We then started to work, but about twenty minutes into the sitting her secretary informed Rogers that her mother was calling from Palm Springs. Without question, other concerns waited while Rogers talked, totally unselfconsciously, to her "Baby Girl." Their conversation was devoted to the latest developments in Rogers's dealings with accompanists, choreographers, agents, and nightclub managers in-

76

volved in the creation and booking of her new act. Despite her many endearments to her mother, I occasionally heard a slight note of impatience slip into Rogers's voice.

Rogers resumed her position in front of me, and in about an hour more of work I finished the drawing. "You've done it again!" Rogers declared almost triumphantly when she first looked at the drawing. "The space between the bottom of the nose and the upper lip is *too long!* Here, let me show you," she said. She knelt down beside my chair, put her face close to mine, and, taking my left hand in hers, separated my fingers into various combinations and placed them onto her face to measure off the proportions she had "calibrated."

I didn't resist her, nor did I betray my instinct to shy away from this physical contact, but there was something oddly carnal in her didactic demonstration. The feel of her soft, warm, folded flesh under my fingers was uncanny, the nearness of her face almost mesmerizing. There was, too, something perverse in the strength of her hand firmly controlling and guiding mine while her face passively yielded up its treasures. It was as if she were using my hand as an instrument for masturbation.

Made crafty by my determination to save my drawing from her exacting criticism, I underwent the finger ordeal without objection and then said in an eager, good-sport tone, "Just for the sake of curiosity, let's measure the drawing with a ruler." Relieved to find the small, green plastic ruler that I'd hoped was in my drawing bag, I placed over the drawing a piece of notepad paper light enough to see through and marked off with my pencil the distances between her facial features. Using the space between the bottom of her nose and the top of her upper lip as one unit (equivalent to one finger), I measured three units exactly from brow to eyebrow, three units exactly from eyebrow to bottom of nose, one unit exactly for upper and lower lip, and two units exactly from lower lip to chin. I was surprised myself that my drawing so completely confirmed her own measurements.

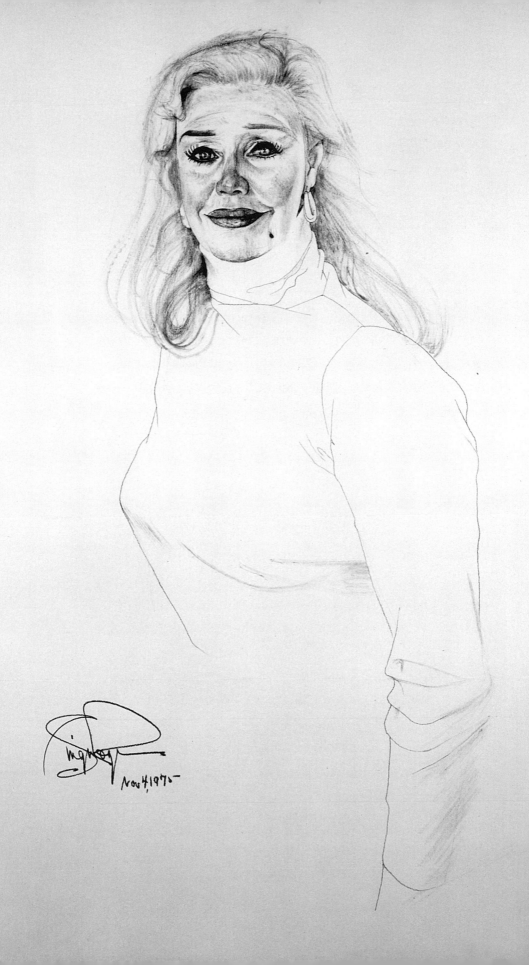

Nov 4, 1975

Shaken but unwilling and unused to surrender, Rogers said: "Then the space above the upper lip must be too light. It should be shaded more." Realizing she was routed, I generously agreed. Knowing I could remove it later if I didn't like it, a bit of added shading both mollified her and improved the drawing. Her lust for power aroused, she urged further shading. I warned in a hesitant voice, "I'm afraid of giving you a moustache." At this she laughed, and I knew I'd won the game.

After I applied a touch of darkening to the iris of the eye on the left side of the drawing, and also promised to consider when I got home the removal of a glimpse of earring on her right ear, which she again claimed looked like a growth on the side of her face (a possibly valid but trivial complaint that I did nothing about), she was ready to concede.

The drawing, done in no more than an hour and a half, is one of the best I've done lately and certainly better than all of the first three of her, but she only mildly praised "the color" I'd put into her face and, despite my failure to curl it for her, my rendering of her hair. She also liked the long line of her arm.

As Rogers was about to sign the drawing, her accompanist had arrived. An ungainly, harassed man with a bald head and dark eyes that rolled around in their sockets like loose marbles, he was asked by Rogers what he thought of the drawing. His immediate assumption that it was a self-portrait clearly characterized his own dealings with her. That she would undertake a portrait of herself seemed perfectly natural to him. As though confirming his mistake, Rogers positioned herself to sign and date the drawing. I had wrongly assumed that she would remember the procedure from the first sitting and only narrowly avoided a dedication from her when, before signing, she asked me: "For Don?"

# Aaron Copland

This afternoon Aaron Copland himself was at the station to meet my two-thirty train. When he recognized me, he gave me his open-mouthed, toothy smile, which is more like a reflex action. There is not much oomph behind it, and, though kindly, its uncommitted vagueness betrays his unthinking use of it.

He drove me to his house, which is twelve minutes from the station, in his elegant, dark green Mercedes. He asked me if I knew the Hudson Valley, and I said no and only remembered later that once, more than ten years ago, Chris and I had visited Gore [Vidal] and Howard [Austen]'s mansion overlooking the Hudson River. I felt I should say something in praise of the landscape but could think of nothing convincing.

In the midst of a grove of slim, gray, leafless trees, Copland's nondescript house is on a slightly raised foundation. From an outside semi-terrace I could see the Hudson River, a narrow silver sliver in the distance as it reflected the warm sun. Though it didn't seem much to me, when Copland mentioned "the view" on our way to the terrace I enthused over it to make up for my silent reception of the Hudson Valley itself. When he accused me of reacting before I could even see the river, I explained that I had got a glimpse of it as we came up the stairs to the terrace. The trees all around, like posts in an obstacle course between the house and the river, did, even in their barren state, obscure the river and, when in leaf, would block it out entirely.

He led me from the terrace into his workroom, which faced the river and the afternoon sun. With its long row of westerly windows shut, the room was warm and stuffy. A piano piled with sheet music

and a desk covered with papers created an air of clutter rather than disorder. The several framed photographs included one of Nadia Boulanger and another of Stravinsky with an inscription thanking him for his contribution to *Les Noces.* A much-used low-slung chair with cushions covered in a sun-faded plaid fabric idled near a wooden table with stacks of magazines stuffed under its glass top. The room, like the exterior of the standardized house, is anonymous and depends for atmosphere on its occupant, in this case one so absorbed in his work that he is indifferent to his living quarters and, when he needs relief from them, goes outdoors.

When I asked for coffee, Copland brought a tray with a kettle of steaming water, a jar of Maxwell House instant, and a plate of cookies from a commercial box. He was uneasy now, like a dog with a new owner. I realized that he had no idea what I expected from him.

"This is harder work than I thought," he said after he'd been sitting for forty-five minutes. From his admission that he'd imagined me like a photographer catching him "in action" as he worked, I realized that he had not intended to give up the afternoon to me. I'd already learned, from the few indifferent drawings and paintings on the walls, that he cares little for graphic art. "To me," he later confessed, "it is the strangest of all the arts." At the Brandeis awards ceremony (where I had asked him to sit for me), he was awarded a medal and claimed in his acceptance speech: "Musicians get much less recognition than writers and painters." Even then I had thought him prejudiced as well as misinformed, but I forgave him because, as I left the podium after accepting a literary award in Chris's stead, Copland had praised me: "Good speech!"

When I told him that Chris had little interest in music, he laughed, but I could see his shock. For him a life not centered on music was incomprehensible. He then said approvingly: "Auden and Spender are both very knowledgeable about music."

Copland is competitive, particularly with his contemporaries.

He asked me Chris's age and, when I told him seventy, said with sur-prise, "He doesn't look it." Copland's reaction was complex. Reas-sured because Chris had not bettered him by avoiding age, he also ad-mired and even envied him for still looking so youthful. But seventy was older than he had expected, and made his own seventy-plus age correspondingly more alarming to him. Yet, he appreciates the pres-tige derived from seniority, what Chris calls "age-competition." Only half-jokingly, Chris now claims that he prefers to be the oldest person in a room.

With my back to the window, I began drawing Copland with his head turned toward the river view. I stopped after more than ten min-utes and started again with him looking at me. His head tended to change its axis often, and I hoped looking at me would help to steady it. It did, but not much. His attention wandered easily, and behind his friendly, cooperative exterior lurks a selfish, indulged child, and a haughty genius. Both were offended (if not outraged!) to be sat down and told to keep still.

He asked to play the phonograph, then got up and showed me what he was going to play, a fat album of several records containing Leonard Bernstein's Norton lectures. There was something wry in the manner with which he indicated the considerable bulk of the album. Because his phonograph isn't automatic, I had to stop work while he got up to change records and was glad that after two he'd had enough.

The records he played were from the middle of the series. While listening to them his mouth would broaden suddenly in silent laugh-ter, as much at the tone of Bernstein's voice, I guessed, as at what he said, which Copland criticized as too technical for lectures meant for the layman. Underscoring the rivalry evident in his reactions to Bern-stein's pronouncements, he told me that he himself had once given the Norton lectures.

Copland wore down as the sitting wore on. Probably he takes an afternoon nap and was tired because he was denied it. His tired-

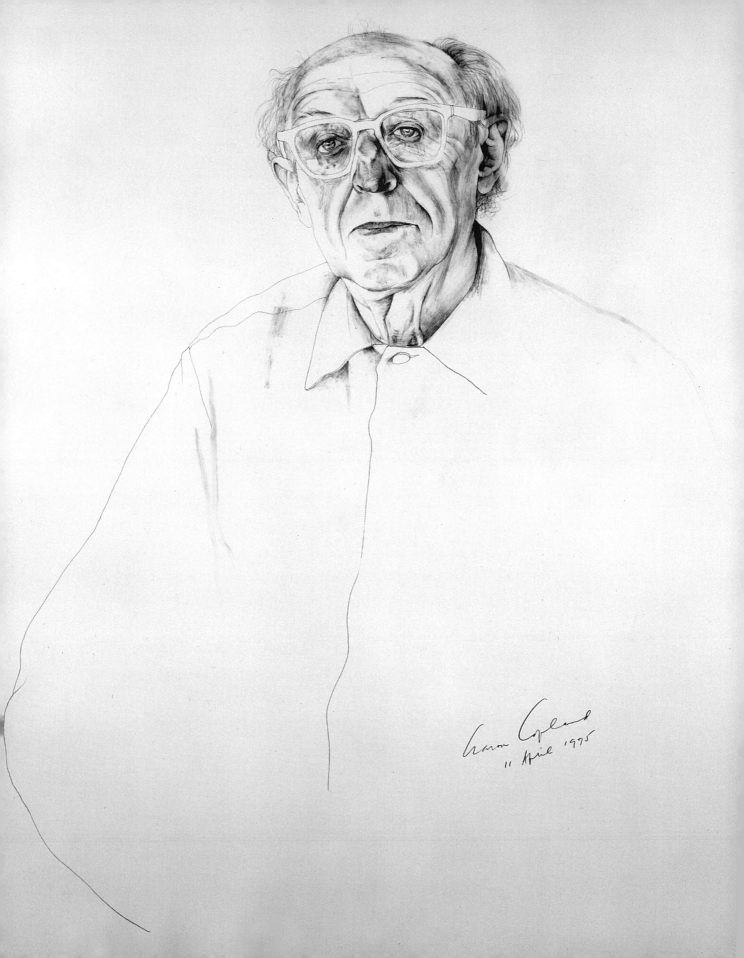

Aaron Copland
11 April 1975

ness increased his restlessness, and the more he moved, the slower I worked. Also, in a surge of energy as I began to work, I had made his eyes (my starting point) so big that my drawing was nearly life-size. My difficulties in controlling the large scale slowed my work even more.

It was four-forty-five when I finally finished the drawing. I was relieved that his reaction to it was enthusiastic. Yes, he said, when I asked if it looked like him, and he liked what he called its "delicate quality," and "the way it seems to grow out of thin air from the bottom up." He kept returning to it, cocking his head to one side and then the other, first amused, then uncertain, then pleased again. His thirteen-year-old godson, Jeremy, was brought in for his opinion. Very sexy with his luscious, sun-ripened-apricot complexion, Jeremy immediately pleased his godfather, and me, by declaring the drawing "authentic."

Then a hefty middle-aged man called Victor [Kraft] entered the room. Virgil [Thomson] told me later that he is an ex-lover of Copland from long ago. Submerged in beard and hair, with bright-eyed sincerity, Victor looks like a classic hippie. But, in the car on the way back to the train station, Copland assured me that Victor looked very different when he first knew him at seventeen. In case I hadn't guessed, he wanted me to know that Victor had been beautiful. Jeremy is his son, and they are visiting Copland for several months from their home in London.

Copland told me that he is trying to write his autobiography but, afraid that he's waited too long, has done only one chapter. "My memory isn't good enough any more." Indeed, by the time we were on our way back to the train station he had already forgotten the dinner date we'd made only minutes before—he will be in California next month to conduct some concerts, and I have invited him to our house for dinner on the eleventh. He then repeated that Victor was seventeen when he first met him. He wanted me to know that Chris wasn't the only one who could swing it. He, *too,* had had a beautiful young lover!

His subtle flattery—of Chris *and* me—was all the more agreeable to hear because it was unintentional.

"Well, it makes me look benign." That, I remember now, was Copland's first comment when he looked at my drawing of him. "Am I that benign looking?" he asked a bit later. "I don't think of myself as so benign." He seemed both surprised and pleased at the notion, but then I wondered if he might be using "benign" as a euphemism for "old." "Isn't that a drawing of a kindly old gentleman?" he said when he and Victor were looking at the drawing together. It seemed to be a wry, self-mocking question which didn't require an answer, but, when neither Victor nor I responded, Copland said: "Well, I thought someone was going to contradict me!"

# Joan Blondell

"A good dame" is an old-fashioned term which suits Joan Blondell, and she is wise and unpretentious enough to know that being old-fashioned is part of her appeal. "I'll make the best of you if you'll do the same for me" could be her motto. Her good-natured, down-to-earth manner quickly made me feel comfortable with her, even cozy. Her effectiveness in movies comes from her ability to be herself in front of a camera, to allow her personality to operate as freely as it does when she is taking a stranger into her home.

Now, with her magnified eyes, colorful makeup, and catchy voice, Blondell looks like a gaudy but lovable caricature of her earlier self. Her round face and eyes and the well-rounded, overlapping curves of her chunky but still feminine body make an overall impression of roundness, and the champagne-colored hair around her face forms big, rounded curls. "Your gray hair is a beautiful color," she said to me. "My hair's white, but with my old face it's not so good."

Blondell lives on the third floor of an apartment house on Ocean Avenue [in Santa Monica] and has a view of the ocean through the tops of the palm trees in the park across the street. The ocean sparkled in the afternoon sun. The velvety, olive-green luxuriousness of her apartment's L-shaped living-and-dining room is well-suited to a Blondell movie character, the manageress of a plush steak house with flocked paper on the walls.

She opened the door to me herself and was soon showing me around her apartment. A counter separates the dining room from the kitchen. She says she cooks a lot but hates the electric stove and oven, which, after three years in the apartment, she is still not used to.

In the living room is a Paul Clemens oil portrait of her done in 1942, a good likeness but not interesting to me as a painting. In it, with her sun-streaked blond hair shoulder-length and fluffed out, she looks as she did in the summer of 1944, when, at age ten, I saw her strolling in a Balboa penny arcade with her husband at the time, Dick Powell, and their two children. Her shirttails were tied under her breasts, and, with her deeply tanned bare midriff and no makeup, she was smaller than I had expected and leathery-looking.

Blondell said that the producers of a play she is planning to do in London this summer were coming to see her at two-thirty, and she suggested a three-thirty sitting. When, as she asked, I called before leaving for her apartment, she told me to come at three-forty-five. I suspect that she had scheduled me right after her meeting because then she would have to make herself up only once for two occasions, and she could use my call and imminent arrival to get rid of the producers.

Months ago, after Jamie [James Leo Herlihy] told me that he had shown her a catalogue of my work and she had agreed to sit for me, I began telephoning her. "Call me in two or three weeks," she had said several times and made incoherent references to a court case she was involved in which had to be settled first. I think, like Chris, she finally agrees to see those serious enough to go on calling.

Joanie, her tall thirteen-year-old granddaughter, shares the apartment with her. Friendly in an impassive way, the girl seems some-what dazed, or maybe she's just playing it cool. Blondell is fond of her but careful not to be possessive. She cited differences between the girl and herself when young. "If *she* wants to see a boy, she calls him! I would have died first."

She is worried about the girl's size. "She's pretty, but big. Every-thing about her is big. Big hands—pretty hands but big hands. Big feet—pretty feet but big feet. The only thing small about her are her boobies. These kids today—flat as boards. Beautiful, but flat."

A woman who regards her big boobs as a gift to be borne with

pride, Blondell is pleased to have measured up to the strict physical standards for a movie starlet of the 1930s. But she also has a moral side to her. "I had three husbands. That's too many, but I loved them all. And when I was with them, there was no one else, never."

She told me that she likes to sit out on her balcony and observe the people below. Once she got very involved watching a young girl waiting at a bus stop. "First she's standing up, and in a pair of high-heeled shoes much too big and high for her. Then she sits down on the bench and lets bus after bus go by. Finally a guy in a huge convertible pulls up to the curb half a block away from her, and he makes her walk to the car in those uncomfortable shoes." When the guy didn't bother to get out of his car or even lean over to open the door for the girl, Blondell was so upset that, after the girl got into the car and it began to pull away from the curb, she leaned over her balcony and shouted, "You be good to that girl, you son-of-a-bitch!"

Though she was very respectful of my skill, I could tell that Blondell didn't really like my drawing of her, even though, and to her chagrin, her granddaughter announced: "It looks just like you." But not one word against the drawing from Blondell, except for her reference to the arthritic hands. "Anyone who sees those knobs will know I've suffered pain." There was a curious note of satisfaction in her voice, a hint of masochism rewarded. Maybe most good dames are masochists at heart.

## 4 June 1975

I drew Joan Blondell again on Monday. She had put off our second sitting several times at the last minute. Even on Monday morning, when before leaving I called to confirm, she was reluctant to let me come, and when I arrived at eleven she was noticeably grumpy. I found out later that her arthritis was giving her pain.

Blondell and I worked again in the living room. Home from

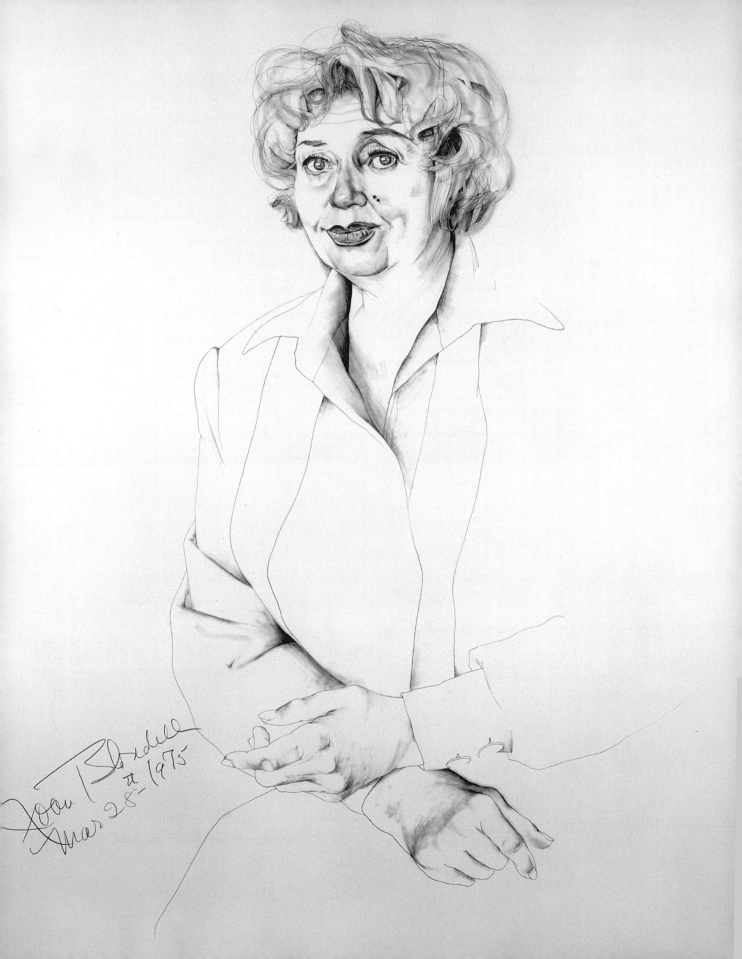

Joan Blondell
Mar 28 – 1975

school after an "exhausting" week at camp, her granddaughter, Joanie, wandered into the living room like a lanky sleepwalker. The blue eye shadow on the lids of her tiny, half-closed brown eyes accentuated their sleep-swollen look. Blondell asked Joanie to give her a Percodan pill.

Joanie had been watching *The Three Musketeers* on television. I was skeptical of her enthusiasm because, when I asked, she wasn't sure whether the version she'd seen was in black and white or color. (I learned later from a television guide that it was the black and white 1935 version.) Her inattention confirmed the impression I already had of her. I think Blondell finds her company comforting, like that of her dog and Siamese cat.

Blondell is an animal-lover, and much of her talk is of cats and dogs, her own mostly. She told me that none of the residents in the apartment building bother to walk their dogs four times a day as she does. Once she had even got involved with a pair of dime store turtles that had been given to her. "When one went blind," she said, "I hand-fed it with blood I squeezed from raw hamburger."

She praised the intelligence of her cat, who wakes her up in the morning by dropping its favorite toy, a plastic bottle cap, on her face and chest. If it fails to rouse her, the cat drops the cap on her feet, which Blondell said are always intentionally uncovered when she sleeps.

I had already seen from her open-toe slippers that Blondell's feet are large and strong, with heavy, curling nails partially coated with last week's pink-red nail polish. Her cat story conjured up in my head a picture titled *Blondell Asleep*: a big, warm, fat mound under heavy blankets, bared feet sticking out at one end and tumbled hair at the other, the whole seething mass orchestrated by chugging snores. She's like a much-loved animal character in a children's story.

Considerably more pulled-together for our first sitting and the visit from her theatrical producers, this time Blondell had done a

minimum job on herself. The tossed look of her hair had been achieved by last night's pillow and hardly disturbed since. Her eyelashes, mascara, and eyebrow pencil were in their places, but her lipstick was pale and worn off. The haphazard effect, patches of makeup hastily applied over an unwashed face, was augmented by a last-minute inspiration. Having displaced the sporty dark blue pantsuit of our first encounter with a mumu, she pulled down its front zipper just before I started work and, turning under its neckline, exposed some of her ample cleavage. "It'll give a dressier look," she assured me.

Once we started working, her grumpiness abated. After a cigarette or two, a liberty she had not taken during our first sitting, even her distracted air surrendered to her instinctive professionalism, which will not let her give less than her best, whatever the task. By the time the Percodan pill had taken effect, she was her characteristic, easygoing self, and her good-natured tolerance of humanity had been re-established sufficiently to include me. Throughout the sitting she cooperated fully and resisted in no way my scrutiny. For a while, we were content together.

In her restless, irritable state before we started work, she had made only one stipulation, holding a photograph of my first drawing of her with an indelicate arthritic clutch: "Let's not show the hands this time."

Though I obeyed her ban, I recorded everything I saw in her face. So I was surprised and relieved when she instantly said she liked my drawing and praised its "look of vulnerability." Not meant as criticism of my work, her chief remark was made almost as an aside: "That face is lived in, all right."

Joanie joined us again, and her one comment on the drawing, "She's pretty," pleased me because it reassured Blondell.

"I'm being a lousy hostess," said Blondell after signing the drawing. "Can't I offer you something? How about some coffee?" I asked for instant and saw her relief at being spared the nuisance of making

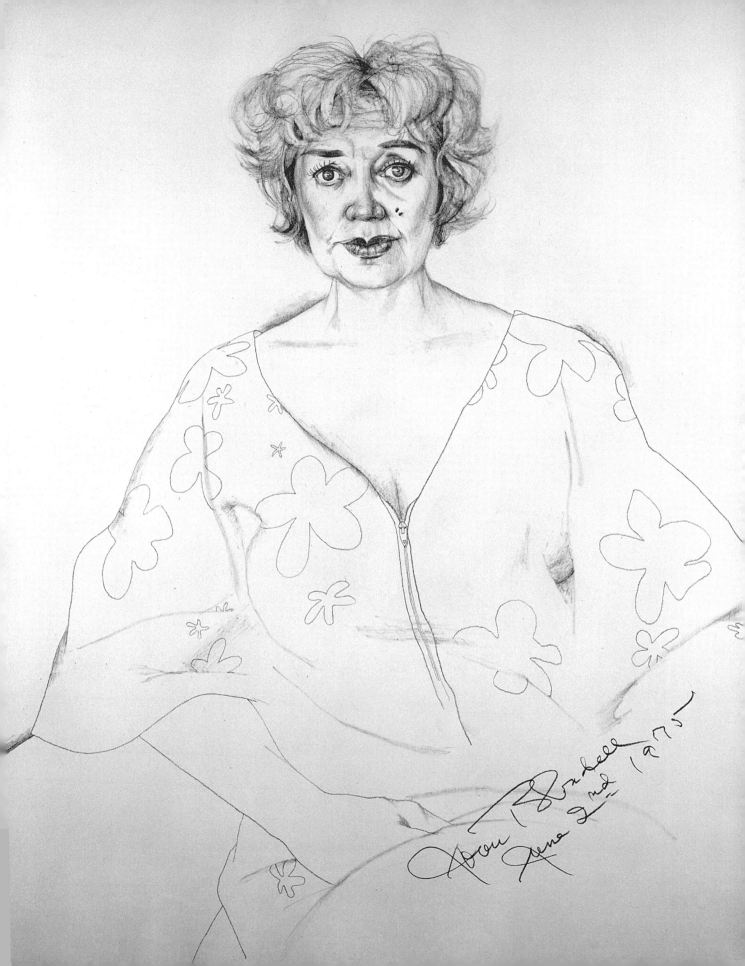

proper coffee. Though I chose ordinary when she asked if I'd like that or mocha, she extolled the virtues of a new mocha instant she'd discovered and insisted that I take with me a nearly full can of it. I inspected the label when I got home and was impressed by its long list of synthetic and unwholesome-sounding ingredients. Still, her impulsive gesture, like Blondell herself, had been generous. It easily compensated for what the coffee lacks in wholesomeness.

# Ingrid Bergman

*20 April 1975, Santa Monica*

A week ago today I drew Ingrid Bergman in her suite at the Hotel Pierre in New York. I have resisted writing about the sitting because I don't like the drawing I did of her, and don't understand why I didn't do better. She is an intelligent, straightforward, and genuinely likable woman, and she behaved marvelously to me. She took the sitting perfectly seriously and sat very still. Yet, for some reason unknown to me, I had trouble identifying with her or getting close to her. And achieving a likeness, discovering where in her face her personality resides, was unexpectedly difficult. It was unlike me, but I think that I was intimidated by her. I didn't feel that I was master of the situation.

I did only one drawing and spent too long on it. I should have done a second, and wanted to, but, and again it was unlike me, I didn't dare ask. "You said it would take two hours, and that is just what it took," she said when I'd finished. How could I then be pushy and use my presence in her room to wheedle more time out of her? My instinct told me she might refuse, and I didn't want to force her to do that. She is a professional and treated me as one. She had been totally reliable about the sitting and never hesitated or changed her mind about the day or made me call too often to confirm the time. It would have been unethical to press her to sit for a second drawing. Like Chris, she is a Virgo, and they do not respond well to persuasion tactics.

My dissatisfaction with the drawing is based largely on its tentative likeness to her. It is identifiably her, but only just. She didn't like it, either. Though she felt the eyes were right, she was dissatisfied with the mouth, and, to my surprise, one of the details which bothered her

Ingrid Bergman

April 13, 1975

most was the way I'd drawn her hair. "I like to see my hair higher in back." Whipping a comb through her hair, she strode to a picture mirror to fluff and pat it with her hands and then turned to me. "This is how I try to make it look."

When she also questioned the wideness of the bridge of the nose, I shaded it a bit to please her, knowing it would make little difference. Even then I was almost certain that the drawing was a failure. She signed it, however, and without any objections. Asking first if I wanted it signed "To Don," she was then embarrassed by her question: "Of course not. Why should I sign it to you—it's yours!"

I asked her to look at me while I drew her, which didn't seem to bother her, but her eyes teared after the first few minutes. I didn't know whether this was due to the strain of staring into the light from the window behind me, or to some emotion that touched her while I drew, which can happen when my sitter is unused to being still and silent. Since she didn't comment on her watering eyes, neither did I.

When I looked into Ingrid's eyes, they seemed much smaller than I had expected. Very little of the whites show because most of the space between her eyelids is filled by her clear grayish-green irises. They might have taken on some of the pale turquoise of her blouse, which was of the same lightweight material as her jacket and trousers. Her sandals displayed her soft, shapely feet with red-lacquered toenails.

When I got out of the elevator at the thirty-seventh floor, she stood smiling in the doorway of her suite (3708). She showed me into a smallish sitting room made smaller by its thick carpet and by being too warm. Lamenting the heat, she showed me the window she had opened (not wide enough I thought) but said it had not helped.

Big, smiling Ingrid in a small, stuffy room. She laughed and talked freely, first about touring in *The Constant Wife.* "Such a happy company. Everyone is so nice. I know there will be such tears when it's over. Usually there is at least one person with a temperament who is

difficult, but this time there is no one. We all get along so well. I shall miss it when it is over."

She contrasted her warm feelings for the members of her company with her reaction to a journalist who had interviewed her a few days before. "He was one of those people who, the moment you see him, you know you could never like." He'd been ungracious and asked her why she wanted to do a "worthless" play. "At least he put his own questions into the piece," she said, "and, when I read it a few days later, I did think it was more interesting than the average interview."

The telephone rang about twenty minutes after we'd begun to work. She was in the bedroom asking who the caller was when I heard her incredulous "Danny Kaye's daughter?" (The girl, Ingrid told me later, works for a newspaper and wanted to interview her about "my beauty secrets and how I keep my looks." Ingrid smiled derisively at such a notion.) "No, I'm not giving any more interviews," said Ingrid breezily, "I don't have to now. We're doing very good business, what with the award and all. There's no reason for me to sit around in the hotel giving interviews." Her light, friendly manner emphasized the firmness of her refusal without a hint of unpleasantness. Danny Kaye's daughter was simply given no recourse.

During the run of the Maugham play in Washington, D.C., Ingrid told me that the American Film Institute had offered her and her company a screening of any of her films. Her choice, *Notorious*, she hadn't seen in years and was delighted to find it "so entertaining."

Ingrid showed me a photograph of herself in the wheelchair in which, after breaking her ankle in Los Angeles, she had performed the play for several weeks. In the photograph she held a bag of dog food, an opening night joke-present from the company members. Why the dog food I forget, but while drawing I once noticed her fighting a smile. When we took a break a few minutes later, she told me she'd been thinking of Marti [Marti Stevens, an actress in the play with her, at whose house I first made my request to Ingrid for a sitting], who has

been worried by warnings from friends that her heavy makeup, suitable for the large theaters on their road tour, is too extreme for the small New York theater they perform in now. Musing on Marti while we worked, Ingrid had decided that, as part of the inscription Marti had asked for on the photograph, she would draw long fake lashes around her eyes.

"Christopher sends his love to you," I had said soon after my arrival in Ingrid's suite. My words were a formal courtesy more than anything else. I'm not sure if Chris actually told me to give her his love—he certainly would have had I asked if he had any messages for her. But rather than accept my conveyance of Chris's love at its surface value, for a moment Ingrid, as though expressing physically a mental doubt, became almost imperceptibly tense and awkward. Knowing her wariness of insincerity, I guessed that she was asking herself: Love? Does Christopher love me? Do I love him?

Ingrid's determination to avoid any kind of Hollywood gush is part of her straightforward Swedish rectitude, perhaps the most valuable instrument in her Hollywood survival kit. She has not forgotten that, at the peak of her career in Hollywood, adulation for her soured almost overnight, and in a joke sweeping the movie world, she became known as a key ingredient of "a Stromboli sandwich," the pair of Swedish buns between which was stuck an Italian wienie.

Good sport that she is, however, when I was leaving Ingrid said: "Give my—," she hesitated just an instant, "—love to Christopher when you see him." It cost her, but she was trying not to let the old Swedish Sincerity Inspector get the better of her.

# Alec Guinness

*25 December 1975, Santa Monica*

I was halfway into my drawing of Alec Guinness when he informed me that he was sitting for me only because I am "a friend of Christopher." From his reading of the words I knew he meant: Christopher's friend. He was frankly acknowledging my calculated, almost sadistic use of my position as "Christopher's friend" to force him to sit for me. I had guessed that, out of respect for Chris and a desire to please him, Guinness wouldn't refuse me. I even slyly involved Chris in my telephone call to confirm the sitting, making Guinness know, should he be considering postponement or even a cancellation, that Chris was in the room with me.

Guinness's candid disclosure of what had motivated him to sit for me was the first hint of anything more than a scrupulous politeness between us. In our few previous meetings, his expert British manner with me was so meticulous that it was almost like a test, or a provocation, as though he expected and even hoped that I would be guilty of some gaucherie or tactlessness which would confirm his low opinion of me. But I felt in condition last Saturday morning (20 December), on guard and poised at the same time. My early impression of Guinness as pretentious and snobbish allowed me to disdain any urge to please him while it sharpened my determination to beat him at his own game of manners. If I could also come away from our sitting with a good drawing of him, my triumph would be complete.

Ostentatiously punctilious, Guinness came down to the lobby to escort me to his room in the new back portion of the Beverly Wilshire Hotel. Despite its expensive-looking furnishings and easy access to an outdoor terrace and pool, the room felt small and cramped. While I

rearranged chairs and tables to fit my large drawing board and bench into the middle of the narrow room, Guinness told me that he'd just had a long session with a tax consultant and been informed that, unless he got a refund of some of the money he had already paid in taxes, his current visit to Los Angeles to work in the same movie [*Murder by Death*] as Truman [Capote] would leave him "out of pocket."

Before assuming the role of sitter, Guinness removed the jacket he was wearing and put on a soft wool pullover, which, though it hid almost all of his shirt collar, formed an ambiguous bulge over the knot of his otherwise-hidden tie. This bulge echoed a much bigger one, his portly stomach, and both eventually became difficult drawing problems for me. Another problem occurred soon after I started to work: Guinness's eyes began to water. Still playing his game of politeness, he apologized for his tears and, carefully refraining from moving the position of his head because he knew that I was drawing his eyes, allowed the tears to stream down his face unchecked. Challenged by his brave forbearance, I was solicitousness itself as I rose from my bench and, pulling on the window curtains, deflected the glare from the morning sun.

As has happened before, the sitting helped to establish a better understanding between my sitter and me. Our mutual scrutiny inspired a respect for each other as professionals. Probing for information about my background, Guinness asked, "Where does the name Bachardy come from?" I told him I'd guessed that the name had been garbled by immigration officials when my German Hungarian peasant grandmother arrived in this country. "She couldn't answer their questions or correct their spelling of her name because she didn't understand English." Such candor is usually effective with anyone snobbish, particularly if he also comes from a dubious background and has raised himself into a position of respect.

"How long have you known Christopher?" Guinness then asked. He was surprised, even impressed, when I answered twenty-two years. I

then politely asked how long he and his wife had been together. "Since 1938," he told me with a careful avoidance of smugness, but still a proud one-upmanship showed through his actor's throwaway delivery.

I had requested an hour and a half of his time, and, even without checking our watches, both Guinness and I were aware of the approaching deadline. As I'd anticipated, his stillness and cooperation throughout the sitting were impeccable. Knowing that to take more of his time than I'd asked for would be regarded as an infringement of our bargain, I stopped exactly on the ninety-minute dot. (I only checked my watch afterward.)

Shortly before I finished, he asked: "Would you mind, would you understand and not be offended, if I didn't look at the drawing?" After explaining that I always ask my sitters to sign and date my drawings, I suggested that I cover the drawing with another sheet of paper but leave enough space exposed for his signature. "Oh, no," he said, "that's not necessary. Of course I'll sign. I'll look at the drawing, but I warn you now I won't make any comment on it." He was true to his word.

As I was packing up my drawing equipment, he asked me if I would have some lunch with him. I told him that Chris and I had a three o'clock appointment—to see *Barry Lyndon* at the Motion Picture Academy, though I didn't let Guinness know this—and asked if I might call Chris and propose that he meet us for lunch. Guinness was clearly pleased by the idea, as I knew he would be.

After I'd telephoned Chris, Guinness asked, in his best English-humble manner, if I would have any use for a sweater, "much used and certainly in need of cleaning," which he'd bought in Beverly Hills but found "too bulky" to take back to England with him. It was immaculately clean (as I knew it would be), and, though much too big for me, I accepted it. (I guessed that it might do for Chris, who has indeed taken to it as the only thing which keeps him really warm.) After stowing my drawing equipment in my car along with my more comfortable

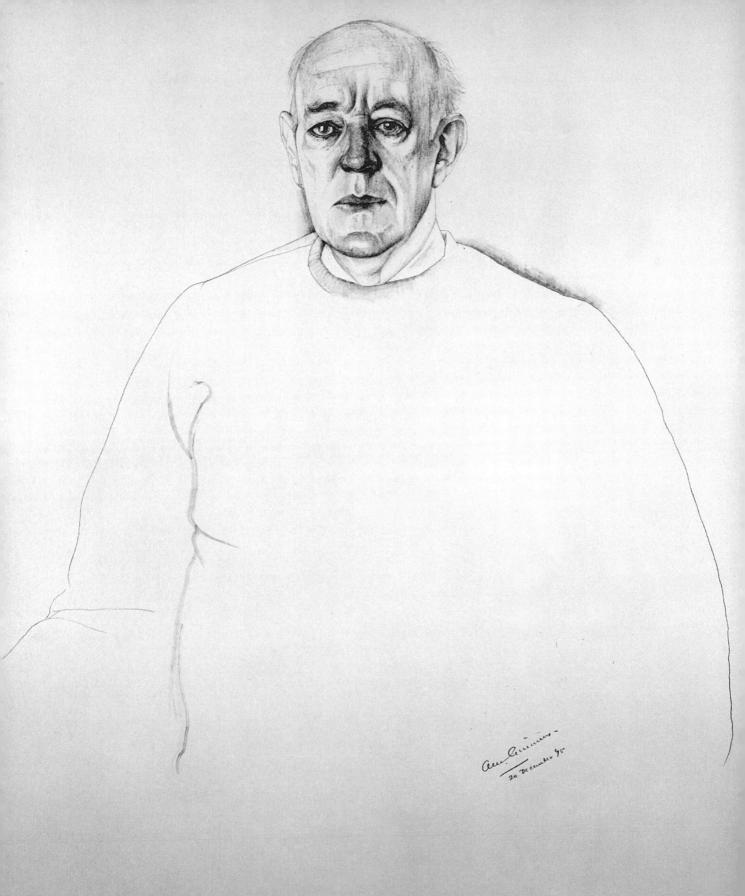

and better-fitting jacket, I put on Guinness's sweater and returned to the hotel lobby where he waited.

Surprisingly quick, Chris arrived shortly after one at the hotel dining room. There Guinness immediately assumed magisterial command. (He marred his performance only once, briefly, by visibly wincing at the maitre d'hotel's obsequiousness.) To encourage the festive air Guinness had established, I ordered vodka. "Would you like *Russian* vodka?" he inquired. I accepted his offer while Chris had a mere margarita.

The three of us were together little more than an hour, but the atmosphere of warmth between us was unforced. When Chris asked after his wife, Merula, Guinness was particularly touched that he had remembered her name.

# Peter Pears

*8 November 1976, Santa Monica*

In his room at the University Hilton (across the street from USC), I drew Peter Pears yesterday—at *eight* o'clock in the morning! I've never done a sitting at such an early hour, but he claimed that was the only time he had free. Though I said that I would be at his hotel at seven-forty-five, I arrived nearly fifteen minutes late and was told by Peter that he was being taken to a rehearsal in the Capitol Records building in Hollywood by a woman who was picking him up at nine-thirty. So I started out knowing that I had less than an hour and fifteen minutes.

I had gotten up at six with a semi-hangover. I felt depressed, too, because the day before I'd fluffed my sitting with Sylvia Sidney, and in the evening had cooked (for Peter, David Hockney, and David's assistant, Maurice Payne) one of the worst meals ever (dry tough pork chops under a creamy tomato and mustard sauce—ugh). Also, a pill I had taken to counteract my dazed, disconcerted state had made me feel both reckless and driven.

Under such unpromising circumstances, I decided to keep the drawing simple and make it fast, but difficulties arose soon after I started work. They began with Peter's reluctance to look me in the eye. He determinedly looked past me rather than at me, and, once I'd adjusted to his avoidance of my eyes, he then forgetfully began to shift his gaze all around the room. Then, while I was still drawing his eyes, the most crucial phase of a drawing, he altered the angle of his head by raising and turning it more fully toward me. Because time was so short, I quelled a negative urge to start again, and eventually Peter steadied himself. But then his lips began moving in what I soon learned was silent recitation. Glad, he said, of the opportunity to be

quiet and "sit still" (!), he was concentrating on his memory work and going through the songs he had to know for that morning's rehearsal. None of these problems really mattered, however, because, for no known reason, I began to feel a rare and exhilarating confidence that, at least for that morning, I could handle any kind of resistance. Increasingly and almost as if by magic, the drawing began to do itself.

Peter's politeness is so exaggerated that its effect is sometimes the reverse of what he imagines and begins to seem like something he is doing for his own benefit, an unconscious ritual of self-regard. His manner with me was faintly like that of a great and noble personage subordinating himself to an inferior. What at first seemed like a look of pain on his face turned as I drew him into a look more of discomfiture, the strain of rare grace submitting to coarse greed. In true aristocratic fashion, however, he was able to justify this waste of his time by turning it into an occasion for developing, with an attendant show of monklike dedication, his own art.

My nasty appraisal of Peter shocks me. It must come from the sourest depths of my intuition. I am probably quite mistaken about him. On the surface he is kindness and gentleness distilled, and I must be a mean, stealthy traitor even to suspect him. Certainly our behavior with each other is hesitant, and spurred at least somewhat by obligation, but it is also cordial, even affectionate.

An example of the discomfiting cast of his politeness occurs to me. I brought with me a thermos of coffee and offered him some. To my surprise he accepted my offer and, realizing that the thermos had only one cup, its own cap, started for the bathroom saying: "I'll get a glass." I could see him thinking, and, an absurd but revealing reaction, he decided that I might construe his fastidiousness as a fear of contamination. "Or we can share the same cup," he said, trying to make his tone sound casual. He envisioned, however, the impracticality of passing the same cup back and forth while I was trying to draw him and, without further deliberation, redirected himself to the

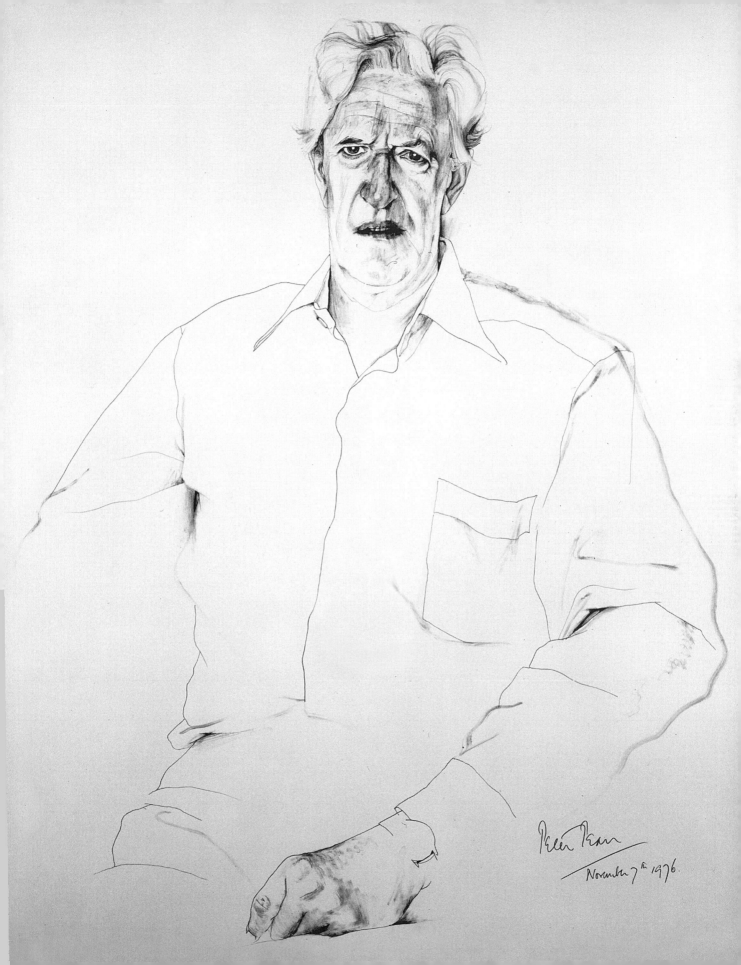

Peter Bean
November 7th 1976.

bathroom and returned with a glass. Since, unlike the cap, it had no handle and would therefore be uncomfortable to hold with the hot liquid in it, I gave him his coffee in the thermos cap and kept the searing glass for myself—my own small effort at retaliatory politeness.

The night before, while I was in the kitchen concocting the pork-chop disaster, Chris was in the living room with Peter and David (and Maurice, who all evening contributed nothing but his physical presence). Despite Peter and David's friendliness to each other, Chris said later, he'd felt something wary underneath their surface warmth and observed: "David almost winced when Peter mentioned the Queen Mum." I myself had already noted Peter's muted, reverential tone when discreetly referring to royalty, but thought him even smarmier when speaking of [Benjamin] Britten. He makes him sound like a sacred monument rather than a friend he knows and loves.

Peter's tall, pink whiteness is very striking. With his long, beaky face, he's like a hefty egret. His cold, blue, passionless bird-eyes are the darkest spots in their surrounding expanse of pink. His big, clumsy hands are fleshy, like hunks of swollen pink dough.

# Charlotte Rampling

## 2 March 1976, Santa Monica

A few days after I wrote Charlotte Rampling to ask if she would sit for me, she called to suggest this past Saturday or Sunday for a sitting, but never called back to say which. I didn't know her telephone number, so on Saturday afternoon I went to the house on Stone Canyon Road (1439) where she is staying. Brian opened the door just as I was slipping under it a note I'd written. Recognizing me from our brief meeting at John Schlesinger's fiftieth birthday party, he asked me in.

Perhaps her husband as well as her lover, Brian is also, Chris and I were told, the father of Rampling's child. Around forty, with a solid but nondescript kind of masculinity, he has a largish nose, sandpaper skin, dark hair and moustache. He wears dark glasses over his eyes. He is friendly and forthcoming, but his smile has no staying power. Because he says "we" when referring to Rampling's activities, I guessed that I would need his support before she would agree to sit for me.

As I explained to Brian that I'd only come to leave a note, he led me through a rambling hall into a large room, where, on a low, flat sofa covered in rust-colored corduroy, Rampling sprawled. Her unfurled hair spilled over the cushion which propped her head. A fair-haired boy of three or four with shapely legs clung awkwardly to her and looked frustrated, as though he'd failed to find an easy hold.

Before I could offer her any apology, Rampling spoke without raising her head, her deep, throaty voice accentuated by the angle of her repose: "How nice of you to drop in." There was no hint of irony in her remark. Neither she nor Brian minded my intrusion. They seemed used to unexpected visits, even from a comparative stranger.

Brian said he was treating his hangover with a cup of coffee and asked me to join him. Having imposed myself, I couldn't immediately rush off, but I felt awkward. Perched on a chair opposite Rampling and too close to the mouth of a gaping walk-in fireplace, I asked perfunctory questions about the Sherlock Holmes TV film she's working on while Barnaby, her son, fought for her attention. He pawed and dragged at her, his loud, strident voice interposing itself between us. Like a lazy lioness with one of her cubs, Rampling patiently endured his babyish maulings. An element of playacting in her manner suggested that, now that she had an audience, she was finding her "Mother scene" more rewarding than usual.

Rampling's voice maintained its deep, languorous tone for her "Mother" lines to Barnaby. Perhaps testing them on her ears as well as mine, she seemed pleased by their sound. Her head was still tilted back, and she regarded me with her cool, pale eyes. They are larger than I'd expected, and their glass-blue flecks, like chips of ice, make them glisten. I wondered if this glistening might be the outward effect of an impairment of her vision which, in causing an inability to focus her eyes, had also inspired, as a defense, her air of aloof detachment.

She repeated her wish to sit for me but explained that the weekends are the only times she is able to spend with Barnaby and, naturally, consideration of him comes first—at least on weekends. Her suggestion, which I agreed to because I guessed that I had little choice, was to come at two o'clock the following day to a house in Malibu where they were having lunch. Barnaby would be occupied by beach games, and Rampling and I could work undisturbed in a room upstairs. Because his mother assumed that he couldn't understand or care what she was saying to me, Barnaby pretended not to be listening. He, too, was playing a role, the child as demanding, possessive cub, and happily continued his attention-getting antics.

Rampling got up and, taking Barnaby with her, left the room

without a word to Brian or me. As she wandered off into what looked like another large sitting room, I noted the one-piece dark brown jumpsuit she was wearing. Despite its look of unfitted casualness, it cinched her narrow waist and revealed her long, slim hips and low-slung buttocks.

At two the next afternoon, leap year day, I went to the address in Malibu I'd been given, a two-story wooden house painted white. I entered an outdoor, fenced-in cubicle inhabited by a large licking-friendly dog. Pinned to the front door of the house was a handwritten warning not to let the dog in. As I opened the door, guilt was added to my foreboding because the dog expertly pushed past me and darted inside. I was an easy score for him, since I had my drawing board in one hand and my drawing bag in the other.

"So it was you," said a shapeless, pockmarked man with thinning hair who turned out to be the party's host. Out of indifference rather than politeness, he dismissed my apology for freeing the dog while he eyed my board and bag with suspicion and then asked impertinently: "What are your props for?"

In the living room three Warhol flower prints were crowded onto one wall while, on another, a Lichtenstein print, a closeup of a terrified young woman in his comic-strip style, hung between two sliding glass windows which faced the chilly-looking sea. Its hard horizon-line was dark against a clouded sky. Several people, many of them looking sleazy and unappetizing, sat about in the glum, dark shadows cast by the gray day. I recognized no one but Brian and Rampling. He greeted me in his friendly, slightly embarrassed manner. She was with a group of people, so we just nodded, conveying to each other our mutual apprehension: Are we really going to do a sitting? Here? Now?

Though he offered me a drink, the host made even this gesture of politeness seem rude. I asked for coffee and was told there was some on the stove. I followed him into a tiny, disordered kitchen, where he

poured an evil-looking liquid from a metal coffee pot into a stained saucepan and set it over a gas flame. While I stood waiting for the coffee to boil, Rampling came into the kitchen to fix herself some tea. We greeted each other properly but then fell silent, neither knowing what to say. I watched her put water into a kettle, find a box of tea bags in a cupboard, then a jar of honey and a carton of milk. When she had at length concocted her brew, a plain woman in her late twenties came into the kitchen and, covering her uneasiness with presumption, said: "Oh, that's just what I want." Without hesitation or a flicker of exasperation, Rampling presented her with the already-prepared mug of tea and methodically began again.

Absorbed in her task, she remained pensive and remote. I guessed that she was grateful for any activity which delayed her confrontation with me. When she could extend the tea-making process no further, the condemned prisoner faced her executioner bravely and said: "Shall we see if there's an empty room upstairs where we can work?"

Each of the available rooms upstairs was small and uninviting. We chose one and squeezed ourselves between a magazine-littered bed and a low bookcase of glossy-new, unread books. Rampling sat facing a sliding glass door leading out to a deck over the beach, and I placed myself in front of her, my back to the sea.

Rampling gave me the eye-to-eye contact that I requested, but I wasn't sure whether she really looked at me or past me. Her eyes were at their most glistening, every chip of ice refracting the flat, gray light off the sea. Silent but restless, she was like an animal at bay watching for its chance to escape. Continually shifting herself, smoking, swinging her hair back from her face, she was clueless as to what I could want from her. Our confrontation without words, without a character for her to assume for protection, was torture for her. But I persisted, like a fiendish Svengali overpowering his dazed Trilby, her staring eyes glazed with light, till my desperate deed was done.

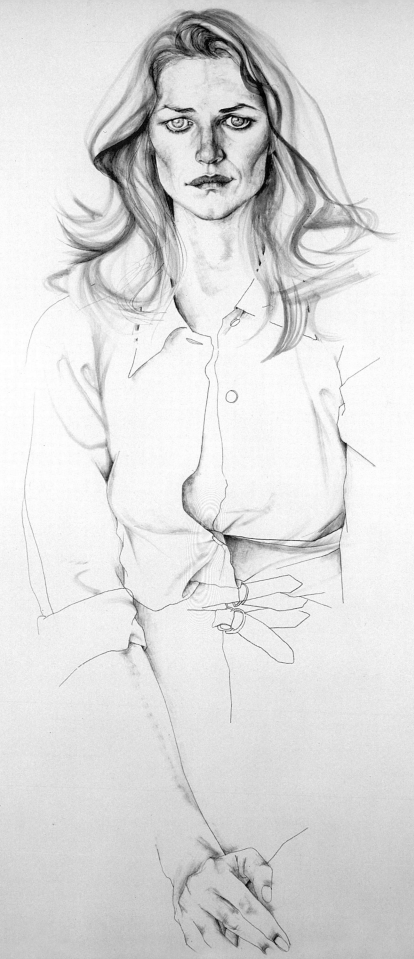

As the drawing emerged on my paper, it seemed increasingly stark and unflattering. I worried that she would think so, too, but, when it was finished, she accepted it without a word of dismay or criticism, as though it were preordained and required nothing further from her but a signature and date, which she dutifully supplied.

# Joan Fontaine

Joan Fontaine's apartment includes most of the fifth floor at 160 East 72nd Street. As I got off the elevator this morning, I saw the door to it standing open. I walked in, and, silhouetted against the morning-lit windows, a small figure moved toward me with its hand extended, talking as it came. Its shoulders were hunched in mock servility, and its voice mumbled a conventional greeting without attempting any warmth.

When I accepted its offer of coffee, the figure quickly disappeared behind a door while its voice emitted directions: "Please take your things into the room which is lighted."

I still hadn't got a real look at Joan Fontaine. A moment later I was stationing my portfolio and drawing bag on the floor of her small, lamplit sitting room when she suddenly slipped behind me and, swift and weightless as a wraith, strategically placed a large mug of coffee on a small table near me. As though forced to forgo conventional graciousness by the many demands on her time, mine not the least of them, she made a direct decree: "I must leave here at twelve-forty-five." "Then we should begin," I answered obediently, my eagerness to get started equal to her own, since her time limit gave me barely ninety minutes to work.

To serve as my drawing bench I had already espied appropriate chairs in the neighboring dining room, which, lit only by the wan morning sun, looked forlorn, as though the light hesitated to enter its high row of small windows. As support for my drawing board I moved one of the chairs from the dining table and caught a stealthy wince of disapproval from Fontaine. Quickly moving to another chair placed

against the wainscot and offering it, she said: "Won't this do?" Faint but deft, the pitch of her voice made her suppressed command clear. "It has *arms,*" I answered in helpless defiance. "My drawing board won't fit between them." My words conveyed nothing to her but an arbitrary denial of her request, but rather than openly oppose me, she conceded a second dining chair. I placed the chairs in front of the fireplace and facing each other, the second for me to sit on.

"Will you need something for protection?" she asked as she bestowed a worried frown on the vulnerable-looking upholstered seats of her victimized chairs. "I have something," I said. Happy to appear prepared for all eventualities, I whipped out the brown paper in which my newly bought portfolio had been wrapped. I regretted my bravado when the stiff paper crackled and rumpled awkwardly as I tried to mold it to the chair seat. I avoided her scrutiny but sensed the disapproval she barely stifled.

Looking around for a chair of the right height for her to sit in, I indicated a lightweight, red-varnished wooden chair with arms and an upholstered seat. I learned from her later that the tiger's head of the seat had been designed by Salvador Dali especially for her, and that she herself had executed the needlepoint work. I asked if it would be a comfortable chair for her. "Yes, perfectly." Her tone implied: Why else would it be in my sitting room?

I crossed the room to fetch my bag of equipment and returned to find the chair upside down. "It's been weakened," she said regretfully as she examined its frame and underpinnings, "it must be its age. It's very old, you see." Her clever contrivance to resist my attempt to begin work also informed me of the rare taste of her possessions.

I noticed nearby another chair of the exact same design and asked if it would do. "Yes, of course," she replied, her tolerance of the delicate chair's sturdy twin resolute but sorely tested.

Once our chairs were in place (my two, partly because of the smallness of the room, snugly close to hers), I was at last able to scruti-

nize Fontaine. Frustrated by her avoidance of eye contact, I had only an impression of her smallness, a flat look to the top of her head, and, at the back of her neck, her usual chignon, its dyed color an unexpected brassy yellow. Her face is remarkably identifiable: broad cheekbones, eyebrows askew, that crooked smile wrought by a cheek muscle which hikes up the right side of her mouth. Its effect could serve as a wince of pain or an ironical sneer.

She gave me a three-quarter view of the left side of her face, her favored angle I was to learn later. Not in the least self-conscious, she wanted to seem so and averted her eyes. "It would be better if you looked right at me," I said, "just while I draw your eyes. I'll tell you as soon as I've drawn them." Tacitly cooperative, she allowed her eyes to drift away only a few times before settling them firmly on mine. The flat gray-green color of her eyes is like murky water undisturbed by any ripple.

The light was difficult to work by. When she looked at me, harsh patches of dark shadow put the left side of her face into unflattering relief and accentuated the pasty, dry look of her complexion. Contrasting jarringly with the harsh yellow of her hair, an unwholesome pinkishness tainted her general coloring, while the darker mauve of her nose threatened to stain its masking layer of makeup.

Her cool glance, however, betrayed no uncertainty about herself or her appearance, no hint of doubt that their old allure might not be working still. When I told her that I had drawn her eyes, she expressed relief, saying that, since she is farsighted, it had been a strain to look at "something" (me) at such close range.

Though we spoke little, she did ask: "Where are you from?" I knew she would find my "Los Angeles" unpromising, so I added: "I went to school in England for a while." "I can hear that" was her unenthusiastic reply. She also asked: "How much do you sell your drawings for?" After a moment's hesitation, during which I decided she would disdain as insignificant the six hundred dollars I was about to say, I

told her a thousand dollars. Her effort merely to "place" me apparently satisfied, she showed no more curiosity about me.

In between our few brief verbal exchanges, I soaked up her changing moods and noted the occasional grimaces that tweaked her face. A quizzical, self-amused smile was repeatedly contradicted by the return of that brave wince of pain, which wrenched her face this way and that, sending her eyebrows soaring up and away from each other while that muscle in her right cheek worked overtime. Her face deftly registers continual messages from the tangle of perversity and artificiality that rules her, but elusiveness, which she uses as a taunt, is her dominant mode of expression.

"How will you manage to keep my hair from looking cropped?" she suddenly asked. "You can't see my chignon from your angle, can you?" "Oh, but I know it's there," I assured her.

Feeling scattered and working with little sense of control, I trusted my instinct and clung to the amazingly unaltered Fontaine look. Or so it seemed until I began to draw her mouth. Painted the same magenta-pink as her shirt, its once-perfect shape had been destroyed by the collapse of the upper lip onto the lower, dragging her mouth down and in. The large collar of her shirt, like the wings of a pink bird rising from the black of her sweater and slacks, camouflaged her loose neck, but it couldn't help her mouth. Just as I was struggling to draw it, Fontaine complimented herself on her choice of shirt and praised the timelessness of its collar. I couldn't help thinking that her collar's triumph contrasted cruelly with the mute capitulation to time her mouth had made.

I finished the drawing, or, rather, I stopped working on it, in under an hour. Foolishly, I was still trying to keep the bargain I'd made with her. When I'd telephoned to make the date for the sitting, Fontaine had asked peremptorily if she would be allowed to keep the drawing. I had proposed that, if she could spare the time to sit for two drawings, I would let her choose one for herself. She had quickly

agreed but then, on my arrival that morning, had decreed a deadline which barely gave me time for one drawing.

I knew while working on it that my drawing was unlikely to please her, and not good by my standards either. After declaring it completed, I quickly added that I would rather she didn't look at it until I had done another. But, almost before I'd finished speaking, she had moved swiftly and noiselessly behind me to inspect what I'd done.

Her tone merely simulated hesitance as she spoke a few preliminary phrases about the drawing being "not right." Moving away after a pause, she then said, almost casually but with a deadly edge: "In fact, I loathe it."

Her timing and delivery of the damning judgment were flawless. My first reaction, amusement, was followed by admiration for her skill. The air was now charged with high-voltage electricity. Silent but lethal, it seemed to give every object in the room, should I dare to touch anything, the power to electrocute.

As I quickly removed the drawing from my board, wanting the offending thing out of view before it ignited in a spontaneous blaze, she said in a final, toneless voice: "I wish you would destroy it." I knew that it was as good as dead already.

Now the balance between us changed dramatically. Fontaine, the Directress, threw off her humble disguise and took control. "The angle is wrong, you see. My face must be seen from a higher level, otherwise it looks broadened, as you've made it. I know this from years of experience with cameras. And it should be at an angle rather than full face." Brisk now, her voice allowed no contradiction. I gave none, realizing that it was to be her way or not at all. I suggested a lower chair for her to sit on. Almost before I'd spoken, she had whisked away the previous chair and put in its place a low stool. Immediately she was arranged on it, her face turned to the favored three-quarter angle.

Her hunched shoulders already proclaiming a failure of stamina, I knew that she could not sustain any posture for long without back

support. In no position to object, however, I obediently started to work with little hope now of any kind of success.

Barely fifteen minutes into the second drawing, she suddenly announced: "I feel sick." She stood up and in another instant was behind me again, inspecting the pitiful product of fifteen minutes' hurry and discomposure: two eyes, a nose, an outline of cheekbone, and a hint of a mouth, all hastily sketched with a tentative, lifeless line which promised little quality and no flattery.

"I can't sit any more, it's too difficult." Glancing at the clock on the mantel, she added: "I've been sitting still for an hour and a half —." The pause at the end of her unfinished, untrue statement clearly implied: And what is there to show for it?

"I can give you a photograph," she said on her way out of the room, "taken from the same angle." I began to put my drawing equipment back into its bag and didn't even keep a pencil out, knowing she would never agree to sign and date the first drawing.

Coming toward me again, she was not walking so much as moving on an invisible conveyor belt, like a mechanically paced cutout figure on a target range which, after tempting sharpshooters to take aim, disappears before they can fire. For my instruction she held out a photograph of herself presenting her at exactly the angle I had just been trying to draw, with the same expression of cool appraisal on her face, the same hairdo, even the same earrings.

I didn't bother to go into my usual explanation about my inability to work from photographs. Instead, I told her of my brother "who is such a admirer of yours" (he isn't) and asked her if she would sign the photograph to him. She hesitated, that familiar look of pained indecision wrenching her face once again, only this time there was an ill-concealed impatience about her. With irritable resignation she took the photograph to a corner desk and performed the irksome chore.

Now it was clear that she wanted me to go as soon as possible.

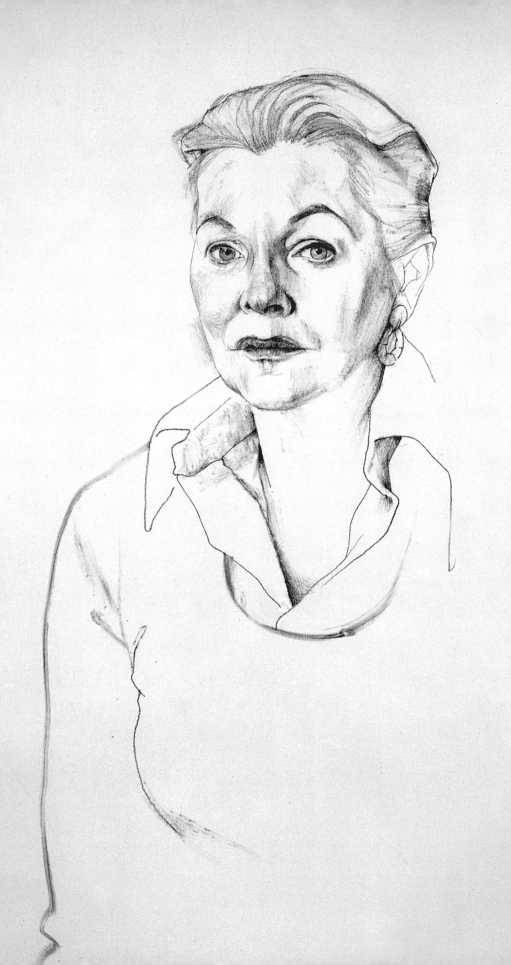

However, my instinct and timing were not functioning properly in the charged atmosphere, and as I returned the dining room chairs to their places, I had an inexplicable urge to soothe her in some way. She had spoken of an autobiographical book she was writing. "Do you tell in the book which of your films you like best?" Again a deadly pause. Not to be placated, and certainly not by a movie fan's question, she replied disdainfully: "I write about the films I've worked in from the point of view of *filmmaking*."

Before my bag and portfolio were in my hands, she had turned out the sitting room lights and was heading for the front door. "I don't hear it," she said, pushing the elevator button impatiently, "it's not coming." Rather than to me, her words were directed to malevolent powers that were ruining her day and merely using me as their chief tool. She telephoned to the doorman and, familiar with the obtuseness of servants prodded too harshly, barely managed to keep the edge to her voice under control: "Is there something wrong with the elevator?" She was off the phone and disappearing into the dark depths of the apartment before the rescuing elevator, having been on its way at its own speed, arrived with a jolt. "Here it is," I called to her. Like an inefficient handyman who had wasted her time with his fumblings, I was dispatched by the distant sound of her voice: "Don't leave anything of yours behind."

# Maggie Smith

Nearly a year after I first asked her, Maggie Smith came to my studio to sit for me on Tuesday afternoon. Beverly Cross, her husband, had called to make the appointment on the previous Friday and said she would come between one and two in the afternoon. I had already planned an all-day session with Don Cribb [a friend and frequent sitter of mine] to start at ten. I let him come anyway, thinking we could most probably work until two, but Maggie arrived on the dot of one while I was in the middle of a painting. Prepared for the possibility of her early arrival (and eager to meet her, too), Don excused himself quickly after I introduced him.

Rattled by her prompt arrival, I fumbled the tops onto my paint jars and rinsed brushes while Maggie stood by cool, collected, discreet. She didn't impose her presence, unless you count modesty and self-deprecation as impositions (I do rather). First she refused coffee, but, when I said that I was going to have some, changed her mind, so I took her into the house. She immediately praised both the house and the view. "Oh, it's lovely. How lucky you are." Her words lacked conviction.

Coffee mugs in hand, we went back to the studio and upstairs to the second floor. More comments from her about the view with the same lack of expression while I struggled with a trivial decision: large drawing paper or the somewhat smaller paper I have been working on a lot lately. The first sheet on my drawing board was the textured kid finish, not my favorite. I keep kid and plate finish in strict sequence on my board and superstitiously accept whichever is first, whether or not that particular surface suits my current mood. I decided to work

on the large kid sheet, and once I started, instantly regretted my decision.

Flustered though I was, all the more so because of her calm detachment, my confidence in myself began to return soon after I started to work. I was firmly guided and supported by her keen concentration, intense and yet without strain. With a precision to her thereness, she was one of the most remarkably still and alert people I have ever worked with, and not in the least shy or hesitant to look straight into my eyes. The cool steadiness of her gaze took me in fully and missed no detail. I sensed that she saw nothing that surprised her, and little that interested her. The large whites of her eyes were as expressive as their contained circles of unresponding gray blue.

After about twenty minutes I told her that I had finished drawing her eyes. "You are clever, aren't you," she said in her British drawl, her uninflected delivery making her words suitable for either praise or derision. Her whole manner seemed to be saying: Laugh or take offense, I don't much care which.

Only once taking a deft sip of coffee from her mug, she returned to her exact position without any adjustment being necessary. Without a single other break, we worked together till three o'clock, about an hour and fifty minutes. In mid-sitting I complimented her on her "amazing concentration" and asked her please to tell me whenever she needed to stretch or move around. "I'm all right, really," she stated with perfect assurance and, until I was finished, continued to sit without flinching, her right leg crossed over her left and surely cutting off circulation.

"I don't know how you do it" is all that I can remember her saying when she looked at the drawing. Her awe seemed more a performance than a true reaction, as though she felt no identification with what she was looking at or any personal involvement with it. At my request she signed and dated the drawing with neither surprise nor hesitation. Then she had her leather bag in hand and, with streamlined poise,

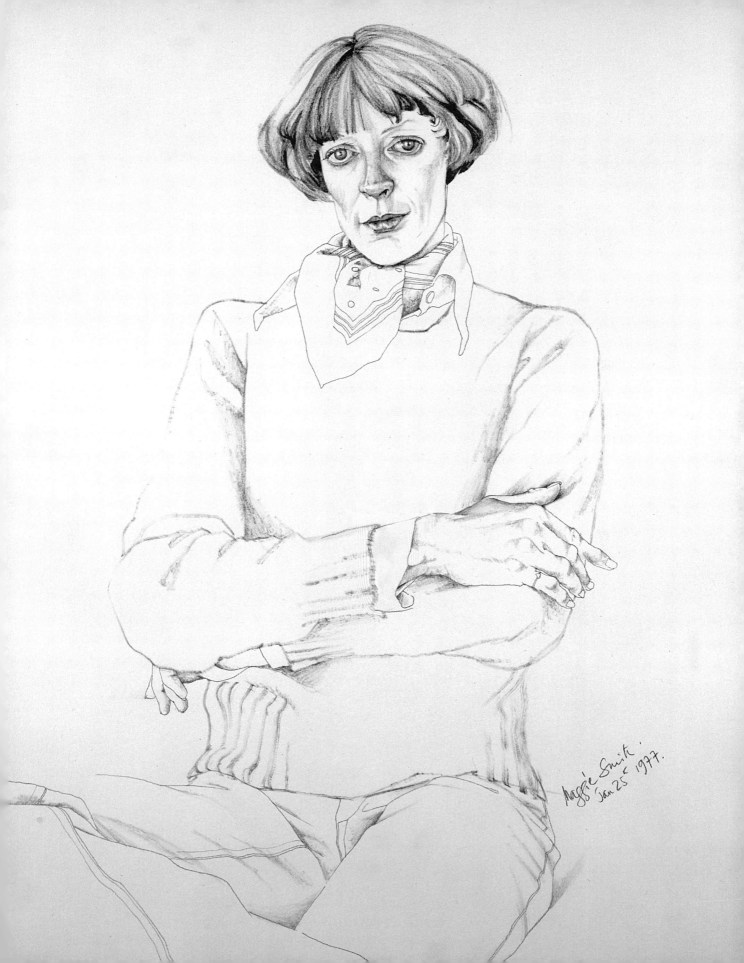

Maggie Smith.
Jan 25th 1977.

was expertly releasing herself from any further obligation and drifting steadily away, her cool, firm authority unshakable and unanswerable.

## 31 January 1977

At a going-away party for Brian Bedford given by John Erman last evening, I talked to Maggie Smith for the first time since our sitting. She told me she had enjoyed it despite her "forebodings." Beverly told me that beforehand she'd kept repeating in a doomed voice: "Oh, I've got to go to *Santa Monica* today." She also told me that two days before the sitting her mother had died, and she'd been doubly upset because she'd been unable to go to England for the funeral. Never having sat for an artist before, she described her amazement at being able "to be still and just let my mind wander millions of miles away." Because the experience had been significant to her, I didn't want to seem to belittle it by telling her I'd often had such a reaction from my first-time sitters. I also didn't share with her my amusement at my own total misreading of her state of mind. She was telling me that she'd been millions of miles away while I was drawing her, and all the time I'd fancied that she'd been so much there.

# Louise Brooks

*9 February 1977, Rochester, New York*

I spent most of yesterday with Louise Brooks, from one-fifteen in the afternoon till nearly eight o'clock.

"You bastard!" Louise said to me when she looked at the three drawings I'd done of her, but I knew that she was impressed by them. When I tried to explain their starkness, their frank expression of pain, she said: "You don't have to apologize for them."

She talked and moved the whole time I was working and kept quiet only briefly when I told her that I was drawing her mouth. We worked for two and a half to three hours but not until near the end of the last drawing did she indicate that she was in any kind of discomfort. Both of us sat on plastic and chrome chairs in her small two-room apartment. She had her right arm on a table which she'd pulled into the middle of her living room floor for a lunch she'd prepared, only for me, of scrambled eggs, toast, and two pieces of baked meat loaf which were dried out because they'd been kept in the oven all the time I was drawing.

She faced the north-lit window behind me. She had difficulty seeing me, she said, because I was silhouetted against the light. I asked her several times to look right at me, but she resisted, so then I drew her looking past me. During the second drawing I told her that I was going to include her left arm and hand. She objected at first, complaining of her arthritic fingers and knuckles which in fact are not very apparent, but then she quickly relented: "Oh well, if you *want* to." She was wearing a pink nightgown and a pink quilted bed-jacket. She removed the bed-jacket just before I started work, saying that she didn't want to be drawn in its scalloped collar.

Tuesday is her day for washing herself. "It's so tempting," she told me, "now that I've got it down to one day a week, not to wash at all. Age is dirty." She'd washed her hair, too. I noticed that it didn't have its oiled stiffness of the previous afternoon when Chris and I had first visited her. Going to the bathroom to slick back her hair with water, she returned with several drops on her forehead. "Have I doused myself?" she asked. She brushed away a few of the drops and those remaining gradually evaporated.

Louise makes contact immediately. She began to talk as soon as I arrived and always watched me while she talked. Her talk was a cover for a minute inspection of me. Her manner is provocative, even challenging, as if to strike sparks to warm herself by. She talks openly about sex and watched my face carefully for any signs of shock. Referring to herself as "a basket watcher," she spoke admiringly of "big pricks," though she allowed that it was usually possible to get some sort of satisfaction from all but "the really drastically undersized." "There are two or three things I like having done to me," she said, "and big pricks are best for those particular jobs."

Redheads, she'd found, had predictably "small and misshapen pricks." She described their often "bent and unappealing forms" and I encouraged her by adding "scarlet heads" to her list of their peculiarities. The look she gave me as she nodded her agreement acknowledged a fellow connoisseur. "I've spent a lot of time on sex," she continued, "I don't feel the least bit frustrated. I've had my share. More than that. And now that I don't need it any more, I don't feel cheated. I got lots of it when I wanted it."

Her look and her drawling voice—"Kansas, real Kansas," she insists—are oddly reminiscent of Ruth Gordon, though Louise's personality is much more straightforward and lacks Gordon's underhanded slyness. Her arthritic hips make her movements painful and laboriously awkward. She leans crookedly on an aluminum and rubber crutch and occasionally lets out shouts of pain when she unintention-

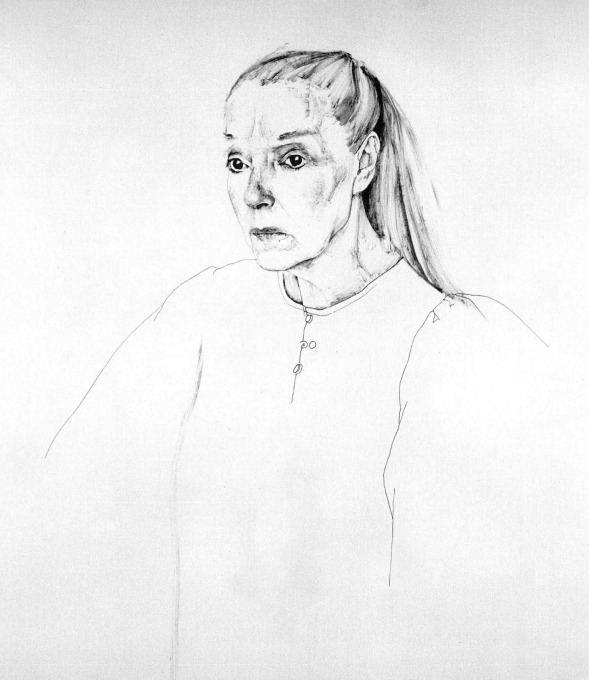

Louise Brooks
8 February 1977

ally brings her weight down in the wrong place. Scrutinizing me as she talks, her dark, dark eyes continually probe with their vital, wounding hardness, like merciless marbles pressing into exposed flesh and leaving telling bruises.

"I have nobody to talk to," she declared, "Why do you suppose that is? I don't know *anybody* in this town really. There is just no one for me to *talk* to. I've been married once. I've had lots of people around me. But now I'm alone. Maybe you don't know what that means?" When she says all this she is not whining, not even complaining. She is stating a fact, making an objective statement about her life, pretending to herself, though not very seriously, that she doesn't understand why such a strange-seeming dilemma should have occurred, but in her heart she knows its cause is her own perversity. She's a malcontent. Whenever equilibrium enters her life, she purposefully upsets the balance. If only for the hell of it, or the excitement, she courts division, dissension, even disaster. A dipsomaniac for sure, probably a nymphomaniac, and certainly a destructomaniac, she is driven to excess and helpless to resist.

Even Chris, who she admires and immediately liked personally, she can't help baiting, testing, defying. "Just what do you mean when you say *operational dialogue*?" she began a characteristic taunt yesterday. She'd heard Chris use the phrase in a radio interview. "Do you mean in contrast to literary dialogue, arty dialogue? You mention the term but then you don't explain. You're a smart one." Obediently responding to her goad, Chris chose Shaw as an example of literary dialogue: "It's amusing on its own, for its own sake." As an example of the operational, Chris proposed Coward's dialogue: "It's nothing in itself but it's potentially scintillating, even hilarious, because of the situation under it." Chris's explanation pleased Louise. She got it and liked it, and was even satisfied—for the moment, anyway.

Later, when he was alone with me, Chris praised Louise for her

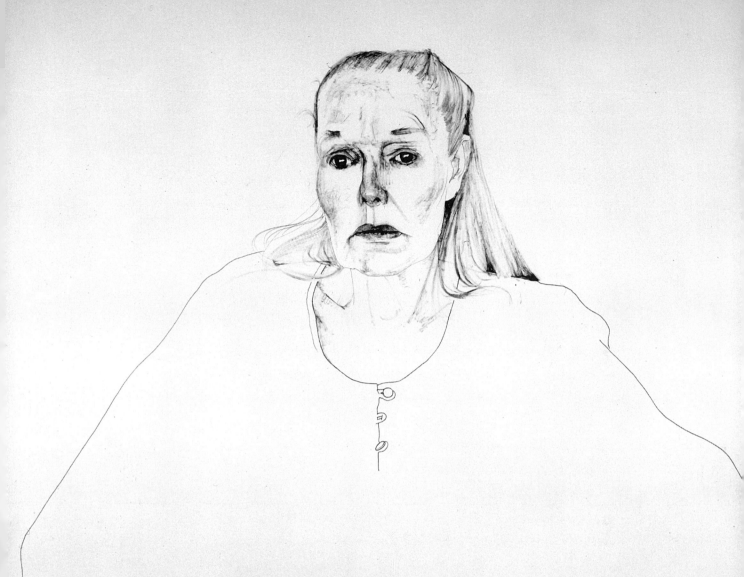

Louise Brooks
February 8 1977.

genuine curiosity. "She's much the most intelligent actress I've ever met." Yet, I know she tired him with her probing and insistent demands for communication. Defending himself against continual accusations, even when subtle and carefully couched, wearies him, especially from a female. Pretty boys or intelligent young men are another matter. But on and on Louise went, sitting up in bed and gesturing with her arthritic hands, smoothing back her long hair and pulling it tighter through the metal clip at the back of her head as she interrupted both of us, even herself. Because she is as helpless as we against the onslaught of her own tongue, the experience of her is more like a happening than a performance.

Her toes, too, are mangled with arthritis, taut and splayed apart into tortured bumps and knots. Could they really be the same feet we saw that very morning in *Prix de Beaute*? Symmetrical and shapely, Louise's feet in the movie seemed to bear no relation to the gnarled, mauve-colored pins on which she tottered back and forth over the bare floors of her neat, drab little apartment.

After our drawing session and the lunch she prepared for me, Louise got up from her bed with her usual difficulty but without asking for help or making any pitiful demonstration. She went into the bathroom and, perhaps intentionally, didn't bother to shut the door. I could hear liquid tinkling into the toilet bowl. Then she coughed and the coughing made her fart. Because she is a straightforward, nononsense woman who would never do anything so unfriendly as to behave like a lady, her fart in no way impaired her dignity.

## 13 March 1977, Santa Monica

I telephoned Louise Brooks this morning to know if she'd received the photographs I'd sent of my drawings of her.

"I can't understand why you should do such perfectly hideous

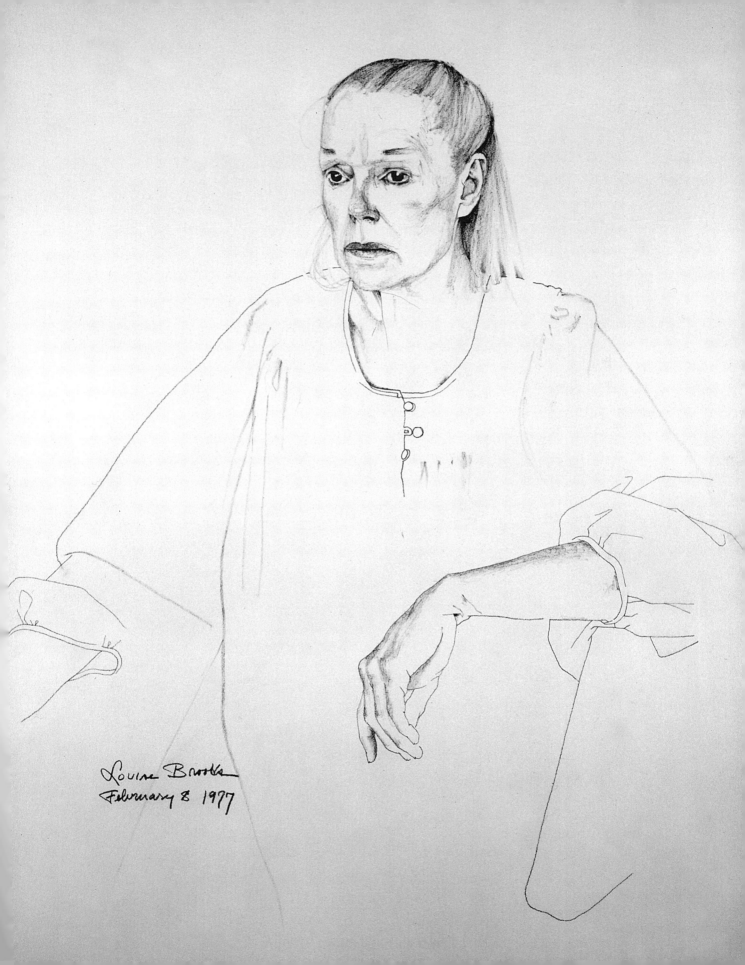

Louise Brooks
February 8 1977

drawings of me," she said. "You don't do such drawings of Isherwood or Auden. All I know is that I want them destroyed. How are they going to further your career? How can they make you famous?"

"Louise," I answered, "I thought that as an artist you would understand."

"Artist! What makes you think you're an artist?!" and slam went her receiver.

[The following three handwritten letters were sent from Brooks's apartment in Rochester, the first a week after our sitting, the next one nearly two years later, and the third three months after that.]

*6 February 1977*

*Dear Don—*

*I wish you would destroy those terrible drawings of me—At any rate do not send me*
*    photos of them—*

*Louise*

*15 January 1979*

*Dear Don—*

*I've been reading Fryer's* Isherwood *and your 1976 drawing of Chris made me realize*
*    that I must apologize to you—not for being angry because you broke your promise to*
*    destroy the drawings of me—but for being a liar when I implied that you were a lousy*
*    artist before I banged up the phone March 13, 1977.*

*I think you are an extraordinarily gifted artist. Having been born in a house filled with*
*    music, laughter and books—one of them a book of Chinese painting, black and white,*
*    with which I fell in love—how could I not equally love your drawings which dare the*
*    same blank spaces, the intervals of mysterious silence which set my imagination free to*
*    share in your art.*

*Love to you and Christopher—*

*Louise Brooks*

*30 April 1979*

*Dear Don—*

*Thank God you answered my letter and prove* [sic] *my belief that you are a darling boy
without meanness. It was the truth of your drawings of me that I found terrible—the
tragic tension of the eyes—the poor sad mouth—the lower lip sagging down, out of
line to the left due to the loss of teeth on the lower left jaw. But now I withdraw all
objections to you exhibiting the creature Brooks (who is always hollering for* truth*)
where ever* [sic] *you like.*

*In the end too, what truth is to be known about Chris will be found in a book of your
drawings of him.*

*Which brings me to the Fryer book. It is almost comical to see his enthusiasm collapse like
a balloon with a slow leak. Because Chris does not reveal his true essence to anyone
[*"(*except you)*" *has been crossed through*]*, not to the readers of his novels or
autobiography—maybe not to himself.*

*I think of Dickens who stopped sending John Forster, his friend and editor, pages of his
biography because he found the truth of his childhood too agonizing to write. So he
switched to* David Copperfield*, a novel in which he could invent himself and his
family. He suffered so with Thackeray's cheap contempt that I wonder if Dickens
might have traded his genius for aristocratic birth.*

*You make me see that my vanity is all contained in the beauty of 50 years ago. I don't
give a damn about being born of Anglo Saxon farmers "who prayed in the parlour
and practiced incest in the barn." (Quoting film article [by] myself.)*

*Love to you and Christopher*

*Louise*

# James Merrill

## 24 February 1977, Santa Monica

James Merrill came to tea on Sunday. He was brought by Peter Shnei-
dre and Jim Gates,* who were surprised and thrilled to meet Stephen
Spender. None of them knew that he would be present. Merrill and
Stephen know each other and later excused themselves for a private
talk in Chris's workroom about Merrill's occult practices in his effort
to communicate with Wystan [Auden]. While they were gone Peter,
characteristically, remarked that Stephen is neither admired nor read
by any of the people Peter knows.

Merrill is dapper, contained, precise. His clipped speech comes
from a wry mouth, its wire-like line pulled up at both ends into a
perpetual taut smile. He is apt, finding the right word for the occa-
sion, suiting a droll story to a dry situation. He was wearing a crisp,
black, shiny gabardine jacket, a pastel striped tie, and faded blue den-
ims. His hair is cut short and neatly combed. His skin, mottled and
lined by the sun, is pulled tightly over his features.

On Tuesday afternoon Merrill sat for me in my studio. I picked
him up at a big, old wooden house on Fifth Street in Santa Monica
where he was staying with friends. He was watching for me and came
out of the house before I got halfway across the front lawn. When I
had asked him to sit on Sunday he was evasive until I told him that I
only needed an hour and a half. I worked at least two and a half hours.
Only about fifteen minutes before I stopped work did he claim to be

---

\* *They were in their early twenties, and longtime buddies despite Peter's wincing disapproval of Jim's
homosexuality. They shared an avid interest in both literature and Vedanta. In the late sixties they
had telephoned Chris and, declaring themselves his fans, asked to meet him. The four of us soon be-
came friends and each of them sat for me many times.*

getting a bit worried about time, politely deploring having to mention time at all. In spite of working longer than I'd promised, I still felt rushed and unable to fully master a simple treatment of his shirt, arms, and hands. Nevertheless, the drawing is a good one.

He sat agreeably still, smoking occasionally but never making it or anything else an obstacle between us. We spoke very little. He told one appropriate story about a friend of his who was being painted by a portrait artist who grumbled and complained throughout the sitting about the difficulties of what he was trying to do. When he asked why then did he do it, he answered: Because I can.

Merrill and I liked each other. He was impressed by the drawing and said of it: "It's so alive."

The sun was still shining and the afternoon air was clear when I drove him back to Fifth Street. In the car he asked questions about my attitude to drawing. Feeling a compulsion to compensate for my silence while we'd worked, I gabbled away. I was exhilarated by the sense that I'd done a good drawing, and my liking for Merrill made me want to please him. But I was also more exhausted than usual from my intense, extended concentration, and wound up from too much coffee. My rush of words sounded to me overemphatic, but Merrill looked at me intently with his kind eyes. Habitually intuitive and polite, he was trying to satisfy my wish to be of interest to him.

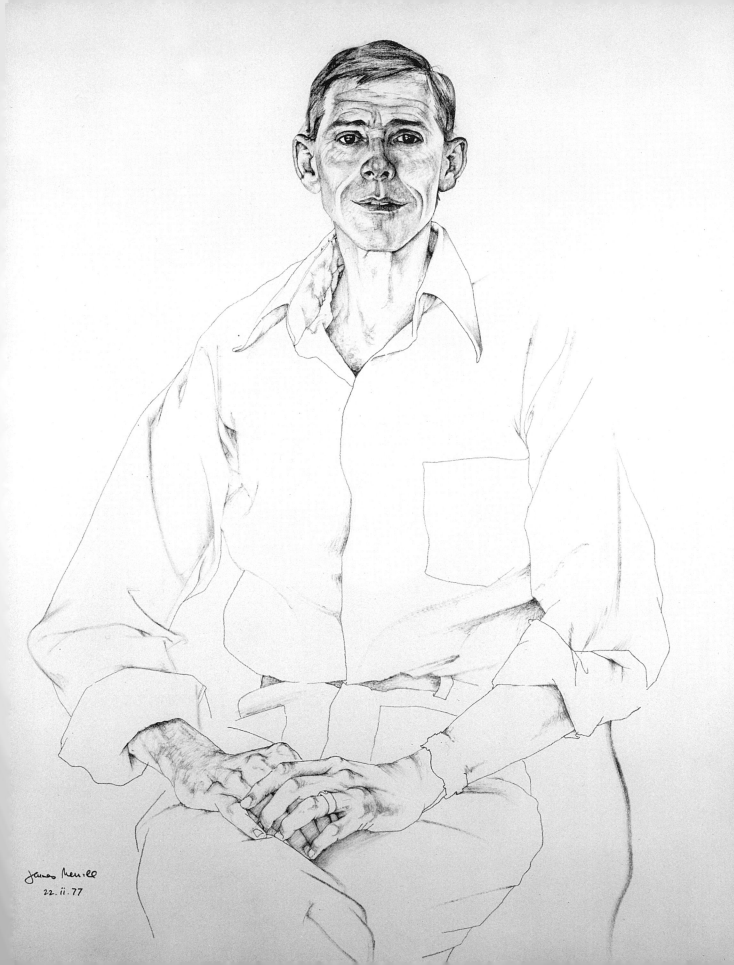

James Merrill

22. ii. 77

# Barbara Stanwyck

*26 February 1977, Santa Monica*

Yesterday afternoon Barbara Stanwyck sat for me in her house in Beverly Hills (1105 Loma Vista Drive).

[We had not met before. A few days earlier Walter Plunkett had sat for me, and while we worked, he had asked if there was anybody I particularly wanted to draw. Not guessing he and she were good friends—I'd often heard that she disapproved of homosexual men—the first name out of my mouth was Stanwyck. He must have called her soon after I left his house, because only moments after I returned home my phone rang, and the deep, scratchy voice at the other end of the line informed me that it was Barbara Stanwyck—calling *me* to make a date for a sitting!]

Her low-lying, vaguely ranch-style house is almost invisible from the street because of its featurelessness and its similarity to the neighboring houses. I parked on the street rather than on the loop-drive in front of the house. Since I was a few minutes early, I stood waiting by my car, drawing board, equipment bag, and bench in hand, until one minute before three, when I took the few steps to the front door and rang the doorbell. After a long pause (almost as though she'd been waiting for the stroke of three), the door was opened by Stanwyck herself.

Stanwyck's flare for the theatrical is not restricted to her movies. Her calculated presentation of herself to me was dashing and highly effective: the sound of quick footsteps on a polished floor, a silent pause, then a sudden unlatching of locks followed by the broad sweep of the front door as it swung open to reveal her, as much as to say "Ta-DUM!"

There she stood in full color. I realize while writing this now that, regardless of her half-dozen color movies, for me Stanwyck is a black-and-white personality. Oddly, in spite of color, or maybe because of it, her white hair is her most standout feature. Its startling whiteness and crisp-meringue texture looked unnatural. I even wondered for a moment if it might be a wig.

She was wearing a white blouse, a bright red sleeveless pullover sweater, black trousers, and shiny black shoes, but her clothes and highly colored complexion were outshone by that dead-white hair. It had certainly been specially done, in a style similar to what she wore in *East Side, West Side,* though more elaborately built-up and set-looking. I suspect that she was going out that evening and, by scheduling our sitting on the same day, had achieved two goals with one visit from her hairdresser. Such a timesaving arrangement is consistent with her businesslike precision.

Stanwyck pulses with efficiency. She seems keenly aware of her responsibility to live up to the Stanwyck image of strength and professionalism, and evidently tolerates no hint of hesitancy or shyness in herself. Behind her brisk, forthright manner, however, a small, white-crested redbreast looks out—quick, leery, sharp-beaked. I felt her cautiously but constantly scrutinizing me with bird-style radar. She avoided looking me full in the face, and mostly gave me just a profile view of her beak, with a bright little eye looking straight ahead rather than at me. Still, I felt myself minutely inspected and my potential shrewdly surmised. Rather than friend or foe, I guessed her categories for judging creatures were hunter or prey.

Her inspection took in my camera bag. Vibrating with predatory menace, her gravelly caw fell an octave lower when she accused rather than asked: "What's that?" "I keep my drawing equipment in it," I hurriedly explained, the threat of sudden, merciless pecking too near for ease. "I thought it was a tape recorder," she said, revealing the unsuspected source of her dread. Other senior actresses might under-

standably fear showing their aging faces to a camera, but Stanwyck dreads a tape recorder's exposure of her verbal clumsiness when expressing any but her simplest thoughts. About her looks I felt a relative assurance, perhaps due to a fairly recent face-job. Eye bags have certainly been removed and I suspect her cheeks have been filled with silicone. Her age is betrayed only by her shiny, mottled skin, her scrawny bird's neck, and her anxiously sinking mouth. (Like Ginger Rogers and Joan Fontaine, her lips were painted a magenta-pink.)

Had my equipment bag contained a tape recorder, Stanwyck told me, she would have allowed herself "a few well-placed four-letter words." Stanwyck the salty talker is another aspect of her image which she feels obliged to live up to. "If you know me you have to get used to four-letter words," she warned with a note of satisfaction in her voice. "Son-of-a-bitch," she croaked to demonstrate her skill, but it sounded disappointingly harmless, and also failed to provide the designated number of letters.

We were standing between her living room and a bar which looked out on a pool behind the house. I noticed that the low-ceilinged rooms were already lamp-lit at three in the afternoon and expressed a worry about the waning daylight. Striding ahead, she took me to a small room with a desk and two windows which afforded as much of the remaining afternoon light as I was likely to get in that dark house. She apologized for the bare appointments of her "office." I was concerned about the room's only chair for her. Small and covered in black simulated-leather, it was so low in relation to my drawing bench that it would give me a steep downward view of her. She followed me to the bar where I spotted, through a sliding-glass window-door, a canvas director's chair by the pool. She firmly squelched my proposal to try it by stating that the chair was the same height as the one in her office. I knew better than to contradict Stanwyck.

We returned to the office where she placed a couple of fat woolen cushions on the black chair, and sitting down to test for comfort, as-

sured me that all was well. I was longing for a cup of coffee but dared not ask, a powerful sense of her very definite plan so intense that my instinct told me not to interfere. There was a job to be done and you don't fool around at Rancho Stanwyck.

Without further prompting I assembled my bench and drawing materials and started work. My only request, that she look directly at me while I drew her eyes, she granted without hesitancy. Her response was almost automatic, as though part of a plan which included another facet of the Stanwyck legend: Is there a man alive whom Stanwyck would hesitate to look straight in the eye? Before long her small bright eyes had locked into a stare, not so much at me as through me. Like a protective shield, her stare deflected my intrusive gaze and almost seemed to erase me from her vision. Her whole attitude implied that she was engaged in a familiar routine. Stanwyck, the inveterate professional, was again doing her job without flutters or frills. With her instinct for the camera, she even put her shoulder into it, literally, by turning her torso away and lifting her left shoulder to give me an asymmetrical view of her. Her tawny flushed face loomed over her hiked shoulder and her stare remained fixed. I don't even remember a blink until I told her about twenty minutes later that I had drawn her eyes. As though coming out of a trance, she shifted her body, pulled herself up for a moment, then, as though settling again into sleep, found exactly the same position, aligned her head perfectly, only now with her eyes averted, and we resumed. Almost without a sound we worked concentratedly for the next hour. There was something man-to-man about our confrontation, both of us getting a job done with a minimum of fuss.

When I'd nearly finished her face, I ventured a compliment on her remarkable concentration as well as her appearance. Though the tone of my voice sounded to my own ears a bit too earnest, her gracious but controlled "thank you" kept her on a straight course through the despised shoals of overemphasis. Her manner conveyed that she is

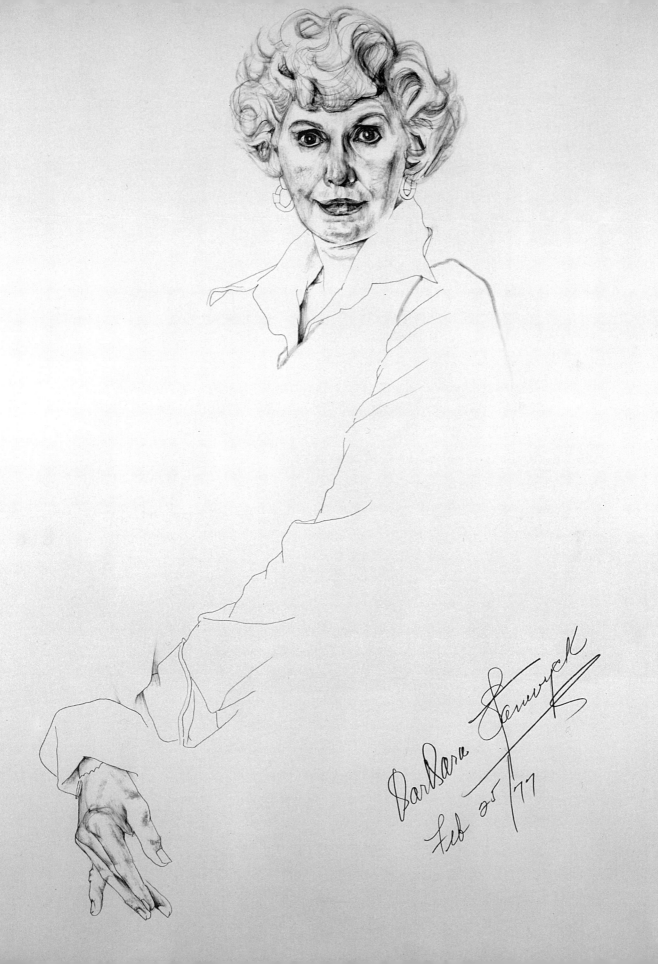

Barbara Stanwyck
Feb 25/77

146

accustomed to compliments, and though she doesn't need them, she is glad for the sake of her admirer that such incantations to Stanwyck, the icon to which even she seems to defer, are regularly repeated.

As the scant light dimmed, an almost sepulchral atmosphere filled the small, silent room, undisturbed by telephone or servants. Then, suddenly, sharply, the doorbell chime, all the more chilling for its simulation of sweet harmlessness, echoed like early doom. Shaken from her trance again, Stanwyck motioned with her head in the direction of the still-reverberating chime and spoke an ominous, rhetorical, "May I?" Neither of us expected me to deny her the right to answer her own door. Her disciplined stillness and cooperation had been so complete that now her righteous power easily, almost sadistically, took precedence over my self-indulgence.

I heard her opening the front door. Some words were spoken, and someone was admitted to the house. I looked at my watch: four-thirty to the minute. I had asked for an hour and a half, and she had given me just that.

Stanwyck stayed out of the office where I waited just long enough to signal unmistakably that my time was up. When she returned, I knew better than to ask for even one more moment. She came to look at the drawing only when invited. Her suppressed gasp of surprise was followed by a direct, flat statement: "There's something wrong with the pulled-up mouth." Then, after a pause: "But of course you will work on it later, won't you." Her statement was not a question. No answer was required.

She made no objection to signing and dating the drawing. It was still clipped to my drawing board as she angled it on her desk. At the end of "Barbara," the lead in the pencil broke from her firm pressure. I handed her another pencil and warned that it had an even sharper point. Undaunted, she resumed without further mishap, the whole of her big signature eerily repeating the drawing's diagonal flow.

"Might I ask one more favor?" I said, and then mentioned my

brother. "He's your devoted fan and would love a signed photograph of you." Far from the displeasure I half-expected, she seemed pleased and quickly produced from a desk drawer an 8 by 10 color print of the John Engstead photograph which, autographed by her, I had seen displayed in a stationer's shop in Beverly Hills not long ago. "Of course I don't look like this," she said, indicating the photograph, "but no one wants to see what I really look like." I told her my brother's name, and as she signed she said, "I'll pretend we know each other very well," thus excusing what might seem, by her standards, an effusive inscription: "To Ted—Best Wishes Always, Barbara Stanwyck."

Now she made what sounded to me like a perfunctory invitation to have "something to drink, a glass of wine?" "You must have things you want to do," I answered, my wish to make further contact with her sounding clearly through my subterfuge. She pressed further, saying, however, that she did have to do something in half-an-hour's time. She's a seasoned escape-hatch expert.

Her manager, wearing an open shirt with sport jacket and trousers, sat waiting in the bar. Fortyish, pasty, and balding, he was also homosexual and, perhaps consequently, careful. His yes-man tone suggested that he knew Stanwyck just well enough to be very respectful of her.

My refusal of her offer to put ice in my white wine troubled Stanwyck momentarily, as though it were an eccentricity or, worse, a pretentious taste for purity. She brought the wine to me in a large half-full wine glass, then placed herself against the light with the dusklit pool and sloping garden behind her. She was in silhouette, and her voice now took over for her face.

Stanwyck opened conversation by asking me how long I'd spent in this country. From a sinister undertone in her would-be-harmless question, I guessed that her curiosity had been mounting since my arrival in her house. I told her that I'd been born in Los Angeles, but remembering rumors of her disapproval of fags and the banishment

of her homosexual adopted son, I omitted any reference to Chris and emphasized instead my time and schooling in England. Wily now, she wanted to know how much time. I implied more than the actual year it had been. A suspenseful pause as she weighed my testimony ended when, perhaps because of insufficient evidence, she seemed to acquit me of the charge of affectation. "But there are lots of phonies around this town," she snarled contemptuously. "I can hear the accent come and go before they've finished a sentence."

From one of my affectations we now passed to one of hers, an interest in learning. She is intimidated by culture. For her it is spelled with a capital "C." Thoroughly intimidated, she is currently struggling with a biography of Thomas Jefferson. The thick volume weighed heavily on the large cocktail table between Stanwyck and me. She praised it as an example of the way history ought to be written. "Not boring dates but personal, human details," she insisted. (Most of the details she mentioned were about Jefferson's black slave-mistress.) Stanwyck's comments about the book were stumbling and inarticulate. She groped for banalities and wearied us as she'd been wearied, by Jefferson, biographies, history, and culture. But, the moment we drifted into current political events she suddenly became authoritative and more opinionated. "Politics—just the same today as in Jefferson's time," she repeated more than once. She meant that it was petty and personal then, too, if not always crooked as well. She obviously watches television news avidly. She mourned Ford's exit and deplored Carter's informality. According to her, parties at the White House should be "elegant, dressy, dignified." She wants to see "the silver table pieces and chandeliers, to feel proud of our country's representatives, august in their fine robes."

"And that Amy Carter!" Her lips curled in disgust. "Amy Carter is my nemesis," she growled. After a moment's reflection, deciding she couldn't afford to abandon support of her country, she added: "But if the Carters are going to be around for the next eight years, I

suppose I'd better get used to them." Then catching herself up with an almost mechanical response, "That is, if I'm still alive."

Her remark was meant to be throwaway, but in her tone was a hint of an underlying morbid bitterness, the grim sound of the supposedly all-powerful finally recognizing the incredible but inevitable final defeat. In all my experience of dealing with strong female egos, I have never before heard from any of them an acknowledgment of her own mortality. It seemed so incongruous, almost unthinkable, that Stanwyck could die, and, even more unthinkable, that she herself should admit this possibility. Most unthinkable of all would be any attempt to provide her with consolation. Sprinkle sugar on the salt of the earth? I'm sure she would spit out her handiest four-letter words. Weathered but staunch, she has become what she evidently enjoyed playing most, a character in a Western.

When she was seeing me out of the house moments later, I offered to send her a photograph of my drawing of her. She mentioned again its "pulled-up mouth" and added: "I'm a clown, but I shouldn't look like one."

# Olivia de Havilland

## 3 March 1977, Santa Monica

Finally, and for a solid hour and forty-five minutes without a break, Olivia de Havilland sat for me yesterday morning in her room (190) at the Beverly Hills Hotel. She cooperated to the fullest and, both placid and confident, boldly presented to me her large, round, fleshy face. She refused my offers to take a break, showed almost no strain, and never flagged in her resolve. The completeness of her surrender was the surest sign of her strength. She gave me Olivia de Havilland in all her rich complexity: warm, cold, soft, hard, true, false, strong—but never weak.

I had made repeated telephone calls to her in one of the most prolonged prologues to a sitting I have known, and she played with me right up to the last minute. She first promised to sit at one on the previous afternoon (Tuesday), but then, less than an hour before I was to arrive, called to beg off because she was "too tired." The night before, she told me, she had spoken at the American Film Institute's tribute to Bette Davis and, having stayed up with Davis and a few close friends till past two, had only had five hours sleep.

Natalie Wood and Robert Wagner had been part of the late-night group of Davis's friends and, when I telephoned Natalie yesterday to confirm our sitting for tomorrow, she told me that Davis had gone on to their house from the hotel and had stayed up drinking till five in the morning. Natalie also repeated Wayne Warga's reference to her and Wagner in his account of the evening in the *Los Angeles Times*. He claimed that all the speakers had acquitted themselves with dignity, except for the Wagners, who were "like a couple of Mars bars on a tray of elegant French pastries." Natalie's wry tone in telling of the putdown

almost, but not quite, hid her indignant outrage. She may not be a perfect lady, but she definitely has her pride and this arrow certainly hit a tender spot. She and I agreed that some of the speakers hadn't acquitted themselves with all that much dignity. She took particular exception to de Havilland's mention of her own two Oscars, as though congratulating herself at Davis's expense, and Natalie also cited Joseph Mankiewicz for his long-winded congratulations to himself. Taking my turn, I criticized Liza Minnelli for her sentimental, phony guff. Our attacks on boasters and bores brought Natalie and me closer together than we've ever been. She is a devoted decrier of falseness and pretentiousness.

Which subject brings me back to de Havilland. In our preliminary telephone conversations de Havilland had given me so much gush and evasion that I was fully prepared for a sitter as difficult and uncooperative as her sister [Joan Fontaine]. Instead, I found myself working with a contained dynamo of professionalism. She withheld no detail of herself and attempted to hide behind nothing more serious than a faintly pleasant expression. It was not quite a smile but, like a smile, it wrested itself from her grasp when she tried to maintain it. Declaring its independence, her mouth turned slightly hard. (It was her bad twin look from *The Dark Mirror*.) I saw her realize that her mouth was going wrong and I also saw her decide not to right it, not to interfere with me by imposing her preference. (For that she deserves my sincerest praise.) Instead, she chose to rely on her self-assurance, and her immense inner strength, to will me to draw her as she wished to see herself.

When she looked at the finished drawing, however, it was precisely the set of the mouth which bothered and puzzled her. She would not say that she was disappointed, nor would she criticize the drawing in any way, and she made no objection to signing it, her distinctive, handsome signature big and clear. In fact, she took upon herself all responsibility for the look in the drawing. "I have to think my way back

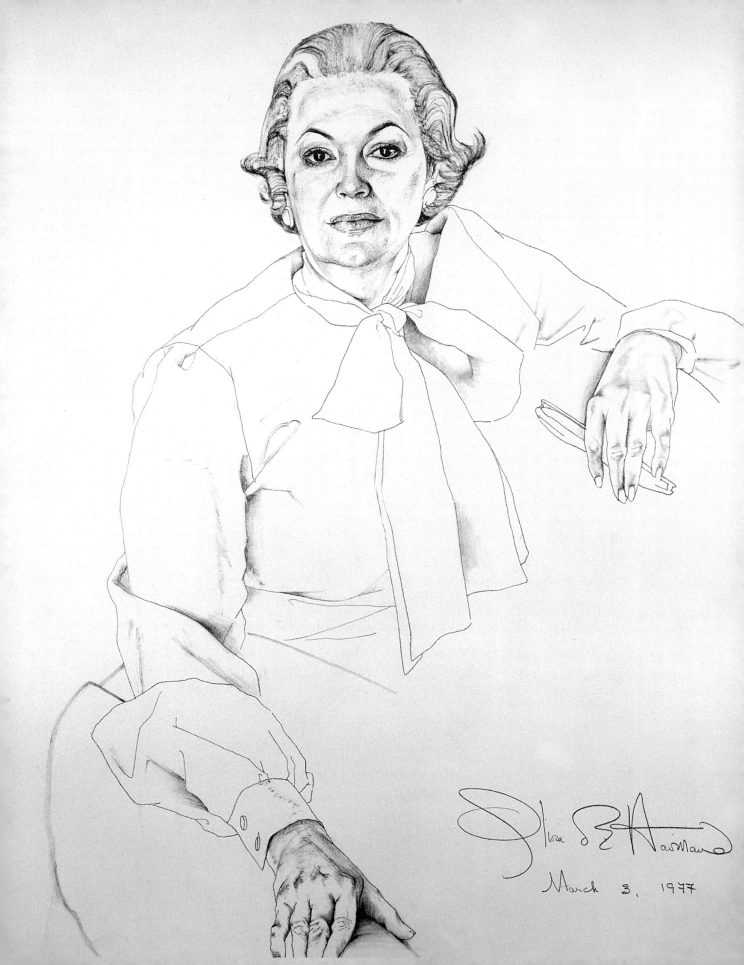

March 3, 1977

to where I was while you were drawing me, what it was I was thinking about that comes through in the drawing and creates that expression I don't recognize." *Won't* recognize would be closer to the truth.

As usual, I said that I didn't know what I thought of the drawing and wouldn't know until the next morning when I looked at it again. I offered to send her a photograph of it if I decided I liked it. "Yes, I would like to see a photograph. It will help me to get back to what it was I was thinking that gave you that expression in the drawing."

I called the next morning to tell her, perhaps unwisely, that I really like the drawing. She was gracious and thanked me for calling, but there was a controlled coolness in her voice. I think she feels betrayed by me.

## 6 March 1977

In her revealing speech at the tribute to Bette Davis, de Havilland said that when, "as a girl" (the age difference between her and Davis is only eight years), she had first seen Davis in *The Man Who Played God,* she had been so impressed that she decided to make Davis's career a model for her own. I realize now that de Havilland is a real-life Eve Harrington. She has been competing with Davis all these years, and the irresistible urge to mention her own two Oscars at a tribute to Davis is clear evidence. I even believe that she decided to sit for me because Davis had, and she thought she could better Davis by willing me to do a drawing of her that was warm and lovely, the very opposite of my sour version of Davis. No wonder the revealing set of her mouth in my drawing bothered her so much.

On the day before our sitting when she called to reschedule, de Havilland was almost overcome by effusion: "I want to enjoy this experience. I want you to enjoy it. I want it to be *right*." And such preparations! "What should I wear? What kind of thing do you want? A simple neckline? What can I wear that's *clean*? I brought very little with me

because I thought I was only staying a week, so I've had to have things cleaned. What is there *left* that's clean? I have a suit with a blouse that has a scarf. A scarf would be all right for you? You're *sure* now?"

## 7 March 1977

I telephoned de Havilland tonight to tell her that I would leave a photoraph of the drawing at the hotel tomorrow morning. Still troubled by the drawing, she has now progressed to being "deeply disturbed" by what she described as "a psychologically penetrating look in the eyes" and "that sensual mouth." Sounds great to me.

# Mia Farrow

*11 January 1977, Santa Monica*

To George Cukor's yesterday evening to meet a Frenchman, Pierre Barillet, who for months has been writing Chris letters and even got Anita Loos to write on his behalf. He's now staying with George and had obviously asked him to invite Chris. Yet, when finally he meets Chris for the first time, he seems hardly interested beyond the usual perfunctory, polite noises. He referred to "The World at Dawn" [for *The World in the Evening*] as the best translation in French he knew of any of Chris's books. If the translation of the title is any indication of the best, the others must be dillies.

Of much more interest to Barillet than Chris was Mia Farrow, who, George announced, was not only to be one of his dinner guests but was coming early especially to meet Chris. She didn't come at six as George expected, however, but at six-thirty, the usual time guests are invited to dinner at George's. But she did come all lit up, her eyes looking unusually large because of their oversized pupils. She was wearing a dark green velvet-corduroy dress with stand-up cuffs which gave it an eighteenth-century look. Her shoes were a dark wine velvet with buckles and low, square-shaped heels. Her hair, short cropped and reddish-gold, was a bit longer and fluffier than her familiar cap cut. Her skin was lavender pale, and her lips, drained of blood, were the barest pink. In contradiction to her soft period-look, her manner was bold and outspoken. Her eyes defied those of her examiners, and, if she told more than she learned, that, she seemed to imply, was as it should be. The confident, experienced volume of her voice dispelled the last vestiges of anything demure about her.

To suggest flattering intimacy with the object of her supposed

reverence, she perched on the edge of the white sofa in George's library to be near Chris, who sat in one of its corners. Her tentative, alert position also allowed her to move closer to Chris should George, still standing and benignly fussing over his guests, want to sit in the sofa's other corner. She was all tact and consideration with just a dash of brash.

She asked for a glass of white wine and lit a cigarette. "Is there an ashtray, Uncle George?" she asked, as her hand with the cigarette hovered uncertainly over the assorted objects on the table before her. George indicated a satin-polished silver bowl in the shape of an intricate shell. "It's much too pretty," she said as she flicked a tip of ash into its innermost chamber.

Moments later George was violently abusing Charles Higham ("a big hulking goof," he called him) for writing in his biography of Katharine Hepburn that George had slapped Hepburn in the face on the set of *Little Women* and brought tears to her eyes. "That's what is politely known as a tub of shit," snorted George, with the indignant contempt he reserves for irresponsible writers and traitorous friends. Farrow, knowing this path well (she is his goddaughter), supported him with her own criticism, cautious but clear, of Garson Kanin, who had written an article about her for *McCall's* which had brought her a distressed call from her mother and obliged her to write two letters of apology. Betraying a hint of satisfaction in being able to suggest her closeness to a distinguished writer, she mentioned that Thornton Wilder had once told her never to trust Kanin because, if you watch him closely at dinner parties, he repeatedly steps into the next room to jot down some remark he's just heard.

When George became noticeably fidgety as seven o'clock, the traditional dinner hour at his house, approached and passed, Chris and I stood and voiced sincere regret for our early departure. George *had* invited us to dinner, but without informing us of the added attraction

of Farrow. Because of our previous engagement, we had declined dinner but said we would come for an early drink with George and Barillet. (Had we known about Farrow, would we, would I, have changed our plans?)

As we were leaving, George jokingly chided us for not putting off our dinner date. Our groans prompted Farrow to suggest a follow-up meeting. Balancing eagerness with practicality, she proposed that we rendezvous midway between Malibu, where she lives, and Santa Monica, where we are, and asked if we knew any good restaurants in that area. Though it is much closer to us, she greeted our mention of Casa Mia [a Mexican restaurant in Santa Monica Canyon] with enthusiasm but no acknowledgment of being its eponym. She said she would get Chris's number from George and promised to meet us there one night soon.

## 6 March 1977

Last night we had our evening with Mia Farrow. She came to 145 and had a glass of wine, showed us a fat wad of snapshots of her endless array of children (her own and several adopted ones), and went into long tales of her efforts to adopt blind and/or crippled Vietnamese children, her current choice for adoption requiring "an act of Congress." She is obsessed by the image of herself as Mother. Taking note of the considerable number of paintings in our living room, she remarked: "My predecessor [André Previn's first wife, Dory] had lots of pictures, too." Then, as though merely stating a simple fact: "Dory collected pictures instead of having children." Perhaps Farrow imagines that Chris and I collect them for the same reason.

We took her to Casa Mia where, deciding that an occasion should be made of our evening together, she declared a change in her attitude to drink from careful to "abandoned." Though she had only one glass

of wine at our house, she ordered a second liter of wine at the restaurant and insisted on paying for it herself. But she still drank noticeably less of it than we.

Midway through the evening I asked her if she would sit for me and she shot back: "It would be an honor." When I called next morning to make a date for a sitting, she immediately said: "I was hoping you'd remember." She then began to find "difficulties" in the coming week and eventually proposed "pencilling me in" on a Sunday ten days hence.

What appetite and ambition she has, and what drive. A fierce little engine fairly hums inside her. She glides along dispensing opinions and observations and even simulates a revelation or two—she referred a couple of times to Frank Sinatra as "my first husband." With a keen sense of what about her interests the public, she wanted us to be interested, too. She wanted to make another conquest. Is it only an excess of energy? Interesting to see if, and how, she follows through.

## 7 March 1977

Mia Farrow called yesterday morning at eleven-thirty to say she felt like she was coming down with flu. Then, sensing that something was not as she'd thought: "Is it today we were to meet or *next* Sunday?" "Next Sunday," I told her. "Oh, that's so like me," she said. I guessed that it was like her only to cancel a date a couple of hours beforehand. For her, vagueness is only an affectation.

## 18 March 1977

On Sunday Mia Farrow came to my studio to sit for me. Due at eleven, she didn't appear until after twelve. She had called first, on Chris's phone, though I'd given her my number, to say she would be late because the baby sitter had arrived late. Her arms were full of a blan-

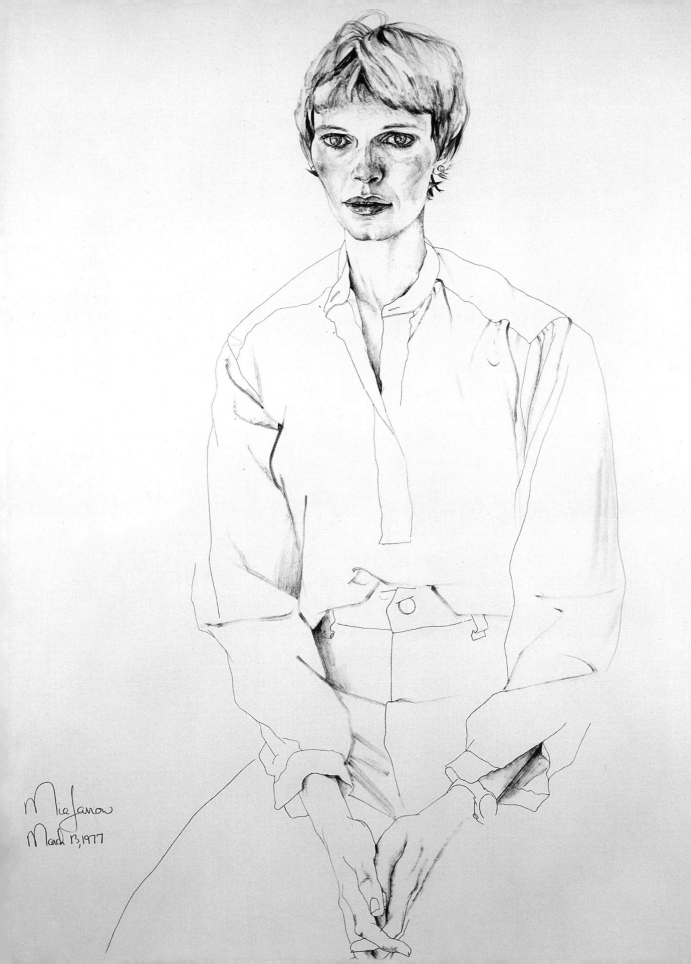

Mia Farrow
March 13, 1977

keted, blond-haired creature whose third birthday it happened to be, she told me, and lightly added with approval that he had "rejected his baby sitter." (At first I thought she had said the reverse and wondered admiringly to myself at the audacity of a baby sitter who dared to audition her charges to see if they met her standards. I worried, too, that he had been rejected because he was especially difficult and would probably do his best to ruin my sitting with his mother.)

After deciding to bring him along, Farrow said she'd stopped on the way to buy a toy to pacify him. I believe that she brought him primarily as the key prop for her favorite performance: "Mother." Also, the baby's pajamas and blankets, blond hair and creamy skin provided a motley of pastel shades which flattered her by echoing and accentuating her own soft tints: lavender and pink around her eyes, peach-colored eyebrows and hair, blue-rimmed irises faded at their centers by a tinge of gray. Her mouth is disconcertingly sensuous, its color, in contrast to our first meeting, that damaged dark pink of a swollen bruise. Not until I started to draw her did I notice her powerful cheekbones. You could break your fist on them.

Frail yet bold, she sat impeccably and with firm control of us both. She looked me straight in the eye, the merest hint of defiant disdain behind the meek obedience she simulated. The character she portrayed for me was a mother-at-bay who, harrowed but enduring, tasted a rare moment of calm respite while her child slept beside her.

# Linda Ronstadt

*22 September 1977, Santa Monica*

The night before last we went to an after-midnight party for Linda
Ronstadt, who earlier that night had opened her show at the Universal
Amphitheater. The party was at El Adobe, where she says she often
eats. (We had seen her there once, with Governor Brown, but didn't
dare to speak to her since we'd only met her briefly.) "I'm Mexican,
you know," she said to me as though explaining her presence in a Mex-
ican restaurant. I, in fact, didn't know. It had never occurred to me.

Betsy Asher had invited us to the party when I telephoned to in-
vite her and Peter [her husband] to the opening of my show. Despite
only a brief previous meeting with us, Linda was warm and friendly
and, finding a front booth, sat with us until after two in the morning.
On the inside of the booth next to the wall, Linda placed me on her
right and Chris across from her. Next to him on his left was Carole
Bayer Sager, a songwriter and performer I had heard of but Chris had
not. Two chairs added to the open end of the booth were occupied by
a changing array of people, most of them in the music world, which
clearly impinges on the art world even less than I'd imagined. In con-
trast to the opening of my show last night, where *nobody* seemed to rec-
ognize Linda, several well-wishers stopped to greet her and got her
friendly, unaffected acknowledgment.

At my show Linda had looked small, demure, and pretty in a
white lace dress. To the party at El Adobe she wore a cub scout shirt
and tight, very short pants with long black stockings. Even in the poor
light of the restaurant her long, straggly hair had a too-dark dyed look,
and her cheeks, wide and full with large-pored skin, were covered with
clay-colored makeup. Mobile with energy and constantly searching

for information and meaning, her intense, very round and very dark eyes frankly fix those of whomever she confronts, then dart away, return and dart away again.

I think she might have been "on" something, maybe some sort of speed. She was definitely up, talking and talking, analyzing swiftly and acutely. Full of bright observations about her latest experiences touring the country, she was almost too alive, too intelligent, too aware, as though she could speed straight off the precipitous edge of the glossy table top.

Linda likes having bright people around her and commended the musicians who travel with her for being "well-read," and also record producers who are flexible enough to understand that all recording artists are naturally co-producers of their own records. She spoke admiringly of Dolly Parton, with whom she's worked, and praised a new sophisticated electronic device to enhance vocal quality, called "an aural exciter." She laughed herself at the term's sexual connotation.

Wanting to make more contact with Chris, Linda was prevented by the conversation he'd been drawn into by small, soft-spoken Carol Bayer Sager. I thought Sager looked vulnerable until I noticed the set of her lusciously-wet, lipsticked mouth and saw behind her outward camouflage an ego and drive of considerable proportions. She may be small but she can bite. Linda and she had not met before. Immediately Linda praised her as both songwriter and performer. Her flattering recognition suggested that Linda regarded Sager as a peer, though Linda didn't actually say so. I felt an uneasy wariness between the two women, snake and mongoose but neither sure which is which.

I like Linda's avoidance of any Dinah Shore—like blandness and charm. "Here comes a pain in the ass," she warned in a low voice as she sighted impending danger. The pain in the ass, a long-faced, big-toothed independent record producer, descended on us and, after in-

troducing his red-haired girlfriend, Gwen Welles, earned his epithet by telling us a tedious tale of the two years he'd attended acting classes "to gain enough understanding of actors to direct them in movies." Linda listened intently to his banalities without a sign of distaste, though I felt certain her ass registered twinges of pain.

## 27 September 1977

Yesterday Linda Ronstadt came to my studio to sit for me. She was due at two o'clock and at one called from Hollywood to say she had left directions for finding me at her home in Malibu. She arrived punctually, wearing the same blue flower-print blouse and denim pants she had worn the night before, and I guessed that, a no-nonsense, ready-for-action girl, she had spent the night in town on a sex-date. After seeing her show, Chris and I were in her dressing room only moments before Ronstadt barged through the waiting assembly of friends, fans, and business associates and, stopping only to embrace Chris and shake hands with me, made a hasty exit. Not wanting to seem puzzled by her abandonment, those remaining, like bits of debris after a fireworks display, settled briefly at a table spread with biscuits, cheese, guacamole, and champagne in pre-filled plastic cups.

Yesterday Linda's flower-print blouse was tied above her pants to display a bare midriff of dimpled flesh punctuated by a navel. Her reddish-brown open sandals with medium-high heels displayed her pretty feet, their toenails lacquered a deep red. The dark mass of her hair was tangled and lackluster. I guessed that its buoyancy of the previous night had been pressed out of it by the intervening lovemaking.

Unlike her hair, Linda was not the least bit limp. She held herself upright, her voice was clear, and, like one obliged to make every moment count and every encounter lead somewhere, her manner was direct and unselfconscious. In sharp contrast to her energetic pres-

ence was the soft-spoken servility of Gail, the large well-padded secretary Linda had brought with her. Providing a physical contrast flattering to Linda is, I suspect, one of Gail's key services to her employer.

I offered the women something to drink. Linda chose tea instead of coffee, so I brewed a proper pot of Earl Grey while they looked briefly at the artworks in the front rooms of the house. Chris came down the hall and, greeting the women in the dining room, stood talking to them from the hall doorway. We both complimented Linda on her performance of the night before, I sincerely, Chris politely, though she could not have discerned the difference. (During her show Chris had complained to me that he couldn't hear the lyrics because of the loudness of her accompanying musicians. If he can't hear the lyrics, there can be no pleasure for him in such a show.)

Linda is a difficult person to praise. Rather than respond with the usual thank yous and smiles, she tends, like an extended freeze-frame, to look fixedly at you, silent and imperturbable. When I praised the lighting of her show, however, she suddenly came to life and was especially pleased when I noted that there was never a repeat of the same combination of lights. "Oh, I must tell him," she said, identifying the lighting man as the one who had done the lighting for David Bowie's show at the Forum last year, "he'll love that." Turning to Gail she moaned: "If only *I* could see it." Then she wondered if she couldn't let one of her accompanists take her place onstage so that she could see the lighting effects as the audience sees them. Her earnest tone sounded to me a bit affected.

When Linda, after saying that she would like to do a Broadway show, mentioned *Mahagony* a second time, I wondered if an idea might be lodged in her ambitious mind that Chris, with his Berlin past, could be useful to her in such a project. On the subject of the various opportunities open to her, Chris said that, such was his belief in this country as the land of opportunity, he'd dared to come to Los Angeles in 1939 with only thirty dollars in his pocket. "I arrived with twenty

dollars," Linda countered, "and, when I left home for Hollywood to become a singing star, the only thing my father said to me was: Don't let anyone take pictures of you without your clothes on."

Underlining her regard for professionalism, Linda turned to me and said, "You probably want to get to work." So, with a tray of cups, spoons, cozy-covered teapot, milk for Linda, and lemon and honey for Gail, the two women and I adjourned to my studio. "You have a much better view of the ocean than I do," said Linda when she arrived in the studio, "and my house is *on* the beach." I asked her to sit in the wooden desk chair reserved for my sitters, but placed it closer than usual to the sliding glass doors to give her, through the windblown slat-shades, the best possible view of the ocean. Gail sat in the uphol-stered chair against the wall and read while we worked. Though I dis-like not being alone with my sitter, Gail made herself as unobtrusive as possible.

Linda was talking right up to the moment when I was ready to start and asked her to look at me while I drew her eyes. Suddenly her talk stopped, her head tilted to one side, her mouth opened halfway in a subtle leer of sexuality, her lips curling out suggestively for extra emphasis, and I began to work. At first I worried about the tilt of her head because few sitters can maintain such a tilt, but she seemed con-firmed in it.

I felt more nervous than I'd been in months. I always forget the real pressure and strain I suffer when drawing someone famous. Do they have more violent electrical fields around them? Do they convey the preciousness of their time because of constant demands on it, like mine for a sitting? Or do I suffer only because of my fierce determi-nation to prove myself, to tame the untamable?

Linda is difficult to draw. The wideness of her face and the full-ness of her cheeks are the only salient, objective characteristics of her "look." The dark intense eyes with eyebrows almost hidden by hair, the short round nose, the curling manipulated mouth, are all slaves

of her will. Only the expanse of her cheeks has an independence, impudently defying her determination to be beautiful and seductive.

In spite of my nerves and worries, her head maintained its tilt and her mouth its inviting curl, like a voracious blossom in full sexual bloom. A bit of mascara stained the white of her left eye and was the only detail, aside from the ring of shadow around her right eye, that I left out of the drawing.

As the drawing progressed and my trust in her cooperation increased, I slowly gained confidence. Even her conventional reactions to some of my work on the studio walls could no longer put me off. She had obviously thought my drawing of Samantha Eggar was devastating. Of my painting of Carole Caroompas, which I think is very like Carole but almost too flattering, she said of its face: "It's slowly running down into tragedy."

Linda took a couple of stand-up-and-stretch breaks during the sitting, one offered by me and the other a sudden, urgent request from her just as I was finishing her left hand. Working comparatively quickly and taking chances, I dared a brisk fine-line treatment of her arms and hands and managed the "feel" of her torso, though I couldn't be as exact as I would have liked because her posture was continually shifting. Oddly, when I had finished it was her posture in the drawing that she instantly responded to. "Look," she said to Gail, "the defensive attitude of the rock 'n' roller—the arms protecting the body. I wasn't even aware I was doing that. It's instinctive!"

After signing the drawing and asking hesitantly, for "some kind of copy of it, a photograph or something," to which I readily agreed, she thanked me for "giving me a look into myself," as though the sitting had provided some kind of therapy for her.

While the two of them stood on the steps outside my studio, I ran into the house for a catalogue of my show that she had asked for. Chris came out with me to bid them goodbye. I unlocked the carport door and watched the two of them walk up the ramp, waiting in case

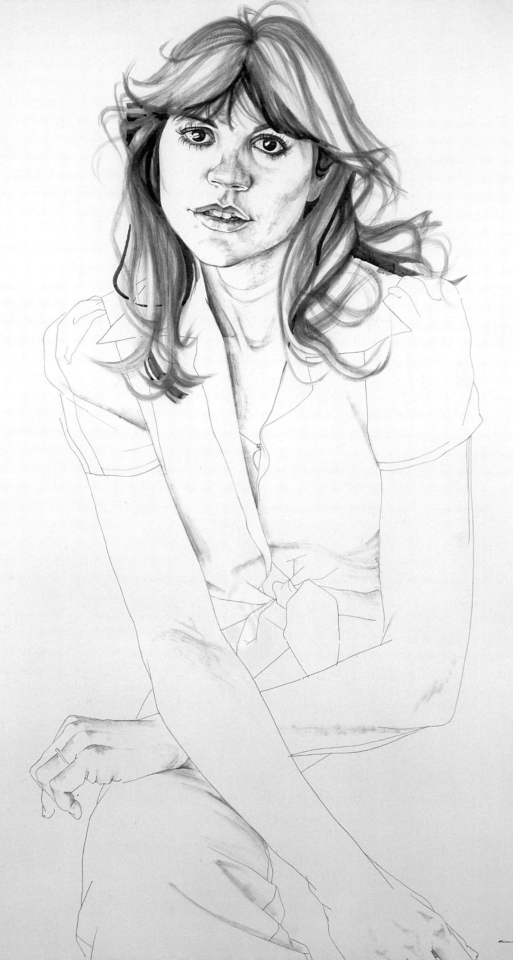

Linda Ronstadt
Sept. 26, 1977

either of them looked back with a final word or wave. They didn't, that careful avoidance of surface sentimentality of "the Now People."

I feel in Linda a very strong drive, cool, unshakable, single-minded. Having got to the top, she is determined not to slip, to go on from there to some other top. Broadway? Movies? Why not? For her standing still is moving backward. I don't think she was on any kind of drug at our sitting. She didn't have that almost maniacal urge to talk and be bright that she had at the party after her opening. But even when subdued, her drive is still evident in every breath she takes. She swims hard even when the tide is with her. Her absolute professionalism at her concert on Sunday was unmistakable, her command of her voice unflinching and unsparing. Song after song was delivered with force and precision. She made me believe that she was producing exactly the effects she wanted, and without sacrificing any allure. Her tiny cub scout pants handsomely exhibited her long, slender, pretty legs, and the pre-rain breeze attractively billowed her hair. When I commented on the appeal of this fortuitous effect, Linda said: "Yeah, just as long as the hair isn't blown into my mouth. I've nearly choked on it a couple of times."

# Irwin Shaw

## 16 February 1978, Santa Monica

Yesterday morning I drew Irwin Shaw in his bungalow (14) of the Beverly Hills Hotel. I arrived a few minutes before ten and, before ringing the bell, heard pronouncements being made inside. Was it Shaw talking? I wondered. I didn't know his voice well but certainly didn't remember it as either loud or dictatorial. Maybe, I speculated, he was already drunk. I heard no answering voice and thought whoever was speaking must be on the telephone. I waited a few minutes, but, when the voice continued and was obviously not going to stop, I rang the bell.

The door opened, and there stood Shaw, large, blowsy, bleary-eyed, looking in fact rather like Shirley Booth in *Come Back, Little Sheba.* His manner was subdued and his voice so soft that I was all the more mystified by the voice I'd heard from outside. Shaw greeted me without surprise. He hadn't, as I'd half-expected, forgotten that I was coming. Once I was inside, he introduced me to Mike Frankovich, a tall, pink-faced man with blond-gray hair. Obviously the source of the voice, he paced back and forth in a corner of the room. Shaw explained to him that I had come to do "a portrait," and would he mind if I heard what he was saying. "Not if you don't," answered Frankovich. (I wasn't asked if *I* minded.)

Quick and businesslike, I proceeded to set up my gear, drawing bench and board, pens and ink. Frankovich resumed his monologue soon after my arrival and continued nonstop, with never a word from Shaw unless he was pressed for some comment, and even then Shaw seemed reluctant to speak. When he did, what he said was short and quietly spoken, his manner diffident rather than hesitant.

The main room of the bungalow was dim in spite of the lit lamps inside and the bright morning sunshine outside. Choosing a chair for Shaw to sit in, I moved it toward a window and opened the window curtains but without noticeably improving the light. So, when Shaw sat down in the chair, I moved my bench close to him. Still, his face, ruddy anyway, almost disappeared in the gloom. His head was turned toward Frankovich, but more in resignation than willingness to attend, and also out of shyness at confronting me. His profile, the lumpy, hooked nose like a massive mountain which diminished the eye I could see to a puddle, was arresting but too difficult to tackle for a first drawing, so I asked him to look at me. Without a qualm he promptly obeyed, grateful, I guessed, to be freed from frontal exposure to Frankovich and his unceasing voice.

I assumed that, under such circumstances, I had little chance of doing a good drawing and so began my work with unaccustomed freedom, sketching Shaw's entire face with nothing but my stomp* dipped in ink wash. As usual, I had started first with the eyes, using a brush that I exchanged for the stomp once the iris of each eye was completed. I only resorted to my pen for accents after eyes, nose, mouth, and the shape of the face had been roughed in.

Shaw got up twice during the sitting. Once he answered the phone and, when he had completed the call, told the operator not to put through any more until he notified her. I was grateful for any evidence that he regarded the sitting as a matter of importance. He also got up to let a room service attendant enter and clear away the remains of breakfast, probably Frankovich's. Shaw isn't the breakfast type.

While I worked, Frankovich went on talking almost without pause for more than an hour. He referred to the two lead characters in "his" script, a version of Shaw's *Nightwork,* as "Cary" and "Dustin," the actors

---

\*   *A cartridge-shaped instrument made of tightly rolled paper and intended for the blending of pastels; dipped in ink wash, it can be used for drawing and provides a soft, diffuse line.*

(Grant and Hoffman) he sees in the parts. His blustering assurances that Cary was all but set failed to convince even himself. (Later he asked Shaw if he knew Cary and, when Shaw said yes, asked him *not* to say anything to Cary about playing the part.)

Throughout the extended hour of Frankovich's monologue, Shaw continued to look at me, his eyes, glassy with age and weariness, those of a dinosaur with extinction clearly in view. One day the kindly old dinosaur will collapse with a heavy thud, but only when all other possibilities are denied him. In the meantime, Frankovich can talk his head off for all that it matters.

Frankovich informed Shaw that his version departed most radically from Shaw's book in the last act. He then fumbled over his script's complicated events and twice cited the success of *The Sting* as justification for their complexity. When finally he had finished his rendition of the plot, he asked Shaw what he thought. With a cool mastery of tact and a quiet voice and manner which gave the strength of understatement to what he said, Shaw began by wondering if Frankovich's version might be "too plotty."

After Frankovich had gone, I told Shaw that listening to him had made me think that for more than thirty years nothing in Hollywood had changed. "That's just what I was thinking," said Shaw, nodding his head. I was about to go on when quickly, urgently, Shaw shushed me. Frankovich had returned for some papers he'd left behind. As he made his exit for the second time, he glanced at my drawing and said to Shaw: "Hey, this guy's really fast."

Frankovich hadn't overheard anything, but Shaw's wariness had revealed something of himself.

"Do you have script approval?" I asked, assuming that Shaw would not undergo such an ordeal unless he did. "No, I don't," he answered, "and it's always the same. They pay a great deal of money for a property and then right away they want to change it." He then told of being involved with Frankovich years before on a film directed

by Robert Parrish, and called *In the French Style.* "He robbed us blind," he said of Frankovich, "and now he talks of not wanting to take this deal to Universal because *they* are so crooked."

"I want to buy this drawing," said Shaw before he'd seen it. At best he'd only had a glimpse of it, half-done, one of the times he'd gotten up. I said I would like to have another sitting before he decided definitely, and he suggested June, when he plans to return. "I will have lost some weight by then, too," he remarked. However brief, his glimpse of the drawing had been sufficient to inform him of its protruding stomach, which, if anything, I had understated.

My work had gone unusually quickly, because it was only eleven-thirty-five when, after signing and dating my drawing without hesitation, Shaw offered me a scotch. Saying that I was "on coffee," I raised the coffee thermos I'd brought with me and, unnecessarily since I'd finished work, poured myself some more. I felt obliged to drink *something* with him, but I sensed that I'd lost some points by not sharing a man's drink with him, regardless of the hour.

Shaw is a good, kind man who, shrewd and leathered by experience, survives out of habit as much as preference. His blend of humility and cynicism is invaluable for good business deals. On Tuesday night Chris and I had gone to his bungalow for a gathering of what Pat Faure, an old girlfriend of his who organized the party, called "dreary acquaintances." (Her derogatory adjective hadn't kept her from inviting us!) On our arrival Shaw had immediately called me "Don" and claimed to remember well our one and only previous meeting, in Klosters five years ago when he was noticeably drunk. With an ingrained respect for "the artist" and the noblesse oblige of a successful and worldly figure, he then spoke to Chris and others standing nearby of my "wonderful" drawing of Salka Viertel, in which, he said, I had caught her "imperious, regal bearing." I like his good manners.

[I regret that Shaw and I never met again, and that I never got to have a second sitting with him.]

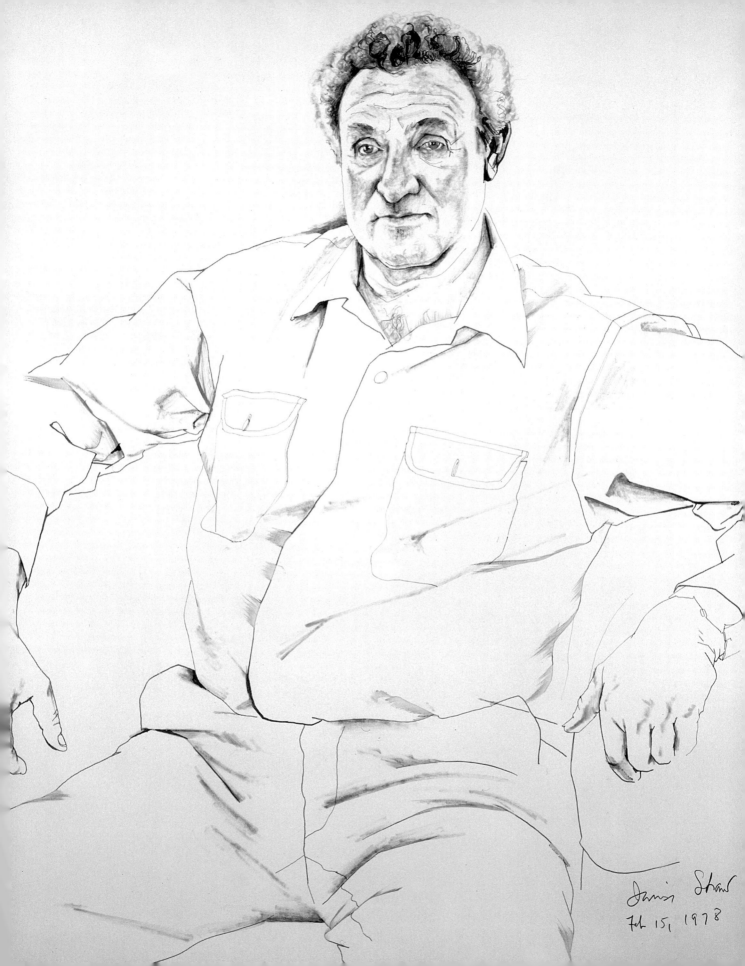

James Shaw
Feb 15, 1978

# Iris Murdoch

## 12 April 1978, Santa Monica

Last night Chris and I went to a party in an apartment in Westwood where Iris Murdoch and her husband, John Bayley, were the guests of honor. The other guests were mostly academics, their goofy, garrulous wives, a few serious, bespectacled, old-young intellectuals, and a smattering of queer academics.

Iris is very solid, with her broad pale face and bulky body. She wore a black smock-dress with a yoke of a fabric so faintly patterned that it was almost white. Her sturdy feet were implanted in suede shoes which looked molded to them. Her drab brown hair, very soft but lusterless, is cut into a short Dutch bob with a curve of bangs following the contour of her forehead and temples. With no makeup, no salient features, no ostentation of any kind, Iris has a powerful physical presence which is also subtly benign.

We arrived punctually, and, because Chris was detained in conversation with an acquaintance whom we encountered on the street, I uncharacteristically entered the front doorway to the apartment before he did. Fortunately, since I had been foolishly debating with myself whether or not I should kiss her, I quickly realized from Iris's perfunctory handshake that she didn't remember me. Later, seeing me with Chris, she conveyed by a subtle increase in the warmth of her manner the recognition absent on my arrival.

Taking advantage of her temperature change, I asked Iris to sit for me. She has agreed to be picked up tomorrow morning at eight-thirty. It is her last day here. Not many visiting celebrities would agree, on the last day of a short stay, to give up two hours to sit for a drawing. John is very sympathetic, too, and, when he and Iris are together, their

fondness for each other is unmistakable. He eagerly proposed that I exhibit my work in a gallery run by a friend of his in Oxford, where he and Iris live.

## 14 April 1978

In our sitting yesterday morning, Iris found it very difficult to look me in the eye. Indeed, she could not, would not, and kept moving her eyes away from me, and her head as well. Still, I felt myself acutely observed by her. Because of her restless elusiveness, I had to change into a whole other rhythm and, working very loosely, trusted the drawing to hold itself together. I did not, however, feel that Iris was refusing to cooperate. She was doing as well as she could something very much against her grain. Feeling a keen appetite to work, I rose to the challenge and even began to enjoy the drawing.

If she were an actress, Iris would be cast as "Cook." She is muted in sound and color, and her voice is like a low, softly slurred foghorn. The dusty-pale colors of her hair, complexion, and eyes could be matched by mixing tiny tints of pigment into a rich, opaque sap. Wrapped in black tenting to accommodate rather than disguise her shapeless bulk, she is built like a broad-trunked tree firmly rooted to the ground. Any overt or animated movement by her would seem incongruous, like a tree being rocked by an earthquake.

As I worked, I felt a growing harmony with her which went beyond my customary, instinctive identification with a sitter. My sense of our outward differences, of her restlessness and avoidance of my eyes, gave way to something which, touching a core of essential sameness within us, united us on another plane. I had an inkling that she shared this odd awareness with me, but there was no question of my speaking of it—we don't know each other well enough!

I did a second drawing, this time with her head turned away as she looked through the sliding glass door into the canyon. Still restless

but more at ease looking away from me, she noted the birds she saw and heard, a mockingbird and a jay. With less than half an hour for the second drawing and spurred by her gentle but firm promptings about time, I hurried as fast as I could. When I'd picked her up at eight-thirty that morning, John had emphasized my punctual return of her at eleven, but she had kindly stretched that to eleven-fifteen. So, minus the time for pickup and delivery, I got almost exactly the two hours I'd asked for.

Though Iris praised "the line" of the first drawing, she thought the second more like her. I agree, but like the first better as a drawing. More than a literal likeness, it has the feel of her. She noted, but only briefly, what she called its "gloomy look." After expressing a shy reluctance to mar them, she signed the drawings without objection but, prompted by her instinctive modesty, bunched her signature and date uncomfortably into a lower corner of each.

Chris had accompanied me on the drive to Westwood to pick her up for the sitting. He was acknowledging her generosity in agreeing to sit for me, and he likes her, too. I listened to their friendly talk in the car and felt that Chris was more in tune with her than she with him. After our sitting I rushed Iris into the house so that she could say goodbye to Chris. "Iris must leave immediately!" I called to Chris in his workroom. Though in the middle of a telephone conversation, he hurried down the hallway, and they embraced awkwardly. The dining room's mirrored wall reflected their opposing bulks (hers bigger than his) as they pecked each other on both cheeks.

Back at her apartment in Westwood, I entered the driveway and, stopping at the front door, kept the motor running. My instinct told me that I shouldn't get out and dash around to open her door, that such meticulous attention to "good manners" might seem unfriendly and embarrass her. "I know you have much to do," I answered when she asked if I would come in, her own observance of good manners making me regret that I'd not opened the car door for her. We then

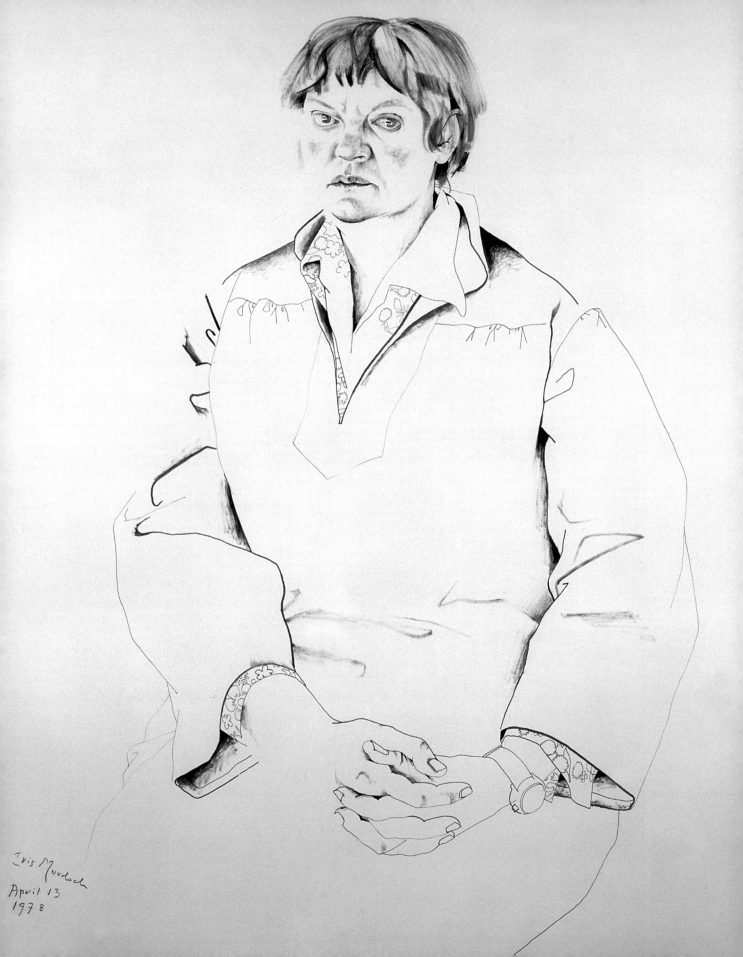

Iris Murdoch
April 13
1978

leaned toward each other and, instead of the cheek I was expecting
to be offered, I got two head-on, full-mouthed kisses. There was no
accident, no hesitation. She was expressing her liking for me with
firm decision.

I backed the car out of the driveway and, feeling the warmth of
our mutual fondness, exchanged a wave with her as I drove off.

As further proof of his gratitude for the time she gave up to me, that
afternoon Chris decided to go to the lecture Iris and John were giving
in a classroom at UCLA, and I went with him. Iris and John were ten
minutes late, and, before introducing them to the class, the woman
who had driven them apologized for their lateness and blamed it on
her difficulty in finding a parking space. Suspecting that, because of
me, they had been late throughout the day, I felt guilty, though I did
get Iris back exactly at eleven-fifteen.

Their lecture was on the novels of Thomas Hardy. John got up
to speak first, promising that "Iris" (they both referred to each other
by first name) would be speaking soon as well. He indicated that her
words would carry more weight, since she is "a noted practitioner of
the novel." Beyond respect and companionship, the tenderness be-
tween him and Iris, their profound appreciation of each other, glows
with a lively, durable strength.

Smooth, shiny, and very pale, John's perfectly shaped bald
head is fringed with wispy dark hair. With a pronounced, even ex-
treme, stammer—not improved, as some are, by public speaking—he
mouthed, spluttered, and yammered over the simplest and most often
repeated words, like "novel."

All the time he spoke, or tried to speak, Iris sat behind him on
his right and looked out the windows with an unseeing stare, the whites
of her eyes, rather than the irises, reflecting the light and giving her
an almost supernatural look, like one of the creatures in the movie *The
Village of the Damned.* Her habitual, instinctive preference to look away is

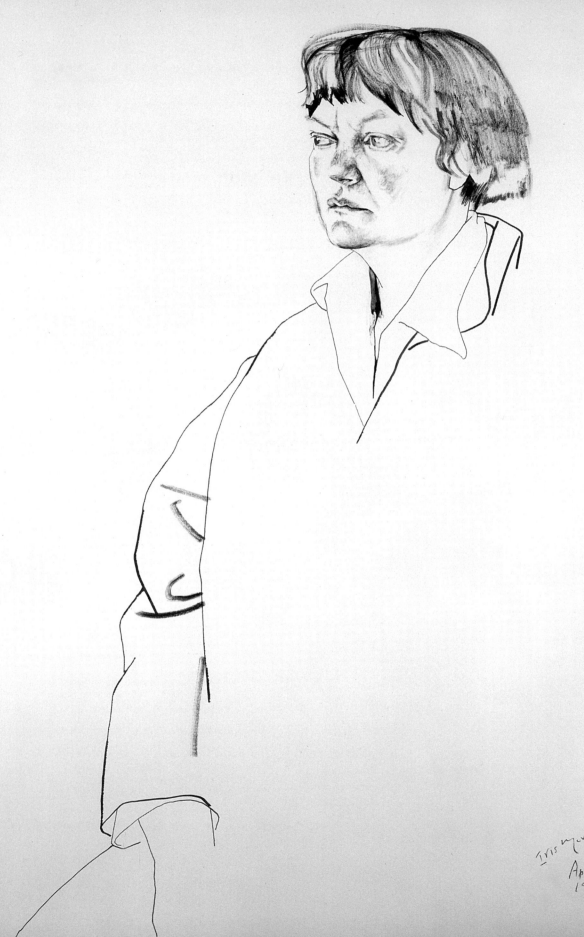

Iris Murdoch
April 13.
1978

an attempt, not to absent herself, but to obscure her visibility to others, to mask the intensity of her own perception of them. She might be tempted to run away, but her body can't move fast enough, and, trapped, she hears, sees, minds too much. It's her acute awareness, not of herself but of others, which makes her self-conscious.

Later, Chris, who loves Hardy, claimed not to have understood a single idea put forth in their lecture. When asking for questions from the audience, John had invited Chris to comment on what had been discussed with regard to his own work. I've seldom known Chris so embarrassed or tongue-tied. I know that he loathes from his bowels the academic approach to literature and longed to declare all he'd heard "pigshit," but he was checked by his politeness, and by his good intentions toward Iris and John.

# Henry Fonda

## 18 December 1979, Santa Monica

I went to draw Henry Fonda at his house yesterday morning at eleven. I arrived promptly, and, as I was removing my gear from the back of my car, Fonda came out of the house to greet me. He wore a red-and-black-checkered lumberjack's shirt, khaki trousers, and laced padded shoes like ski boots.

Once inside his house, we were stiff and awkward with each other. It was a warm morning for December, and he offered me something cool to drink. When I showed him my coffee thermos, I got (as I'd foreseen) a glimmer of approval from him for my independence and organization.

Inside and out, the Fonda house, what I saw of it, looks like a fancy new Mexican restaurant. A clutter of idle furniture adds to the futile toniness of the big living room and a long, narrow corridor which wanders off from one end of it. When Fonda asked me to decide where we were to work, I chose the corridor because of the strong morning light which filtered through the thin white curtains at its windows.

After assembling my custom-made portable drawing bench (I'd also foreseen Fonda's admiration of it), I said that I was ready to start. The narrowness of the corridor meant that when Fonda sat down in the upholstered chair opposite my bench, we were closer together than I'd anticipated.

"Would you like me to be immobile," Fonda asked, "or to talk?" It seemed disrespectful, even impertinent, to demand that Henry Fonda be immobile, but, since the word was his, I chose it, though I tempered it by adding: "at least for the first thirty or forty minutes—

they're the trickiest." He was as good as his word and, as I requested, looked me in the eye without objection. His flawless cooperation as a sitter I had again foreseen, because it was the best way to put me on the spot. Now, I had to deliver, to justify not only taking his time and demanding his immobility but my very presence in his house.

My image of Fonda as a strict fundamentalist-type American who dislikes fags dates back to the mid-fifties and my first encounter with him at a Beverly Hills cocktail party, where he was among the many distinguished show business guests and Chris and I were the only homosexual couple. When we were introduced, Fonda had made clear his disapproval of me by giving me a stony look and then abruptly turning his back to avoid shaking my hand. [Chris was usually spared such overt demonstrations because of his age and literary reputation, but, in my early twenties and looking much younger, and with little reputation beyond my position as Chris's boyfriend, I was a prime target for the homophobia lurking at social occasions we attended together.] So I was amazed when Fonda came up to me at a recent party to tell me that he much admired my drawings of George and Joan Axelrod and their daughter Nina, which he'd just seen in their house. I wasn't tempted to ask if he remembered our first encounter, but I had the presence of mind, and the daring, to use the moment as a cue to request a sitting with him.

I didn't know until I began work and found my hand shaking (it continued to shake for twenty minutes) the full significance for me of this confrontation with Fonda, his august persona even more formidable with age. Now, despite our heterosexual-homosexual opposition, we were united by our subject-artist roles and faced each other man to man. For me the event had the grandness of heroic combat.

Fonda moved only twice during more than two hours of our intense work, both times in response to something I said to him. When I first spoke, about twenty minutes into the drawing, to tell him that I had drawn his eyes, he jolted out of his almost trancelike state with a

sudden involuntary spasm. Startling me into near-paralysis, his violent physical reaction was caused by a combination of his deafness and my deferential soft-spokenness, and also by surprise, since in our long vigil verbal exchanges were rare.

"What did you say?" he asked as he leaned forward to put his head close to mine, a toothful but mirthless grin on his face, and he did exactly the same about an hour later when I spoke to inform him that I was about to draw his hands. Each time it was as shocking as a scene in a horror movie, a corpse suddenly coming to life with a ghoulish leer.

But it was only Fonda's surface stillness and the death-skull look of his head which suggested something corpselike. Within his stillness, behind the death mask, I noted, as well as the vitality of his attention, the dignity of his firm contemplation of the inevitable.

As my drawing progressed, I worried first that it wouldn't look like him, then that it would look too much like him. Still without hair or ears, the face emerging on my drawing paper seemed shockingly old and haggard, but, even if I'd wanted, there was no way to avoid the ravages of age. They had become an essential part of him, and I almost regretted my black ink wash because it robbed me of the opportunity to render fully the vivid war being waged in his face, the valiant but fragile blue of his old eyes pitted against the pink-purple blotches and yellow-brown spots of his complexion.

Once I'd finished the drawing of his head, its look of extreme age was softened, but, even so, Chris, when I later showed him the drawing, remarked that Fonda looked as though he'd had a stroke. Fonda does have a pacemaker. It is probably responsible for his oddly timed speech and breathing, and also for his stiff, jerky movements, which, ironically, are reminiscent of the mechanical effigy of Abraham Lincoln at Disneyland. Forty years ago the young Fonda impersonated Lincoln, and now the old Fonda simulates a mechanical facsimile of him.

By the time the drawing was done, Fonda's left leg, crossed over his right for two solid hours, had to be lifted with both of his hands. Getting to his feet with difficulty and standing stiffly, he waited patiently to be invited to look at the drawing. I have the impression that initially he looked only at the lower half of it, perhaps because his first words expressed admiration for the drawing of his hands. Only gradually taking in the whole drawing, he finally declared: "I love it." When I asked him to sign the drawing, he practiced writing with my pen at a nearby desk and returned with a reproduction of a delicately rendered drawing of his own. (He is a gifted amateur artist.) His odd drawing was of a printed paragraph of words magnified by a rectangular hand glass positioned over it. "My daughter," he told me, "had these reproductions printed and is selling them to raise money for one of her causes."

"I wish Shirlee were here to see the drawing," he said only a moment before a clatter of heels on the living room's tiled floor announced her entrance. "You *must* remember," she was already scolding him, "with a pacemaker you have to keep *moving*." (If she but knew how still he'd been, and for how long!) "Oh boy, you got those Fonda hands," she said to me as she inspected the drawing, "and the pinhead on top of that funny big body." His unfazed acceptance of her frank physical appraisal of him implied a seasoned intimacy between them. With imposing mounds of dark hair, a slim body in a dark, trousered suit, and taps on her boot heels, their metallic staccato a counterpoint to her voice, she drolly transcends her role of the young-wife-turned-boss, whose vigor gains as her mate's dwindles.

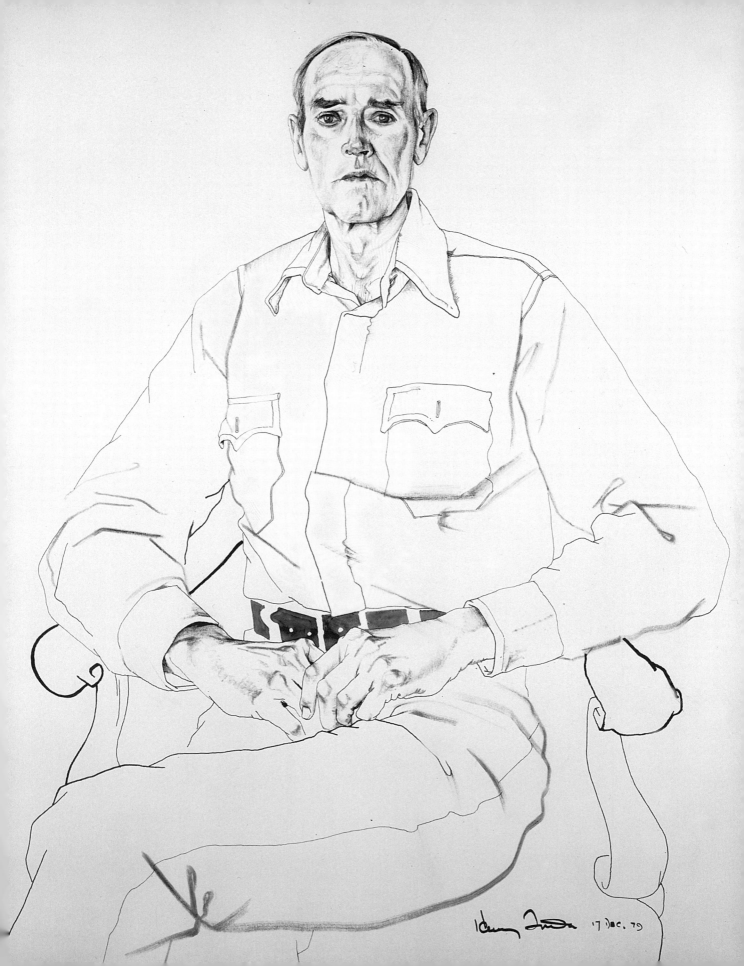

# William Wyler

## 21 July 1980, Santa Monica

I've just returned home from a sitting (my first proper one in almost four weeks!) with William Wyler in his Malibu house. At John and Joan Houseman's party on the twenty-fourth of last July, I made my first request for the sitting to Mrs. Wyler, and it has taken almost exactly a year of repeated telephone calls to set it up.

We worked in the downstairs living room of the Wylers' cozy, old-fashioned beach cottage, and I was much relieved to find him a cooperative and patient sitter. Looking me in the eye without any reluctance, he sat relatively still, especially for someone of seventy-eight, and took only one brief break and a second even shorter one over the full two-hour stretch. His deafness makes conversation almost impossible, though I did venture to praise *Carrie*, which I'd seen at the art museum on Saturday night. After telling me that the movie had been a big failure at the box office, he added that the shortening of Dreiser's title, *Sister Carrie*, was a studio decision he regretted. He then mentioned that "somebody else" had recently made another film called *Carrie*.

I also told Wyler that I admired his movie of *The Little Foxes*. He accepted my praise with mild gratitude and then, after a moment's musing, said: "Poor Bart Marshall's dead now. So's Pat Collinge. Dick Carlson and Dan Duryea, too. I guess there's nobody left from that film." I paused a moment before I dared to say, my hesitant tone making my statement sound almost like a question, "Bette Davis is still going." "Oh yes, Bette," he said, "sure, she's still going. I'd forgotten about her."

Neither Wyler nor his wife, who entered the house in the middle

of our sitting, had remembered that I was coming today. Sticking in the gate when I arrived was a form note from a telephone man who'd been and gone. Wyler probably hadn't heard the doorbell. I'd had to ring several times before getting his attention. When finally he came to the door and discovered both me and the note, he assumed that I was the telephone man. As soon as he learned why I was there, he excused himself to go upstairs to shave and surprised me by journeying to the second floor in a motorized chair. To the sound of its loud electrical hum, I watched him make his slow, passive ascent, his slippered feet the last part of him to disappear from my view.

The only event of note during our sitting was a silent but potent fart from an old black dog called Alex, who lay on the floor behind Wyler's chair. Concerned that I might think the fart had come from him, Wyler reacted with exaggerated indignation and, sending the decrepit dog into the next room, said to me: "He let one go. Can you smell it?"

Wyler liked my drawing and said that he recognized himself. Mrs. Wyler reappeared, and even she gave her approval. Wyler then photographed the drawing and asked me to stand behind it for a couple of exposures. He had recently bought his Nikon camera in Hong Kong and explained that his "clumsiness" with it was due to unfamiliarity. Age and deafness have imposed involuntary seclusion on him, but, at least while he's alive, nobody will dare to think he doesn't know how to use a camera, or dare to mistake an old dog's fart for his own.

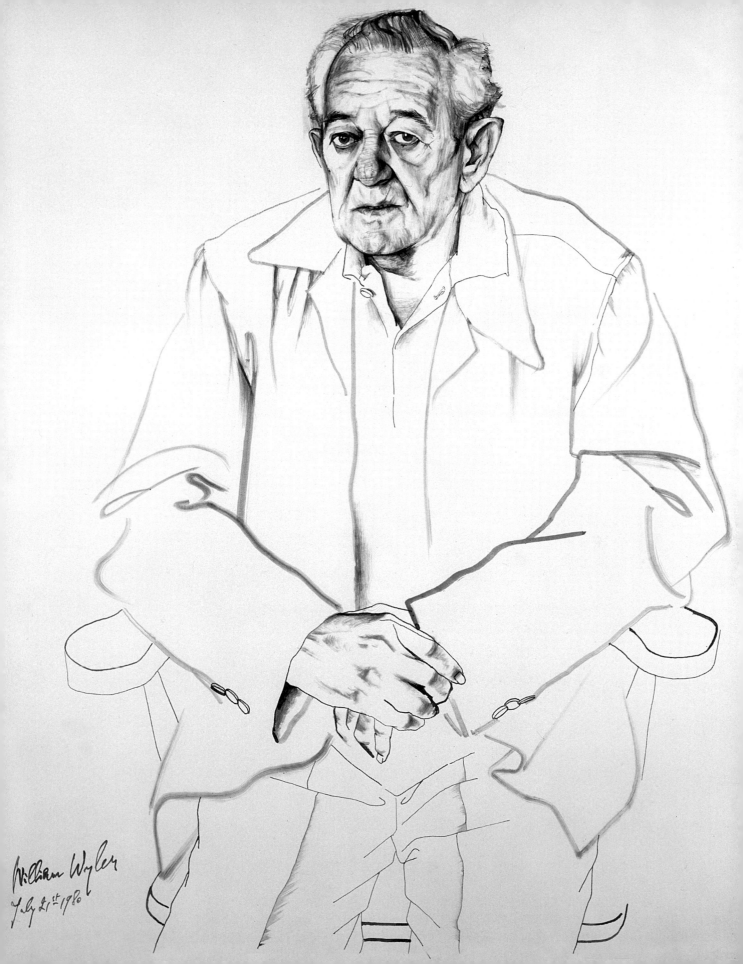

William Wyler
July 21st 1980

# Vincente Minnelli

## 23 November 1980, Santa Monica

On Friday I drew Vincente Minnelli in his house in Beverly Hills. We worked in the room which Mrs. Minnelli calls "the office" but which is really where they watch television. She told me on the telephone to come to the side entrance off the driveway. The door was opened by a manservant in a white jacket. Minnelli himself soon appeared and led me through the first floor of the house, which is like a vast restaurant from the forties that has been sealed up for years, but meticulously maintained. In the large living room, he paused to point proudly to an oil portrait of him done recently by "the only painter allowed to work in the Vatican." The painter had used Botticelli's studio, Mrs. Minnelli later informed me. Those august surroundings, alas, had communicated none of their numinous power. The portrait is sweetly characterless and ineptly painted. "Liza loves it," said her father.

Mrs. Minnelli asked me to come at two-thirty, and I began work shortly before three, too late for ample light this time of year. Minnelli and I were both nervous but, neither caring to admit it, relied on our professionalism to fortify us. Minnelli mustered his maximum concentration, which is still considerable, and made no show of resistance. He sat almost motionless for nearly two hours and asked only for one brief break to swallow some coffee. He looked me in the eye, too, though such confrontation does not come easily to him.

I had trouble beginning the drawing. My first marks all seemed like approximations. Suddenly guessing my problem, I took from my shirt pocket a new pair of glasses and for the first time worked while wearing prescription lenses. The shock of seeing, *really* seeing, was so invigorating that it transformed the act of drawing into a joyful re-

exploration of what seemed an almost forgotten experience. It is my near vision which has deteriorated, so it was the marks I made on my paper which particularly jumped out at me.

Throughout the drawing I dreaded Minnelli's disapproval because, with no choice as usual but to draw what I see, I had faithfully recorded the wide-eyed, almost crazed stare which he had maintained all the time I worked on his eyes. So I was relieved when both he and Mrs. Minnelli professed enthusiasm for the finished drawing, though I heard a faint hint of perplexity in a later comment she made, "I've never before seen Vincente with his mouth open—smiling, yes, or closed, but not just open." Anxious to seem pleased, however, Mrs. Minnelli offered me a drink after he had signed the drawing.

She then left the room to get the drink and didn't return with it for nearly twenty minutes. During her absence he turned on the TV and sat passively watching it. He seemed so enervated by the long ordeal of being drawn that he hadn't the strength to do anything else. I flipped through *The Films of Vincente Minnelli,* which lay on a cocktail table along with a magazine containing a long essay about him and his work. There was also a book of a woman's photographs of American movie directors, which included a poor one of him. I gathered that the prestige from his past work gives him much-needed reassurance.

Through the distracting drone of the TV we spoke occasionally, but he has trouble finding the word he wants, and sometimes doesn't find it. I got the impression that the word exists in his head and, rather than just responding to a vague inclination to speak, that he is making a specific effort to search for it. He still has something to say, even if he can't always say it.

Mrs. Minnelli finally returned with my drink, and I sat with them watching the five o'clock news. Though between the two she is definitely the one in charge, their behavior with each other is mutually and patently affectionate. Killjoy that I am, however, I couldn't help being suspicious of their sweetness to each other. It was somehow

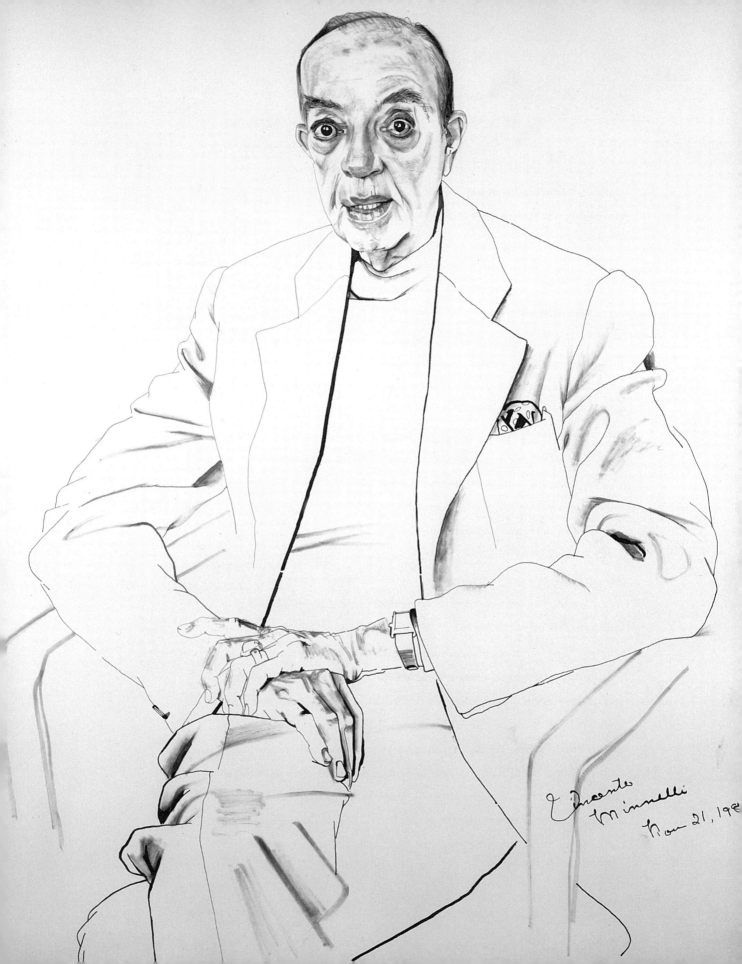

Vincente
Minnelli
Nov 21, 198

tainted with the fear of death, like a last-ditch attempt to reform. As I sat with them, I was intensely aware of age. The Minnellis' expression of it—rich, muted, kindly, prudent—is far from the near-total capitulation of my mother, who now survives on the animal level alone, and farther still from the amazing vigor and resilience of Chris, who is still curious about experience in all of its manifestations.

## 4 December 1980

Mrs. Minnelli telephoned the other day to tell me frankly that they do not like my drawing of him. She cited the "staring eyes" and "open mouth," which, rather than inappropriate or undesirable, she called "untrue." If untrue, where did they come from? My demented imagination? Would that it were so fertile.

Since they hadn't asked for a photograph of the drawing, I hadn't sent them one, so this belated reaction of theirs has been stewing since the day of the sitting. Mrs. Minnelli's call must have been prompted by the receipt of my letter to him, in which I sincerely thanked him for his kind patience and cooperation. I also wrote that I am still uncertain about what I think of the drawing (not true, I *love* it), but am intrigued by its "unusual intensity."

I told Mrs. Minnelli that, of course, I would not exhibit the drawing. ("During his lifetime," Chris added when I was telling him of the call later.) But I realized that she wanted more from me. Then suddenly I knew that she was hoping that I would do another drawing of him, but didn't want to suggest it herself. Perhaps she feared that such a suggestion would sound too much like a commission, and I might then expect her to buy the drawing. "I'd be delighted to try again," I told her truthfully, "if Mr. Minnelli would be willing to sit a second time." She immediately responded, and we made another sitting date for mid-December.

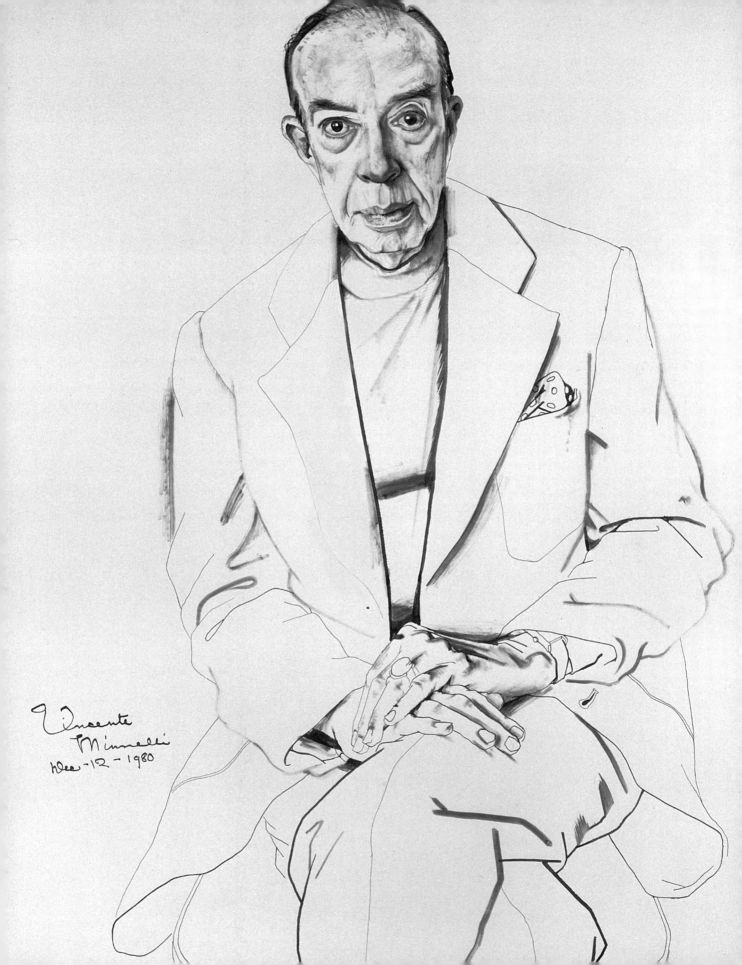

Vincente
Minnelli
Dec-12-1980

[I did do a second sitting with Minnelli, on 12 December 1980, but wrote nothing about it. His concentration and stillness were as flawless as at our first sitting, and he was very careful to keep his eyes from staring and his mouth shut. This time both the Minnellis were sincerely delighted with the drawing. As a likeness and as a drawing, I am as pleased with the second as I am with the first, but, forcing myself to choose, the first drawing is still my favorite. Partly because of its stare and open mouth, it isn't quite like any other drawing of mine, and it reveals a delicate sensitivity in Minnelli which, to me, is essential to his character. Also, the drawing has a lot of what I care most about, a real aliveness. In this case, it's startling.]

# Laurence Olivier

*4 June 1981, Santa Monica*

I only dared to ask Larry to sit for me when I was fairly drunk, after dinner with Chris and him at Don the Beachcomber on Wednesday. Richard [Olivier, his son], who arrived at the end of our meal for a late snack, backed my request and quickly proposed bringing Larry to my studio on Sunday. Despite recurrent doubts during the intervening three days, I felt almost sure that Larry *would* come. Early last year, at Larry's urgent request, Chris had used his influence at UCLA to help with Richard's sudden mid-term enrollment in the theater department there. It was therefore appropriate (as all four of us tacitly agreed) that Larry be allowed to show his gratitude to Chris by sitting for me. So Richard, on his way to a Sunday rehearsal at UCLA, did indecd deliver him to my studio promptly at eleven-thirty.

Though the light is best on the second floor of my studio, I had moved my drawing bench to the ground floor so as not to tax Larry's stiff knees with a climb up and down the steep stairs. Soon after his arrival, he complained of feeling sleepy because of some medication he was taking and asked for coffee. With an apologetic explanation that it would save precious working time, I offered him freeze-dried instant. He easily accepted my offer, and I made the coffee by using the boiling-water tap in my studio.

Larry's mention of sleepiness immediately intensified my dread of the sitting. I'd foreseen the possibility of his restlessness and discomfort, but not his falling asleep. Oh, how I quail and suffer in anticipation of these sittings with the famous. But there's also an excitement in daring the almost impossible, and, if I'm successful, a sat-

isfying sense of accomplishment. Giving and receiving such peculiar torture must indicate a sado-masochistic streak in me.

While drinking his coffee, Larry told me that he had declined David Hockney's request for a sitting. "Why?" he mimicked David's response to his refusal, and caught David's tone of innocent incomprehension: Why shouldn't Olivier sit if he has been asked by Hockney? (Having learned about the old and the grand from Chris, I fancy that I know how to handle them better than David.) "I told David that I no longer have the patience nor the stamina to sit. So you see," Larry nodded at me with mock gravity, "what an occasion this is." He knew that I was charmed and flattered, but did he know that my apprehension about our sitting had tripled? Possibly.

Larry was wearing a pale blue jacket, dark gray trousers, a white shirt, and a shiny pink tie with stripes of silver and dark green. With his florid, almost magenta complexion and the furze of thin white hair on his head, he looked moribund, like a frostbitten yam. On the tricky descent from the carport to my studio, his English fondness for gardens prompted him to ask the name of the tree growing beside the stairs. To my "pittos*por*um" he retorted, as if getting it right for the record rather than correcting me, "pit*tos*porum." But, in case I felt quashed, he added almost as an aside: "I believe that's the usual pronunciation."

Larry sat for two hours without a break. At first he moved his head and shifted his body so much that I wondered if I could draw his eyes level with each other. Calmer by the time I had finished his eyes, he asked me if he might rest his head on his hand. I readily agreed, hoping that whatever made him more comfortable would help me, too, but I dreaded the delicate challenge of drawing a face supported by a hand. To draw his hand the right size in relation to his face, and to keep his hand still enough to capture the subtlety of its supportive position, and all this without the option of erasure—*very* risky. Trying

not to worry about his hand until I got to it, I continued drawing his face, which, by itself, presented more than enough problems.

His unreflecting eyes have always hampered him as an actor (at least on film), and now they are further compromised by the dulling opacity of age. Dark brown or black when he was younger, the irises of his eyes now have a pale bluish-gray edge. Like Mary Astor, he probably got his "klieg eyes" from working in movies in the early days, when the sets were lit by klieg lights. After repeated exposure to them, the color of the dark iris (perhaps only dark-eyed people are prone to the condition) begins to fade from its outer edge toward the center. Gradually reduced in size to a band circling the pupil, the remainder of the dark iris begins to look more like part of an abnormally enlarged pupil. A pale-eyed Olivier with large pupils jars uncomfortably with his familiar image.

In profile Larry's nose is still handsome, but in a full-face view it is a shapeless magenta mass. The bristly white stubble of his eyebrows and mustache are a real drawing problem, too. To darken the complexion tone (to make each hair appear white by contrast) is a time-consuming task, but, if the complexion tone is kept light, any marks on it to denote hairs are likely to look more like dark rather than light hairs.

The cruel, thin line of his mouth is the real key to Larry's face. With just a stomp dipped in ink wash, I surprised myself by quickly drawing it in one continuous stroke without any accents from pen or brush. I then drew his jawline, both firm and lumpy, then his perfectly shaped balding head. The subtle relationships between facial features and head size are crucial to a likeness, and their accurate rendering is made more difficult by a bald head. Larry's already offers a particular drawing problem because of its surface covering of white furze.

When informed that I was ready to begin drawing his hand, Larry adjusted it to a position which he thought he could hold, and did,

without a flinch or the smallest turn of a finger, until I'd finished with it.

Though I might wreck the drawing at any moment, the daring of working in irrevocable ink at a one-chance-only sitting exhilarated me, and my confidence in my control gained in pace with Larry's increasing stillness and concentration. Now he was fully open to my inspection, and I could actually feel the warmth of his energy and support. Whatever the job, he can only give his best, and he treated me as a professional with a standard of performance as high as his own.

Yet, we talked almost without stopping: of Strindberg and Geraldine McEwan; of the first time he acted with Joan Plowright (in *The Entertainer*); of Holman Hunt and Rossetti. At Holman Hunt's table, he told me, Rossetti was so absorbed in his own admiration and curiosity that, in order to inspect the china mark on its underside, he absentmindedly turned over a full bowl of soup. The story, which Larry said had amused him for many years, was a staple of his storytelling persona.

When I declared that I was finished with the drawing, Larry moved with great difficulty from his chair and, slowly stretching out his bent arm, stiffly lifted himself up. "A good portrait that is," he said upon first inspection of the completed drawing, "a very good portrait. Of course I'll sign it." He took the same pen I'd drawn with and, after rehearsing a couple of times on a scratch pad, signed "Olivier" with the date under it. Turning the signature into something especially for me, he pointed out a peculiarity he indulges in when signing his name: the inclusion of four little dots, two on each side of the tail descending from his "r." Like an intimate inscription in code, he made it his private reward to me for a job well done.

Upon his arrival Larry had explained that he'd made lunch plans with Jean Simmons, "since," he added teasingly, "I wasn't invited to lunch." I was sure that I had invited him but didn't press it, saying I had perhaps only mentioned to Richard that of course Chris and I

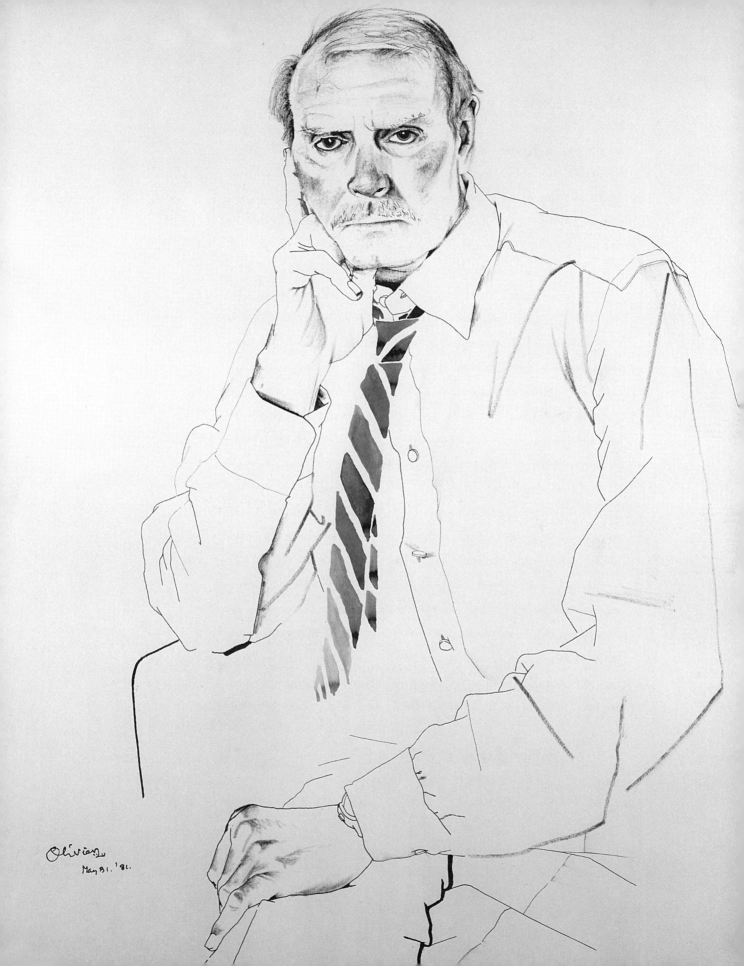

Olivier
May 31. '81.

would give him lunch. To myself I figured that he might well prefer to be with his "Jeanie," whom he had not yet seen on this trip. He gladly accepted my offer of a drink, however, and my offer to drive him to Simmons's house [which is on the same street as ours]. He asked if he might call her. I took him to the telephone in Chris's workroom and then fixed the gin and tonic he'd asked for. After making his call, he joined Chris and me in the dining room, and the three of us stood chatting and sipping our drinks. To spare the tabletop a wet ring which might mar its finish, Larry inconspicuously but carefully placed his drink on one of several gallery announcements lying on the table.

Maybe Larry forgot my offer to drive him to her house, because, while he was in the bathroom, Simmons arrived. "My daughter's waiting in the car," she said to excuse herself from entering the house. We were standing next to the open doorway of my studio and, perplexed at her unfriendly reticence, I impulsively invited her to see my drawing of Larry. Until I'm certain what I myself think of my work, I never like to show it to anyone but Chris. But I was relieved that the sitting had not been a disaster, and my belief that I'd done good work urged me to share my high spirits with Simmons. Her cool, perfunctory praise made me regret my rashness. "I'll tell Larry you're here," I said briskly to cover my chagrin, and noted to myself that the yellow sun hat Simmons was wearing matched the color of her teeth. I returned to the house and helped Larry up the steps and the concrete ramp to the street where, in an open car, Simmons waited with her daughter in the hazy half-sunshine. Larry and I embraced each other before he slowly settled himself in the front seat next to Simmons and was driven away.

# Julian Schnabel

To draw Julian Schnabel yesterday in his room (475) at the Beverly
Hills Hotel. I was pleased as well as a bit surprised by his serious atti-
tude to sitting for me. He looked me in the eye with no hesitation or
embarrassment. He also apologized when his eyes watered and he had
to close them. His Belgian wife, wrapped only in a small white bath
towel, came in and out of the room occasionally but spent most of her
time sunbathing on the balcony. Her slim prettiness is accentuated by
a cool sensuality. Schnabel clearly adores her. He calls her "Sweet" and
is careful of his tone with her. In the middle of the sitting he got up
to answer the door rather than tell her to do it. He also found himself
a "bearable" musical station on the radio rather than trouble her and
only suggested once that she might, if she'd care to, improve the tun-
ing. He was wearing nothing but a light blue button-front shirt and
white Jockey shorts when I arrived, his strong stocky legs and big, pale
bare feet very un-Californian-looking. He put on a dark blue pair of
trousers for the sitting and left bare his big but not ugly feet.

 While drawing him I was struck by his strong resemblance to the
young Don Ameche. He probably hasn't even heard of Ameche, so I
kept this to myself. I'm glad that I did because, when the drawing was
finished, he mentioned that several people had told him that he looks
like Richard Gere. Suppressing any hint of surprise, I answered: "I
know what they mean." They mean that Gere has small eyes, too.

 I like Schnabel's openness and lack of caution. He is confident
of himself and enthusiastic about his own work. He spoke of his excite-
ment at painting outdoors, which he says helps him to keep his attitude
to his work fresh. He wanted to know if the paper I was drawing on

had "a plate finish," a question only an artist would ask. When I told him yes and added that I like working on very smooth surfaces, he agreed and mentioned his use of actual plates for a painting surface. I then told him of my habit of staggering sheets of plate finish with ones of kid finish, to keep the drawing experience continually different and to accentuate my special enjoyment of a smooth drawing surface. He identified with this immediately and said that he often engages in unusual practices when working to shock himself into keener awareness. I like his appetite.

He suggested while I was still drawing that Chris and I might want to come to a cocktail party for him, given by a Barry Lowen, that same afternoon. Wanting to know his reaction to my drawing of him before I committed us, I told him that Chris "usually" stops work by five o'clock.

When I had finished the drawing, his response to it was guarded at first, then gradually more enthusiastic until, finally, he was admiring "the windows in my eyes." His comment implied that his eyes were every bit as responsible as I was for their presence in the drawing. (Come to think of it, he's right!) He said that he liked "the openness" of the drawing, the consistency of line. The only thing he didn't like was the "irregular" line of the hotel chair-arm, but then a moment later he defended that as a perhaps necessary "foreign element." All considered, I thought his responses to the drawing were quite generous enough to merit the effort of our attendance at the Lowen party, so when I got home I alerted Chris to the unexpected invitation and we did go.

When I asked Schnabel to sign and date the drawing, he instantly became cautious, almost suspicious, just like Andy. [In 1970 Andy Warhol sat for me. When I asked him to sign and date my drawings of him, I believe that he, like Schnabel, instinctively worried that I might try to sell my drawing as a self-portrait by the subject and cheat him out of some money. But at least when he did sign, Schnabel's writing

was clear. Warhol's, when he at last agreed to sign, was perfectly illegible, and he insisted on putting it on the reverse of the drawing.] Schnabel finally agreed to sign when I explained that I asked all of my sitters to do so, but once he saw his signature and date on the drawing, insisted that I sign it, too, right then and there. I had already told him that I generally put off signing my drawings for as long as I can, but then I thought, why be so rigid? To the great satisfaction of both Schnabels, I took brush in hand and signed my name. In unison they both sighed with relief.

When I looked at the drawing at home later, I decided that it is okay but somewhat below my usual standard. I had felt tense and uncertain while doing it and was never overtaken by the joy of confidence. My stand-in did most of it for me. Though Schnabel twice admired my handling of his hands in the drawing, I consider them its weakest part. Before I had finished drawing his hands, he had changed the leg on which they were resting and thereby irrevocably altered their position.

In the car today I decided that there is something obscene about Schnabel's looks. With his tapered snout and bright, beady little eyes, he has a rat like grossness. The outward bulges of the combed-back hair at his temples even suggest a rat's ears. His animal rat-look, combined with his aura of talent, fame, and money, produces his peculiar sexuality. He's an eager rat, too, openly munching his success and liking the taste of it. He's also a rat who's been conditioned, because when Dagny introduced us at her opening party [Dagny Janss Grant runs an art catalogue business and had just opened a shop in West Hollywood], his visible and audible reaction was quick enough to seem involuntary. (I remember thinking at the time that I wasn't certain whether he was responding to me as an artist he'd heard of or as the heir to the Bacardi rum fortune!) Two days later I went to his opening at Margot Leavin's gallery with the firm intention of asking him to sit for me.

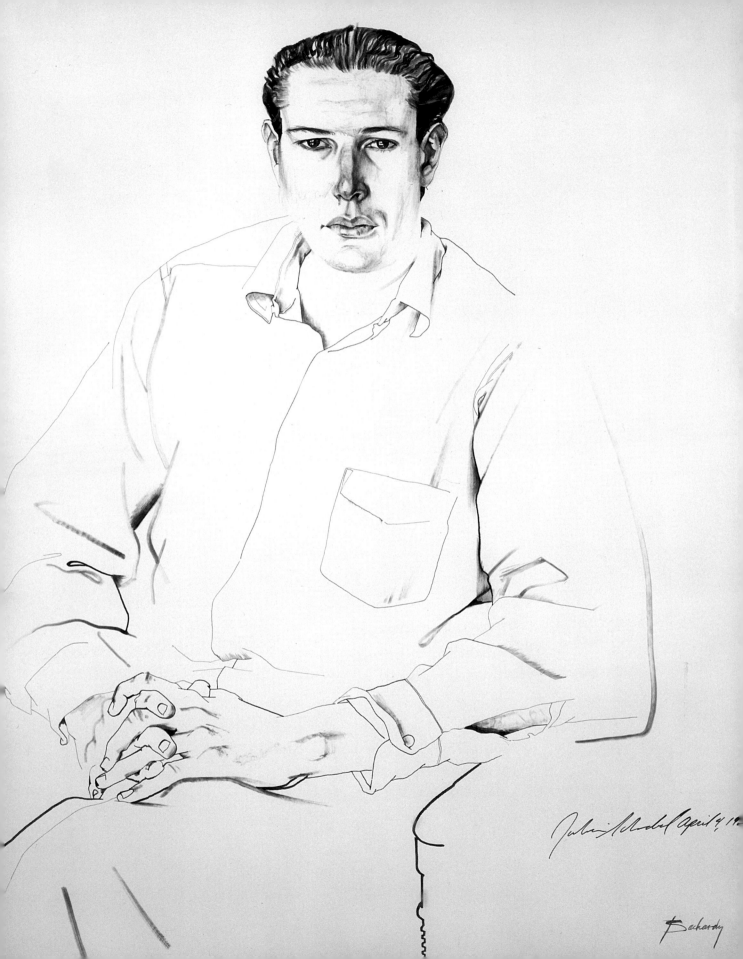

When I telephoned him at the hotel the next day as he'd suggested, he agreed to come to my studio early that same afternoon. That meant that I would have to hurry my sitting with Ricky Bougere, whom I was painting at ten-thirty in the morning. I did hurry, and the pressure caused me to do an unusual painting which pleased both Ricky and me. While we were working, Schnabel telephoned to ask me to come to the hotel instead. I happily agreed, relieved not to have to show him my studio. (I'm always uneasy when an artist comes to my studio to sit for me. I can't help noticing how he responds to my work, or, worse, fails to.) Also, since we would be working at the hotel, there would be no chance that Schnabel might catch me (like a faithless lover in flagrante delicto!) painting Ricky. I guessed, too, that he would have brought his wife with him for protection from a possibly lecherous artist's slobbering advances. I didn't want the weight of wondering what she was doing while I was trying to work. I foresaw Chris getting stuck with her in the house.

# Ellsworth Kelly

*26 May 1982, Santa Monica*

After many telephone calls and tentative arrangements, Ellsworth Kelly called at four o'clock yesterday afternoon to say that he was free to sit for me. I gave him directions to the house, and he arrived at four-forty-five. As I made the iced coffee he asked for, he looked at the pictures on the walls. He singled out the Paul Wonners, the swimmer and the still life with paper cups, for special praise. He even quickly identified the small oil in the kitchen as another Wonner. I was impressed by his eye. He also showed interest in the Hockneys but without praising them.

Caution is the key to Ellsworth's character. He filters his experience to locate hidden dangers which might threaten him. He foresees possibilities, marks developments, makes plans based on contingencies. His decisions for action are tentative, fluid, some long-range but not cognized as such, some apparently spontaneous but actually the result of unconscious deliberation. After our sitting he came into the house and, over a long, strong Beefeater martini I made for him, told Chris and me a story of how he missed a romantic encounter with a young red-headed Jew in the South of France more than thirty years ago. He admitted that he had feared his money and his passport would be stolen. Aware of his own deep-rooted cautiousness, he knew that he was telling us something *on* himself and, therefore, something *worth* telling. He was establishing intimacy by talking about himself, by openly sharing his self-analysis with us.

My drawing of Ellsworth took about two hours and twenty minutes, and I nearly ran out of daylight. Patient and still throughout the sitting, he didn't even ask for a break. I made no objection to his

talking while I worked because I guessed that talking relaxes him. He talked about drawings—he especially likes Rubens' drawings—and Jasper Johns, of whom he claims to be a bit frightened. He reported that Irving Blum told him that Johns had admired a recent blue painting by Ellsworth in a group show at Blum's gallery. Ellsworth said that Johns has never praised him to his face and, in fact, sometimes behaves quite brutally to him. He imitated Johns' firm, impatient tone on one occasion when Ellsworth was fretting about something: "Oh, that's just *you*, Ellsworth!" I like his frank delight in being told that Johns had praised him.

He also talked about *The Road Warrior*, cautiously at first until I told him I'd really liked it. Then he admitted to liking it, too, and even to being thrilled by Mel Gibson.

Ellsworth declared my drawing of him "flattering." "A crime I'm rarely accused of," I remarked. He also said that I had got a lot into it and especially noted that I had caught the curve of one half of his upper lip and the straight diagonal of the other half. "I've drawn that myself in my own self-portraits," he said, "but in reverse of course. The curve and the angle are like the basic elements of one of my paintings." That comment told me a lot about him and increased my liking for him. It is silly—his "but in reverse of course" in particular—and, at the same time, true—the curve and the angle of his lip *are* like the basic elements of one of his paintings, though it strikes me as a somewhat absurd analogy. The comment is also characteristic of his style, a sophisticated mixture of intelligence and vulnerability, of candor and a certain innocence, whether genuine or not.

Many artists have shown a real reluctance when I've asked them to sign my drawings of them, and, usually, the better-known the artist, the stronger his resistance. Warhol and Schnabel come quickly to mind, and now Ellsworth. Where should he sign? In the lower right-hand corner where I suggested? "And spoil that very nice space?" he tactfully inquired. (Tact is one of his tools for getting his own way.)

He finally chose the bottom left corner, too near the edge of the paper I thought, and printed his name and the date rather than supply his signature. I made no objection and just let him do what he wanted. Perhaps I should always let my sitter choose his own place to sign. It would be more revealing of him, and, since my work is intended to reveal its subject, every bit of revelation is pertinent, whether supplied by artist or subject.

In spite of his large frame and the impression of size he gives, there's something indecisive about Ellsworth's behavior which brings out the feminine part of his nature. But, while he vacillates and dithers, he also has an air of standing slightly to one side and observing himself, not so much with amusement as with pleasure at the amusement he is giving you. And that is both endearing and disconcerting. To observe you, to discover who you are, he throws you off guard with his charming performance of dithering. He might even tempt you to feel superior to him, but beware of making such a mistake.

I could see that Ellsworth was impressed to be with "Isherwood." I'm sure that's why he agreed to sit for me. Over his martini after the sitting, Chris was the focal point of his projection, though he was careful to give me intermittent eye contact. I was actually relieved to be allowed some rest from paying full attention to him and in my mind told him: "It's all right, Ellsworth, you can give it *all* to Chris now. I had my share this afternoon."

But I do like him, and I feel the possibility of real contact with him, which, God knows, I can say about precious few other artists I know.

An afterthought: In Chris's workroom, which Ellsworth was keen to see, he praised highly Chris's 1954 photograph of Wystan [Auden] and me, which stands in a silver frame on Chris's desk. He was especially impressed by the dramatic composition, which he said reminded him of one of his own. There it was again, that open self-enthusiasm which I find candid and inadvertently sympathetic. When I praised his

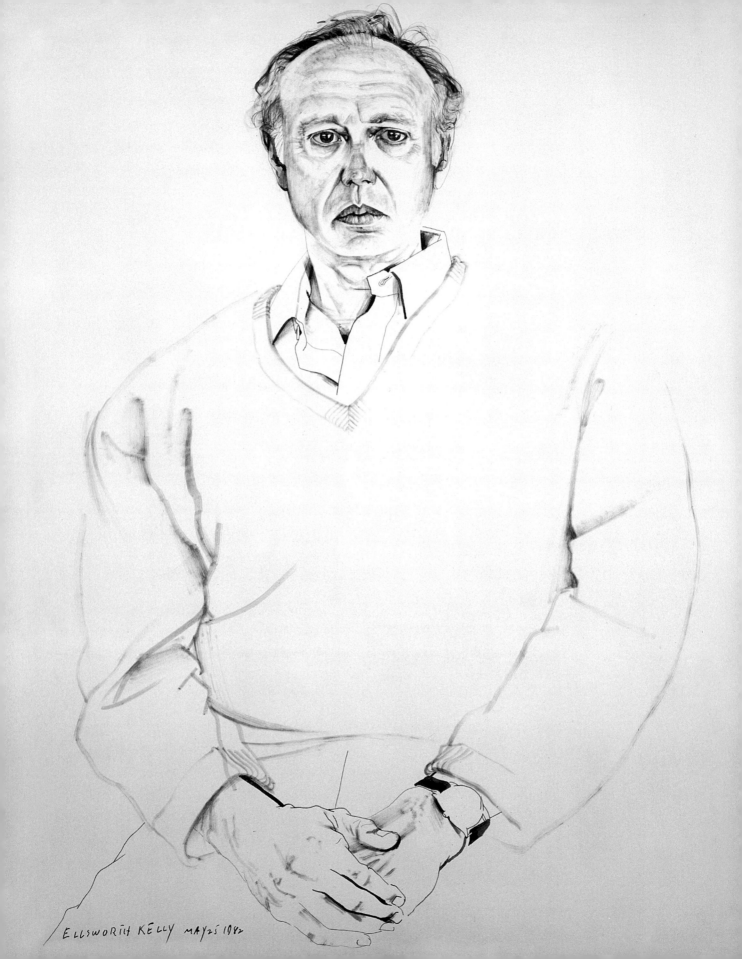

ELLSWORTH KELLY MAY 25 1982

black and white prints at Margot Leavin's gallery, he said he would give us "an S.P." (a special proof I presume) of the one I had singled out. We shall see. If so, I will give him a print of the photograph of Wystan and me, and maybe even a limited-edition copy of *October* [a collaboration consisting of thirty-one diary entries by Isherwood and thirty-one drawings by me executed in the month of October 1979 and published in 1980 by Twelvetrees Press].

I have nearly forgotten to note that there is an odd physical attractiveness to Ellsworth. His "psycho-physical" [a term used by Isherwood and Bachardy to denote resemblances between people based on both their psychological makeup and physical appearance, and irrespective of gender] is Tony Bower [the original of "Ronny," a character in *Paul*, the last part of Isherwood's *Down There on a Visit*], which is not encouraging, but Ellsworth is a much more positive personality. He is truly engaged.

## 14 June 1982

Ellsworth did leave a print for us at Gemini, though quite the wrong one—at least not at all the print I described to him. I don't know if he misunderstood, or if he found that there were no more copies of the one I described. The people at Gemini might have got it wrong, or else just gave us the one they had most copies of. They clearly disliked being party to any gift to us. Anyway, it *is* a black and white print, not half bad, and I'm quite glad to have it.

# Jill St. John

*10 August 1982, Santa Monica*

I liked Jill St. John for behaving as though our sitting yesterday afternoon was a significant occasion for her.

At two she arrived at 145 wearing a loose-fitting black jersey dress with a scoop neck and swagged sleeves. The red of her leather belt and the delicate sandals embracing her dainty white feet matched the red lacquer on her toenails. Her golden-red hair was expertly tousled, and, though she complained of the uncomfortable heat on her drive from town, when we got to the studio she made no attempt to fix herself in the bathroom mirror before we started work. Playing the dutiful subject, she only asked rhetorically if I thought her hair needed ordering. "Just right as it is," I answered. I knew that whatever she might do to her hair would not make it more drawable.

Perhaps to cover her obsession with her appearance, Jill simulates a casual indifference to it. While she sipped ice water and talked steadily to Chris and me before I took her to the studio, Jill had stood a good fifteen minutes in front of our dining room's floor-to-ceiling mirror. Though I never saw her take the briefest look into the mirror, I am certain that she had checked herself thoroughly and found every detail as it should be.

She dislikes social mishaps or any kind of disorder and avoids them with shrewd foresight. Her frothy, carefree air is her reward to herself for her preparedness. While the three of us talked in the dining room, or, rather, while Chris and I listened to and looked at her, only once (and she hardly knows either of us) did I feel the slightest twinge of self-consciousness in her. She always had something to say and enjoyed both performing for us and her performance itself. Lest we

220

think her too material-minded, however, her chitchat suddenly veered away from one of its recurring subjects (luxury in its various forms), and the single glimpse of discomposure I got preceded this abrupt switch. She has a dislike of haste. Time is not her friend.

Judging by her appearance, however, she has mastered time, too. I looked up her birthdate this morning and learned that she will be forty-two on the nineteenth of this month. She could still pass for a pretty starlet, and her voice, too, is girlish, though what she says sounds more like a deft parody of innocence.

It was only when I began to draw her that I realized that her exterior is a clever, thorough mirage. Nothing tangible of herself remains. The surface of her leads nowhere and—except as evidence of her goal, a standardized form of beauty—tells nothing personal about her. The more I looked into her face, the less I saw, the less there was to draw. Within fifteen minutes I realized that I was only drawing from *her* drawing of herself.

Her entire face was covered with several fine layers of makeup in different pale colors, and her fluffy bangs obscured not only her eyebrows, which are crucial to a likeness, but every last vestige of facial expression. Her nose job, the most serious of the changes she has wrought on herself, is the mistake that they invariably are. Hers is far from the worst, but it renders her nose impotent. Behind all of this, or maybe in front of it, is the girlish voice, the nonstop talking of an all-in-one ventriloquist *and* doll. Kept in constant motion, the doll is moved by an unseen power which maintains illusion through calculated movement and continual sound.

I've not examined the drawing since finishing it and don't look forward to doing so. Jill looks in it like someone under arrest but unidentifiable without fingerprinting. (In fact, Jill's hands, in life as well as in my drawing, do reveal more of her than her face.) The lack of rhythmic flow in the drawing keeps its parts from leading naturally one

to the other, and the resulting stasis suggests that Jill is a wind-up doll whose mechanism has run down.

She was too restless for me to chance a dark wash for her black dress, so I gave it a linear treatment which indicates, at least to me, that the dress *is* dark rather than light.

"You flattered me," said Jill when she first looked at the drawing. (I thought to myself that it must be even worse than I'd supposed!) Then, after a pause, she added, "You made my mouth bigger than it is."

Though I would not want to do such a drawing, the best likeness of Jill would probably be some kind of graphic version of her disappearing act itself, the holes in the net rather than its ropes. The odd truth is that, despite the tough and unrewarding labor of the sitting, I liked Jill herself. I even find something admirable in her herculean efforts on herself, however wrong-headed they are in my eyes. At least she is decisive and thoroughgoing. She knows what she wants and likes the person she has made of herself. If you don't agree, she has no use for you.

Her instinctive sense of what might interest me prompted Jill to talk about working with Vivien Leigh on *The Roman Spring of Mrs. Stone*. She believes that Leigh's unwavering meanness to her during the filming of the movie was motivated by jealousy. Jill was only twenty but already had her own sable coat, while Leigh, middle-aged and, according to Jill, resisting her middle-aged role in the movie, had "only a leopard coat." "I'd never kill a leopard just for a coat," said Jill, "but I don't really mind sacrificing a few sables."

Jill told me that her role in *Tender Is the Night* was taken away from her by its first director, John Frankenheimer, when she admitted to having no real acting experience or even training. "I was terribly upset," she said, and then noted in an aside, "That was when I used to care about my career." Because Frankenheimer had also tried to get

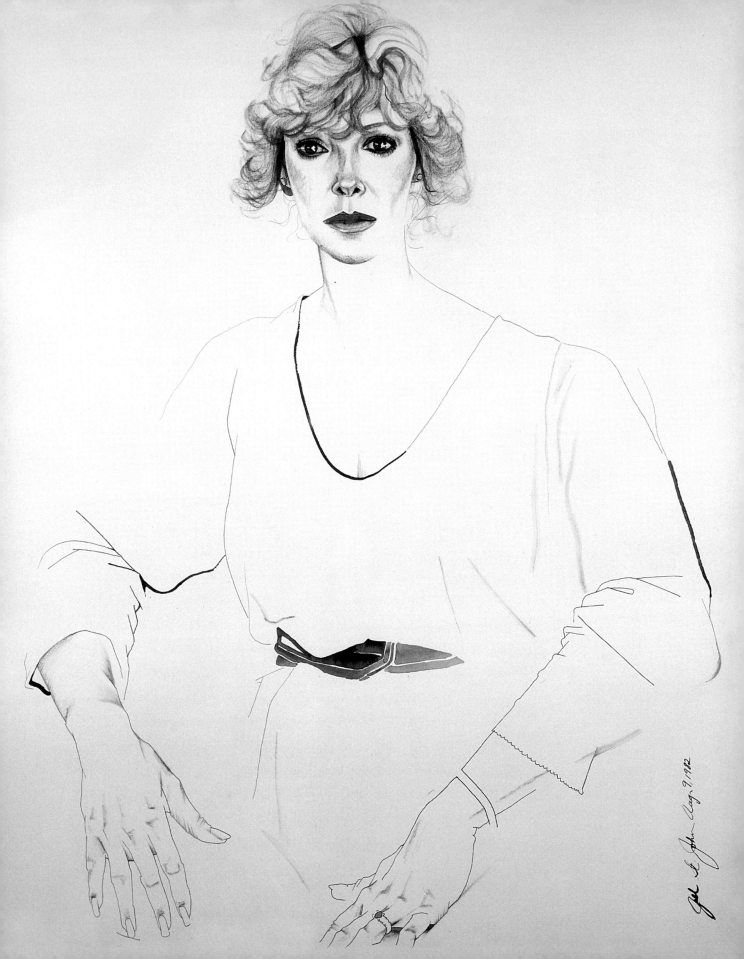

Jennifer Jones out of the movie, said Jill, he was yanked himself by David Selznick. She agreed with me that Henry King, who reinstated both Jill and Jones, was the wrong director for the movie. "But then everyone in it was miscast," she said, and with a mock-demure smile added, "except for me, of course. I was the only one who was the right age."

"Vivien believed that she was too young for her role," Jill continued, "but Jennifer knew that she was too old for hers. But in spite of the strain she was under, she was really very sweet and kind to me, and even came for a drive in my car and brought along Lauren Bacall, who was in the south of France for a lot of the filming because she was married to Jason [Robards, who played the male lead in the movie]. I remember," Jill giggled, "Jennifer cautioned me to take the corners 'very carefully.'"

On the same movie Joan Fontaine had been "vile" to her and had even complained to the producer that she had seen Jill "driving around in a very grand car obviously not her own." Jill's imitation of Fontaine's superior tone was funny. She had intentionally not told Fontaine that the car did indeed belong to her because, Jill proudly informed me, she had just married rich, young, and good-looking Lance Reventlow.

I sensed Jill's determination to marry R.J. [Robert Wagner]. She said that she'd been worried when he first came to her home in Aspen. "You want someone you care about to like the place where you live." Ironically, she and two more of the key women in his life, Natalie [Wood] and Stephanie Powers, had all been together in a school for professional children. "We all called Natalie 'Natasha,'" said Jill. I wish now that I'd asked her, since she'd had no training as an actress, just what kind of professional child Jill had been.

Since I suspect that Cici [Celeste Huston, the fourth and last wife of John Huston] and her embellished accounts of her sittings with me were largely responsible for Jill's willingness to let me draw her, I

was surprised that Jill made no mention of Cici, her longtime friend, at least according to Cici. Throughout the nearly ten years we've known Cici, she has relentlessly parodied Jill's little-girl simper and made fun of Jill's attempts to cover with phony feminine innocence what Cici labels her grasping ruthlessness. Certainly, on Cici's side anyway, a rivalry exists between the two women.

# Allen Ginsberg

## 20 September 1982, Santa Monica

A sitting yesterday, one that I went to bed dreading the night before, with Allen Ginsberg. Checking just now to get the spelling of his name right reminds me of a moment which tells a lot about him. After we'd finished work and he'd signed the two drawings I'd done, I asked him if he would like me to send him photographs of them. He said yes, but before telling me his address (a P.O. box number in New York), he spelled out both of his names for me. This act, with its mixture of modesty and bitchery, is typical of him. Simple on the outside and convoluted inside, it betrays his frustration as well as his arrogance. And he was right about my ignorance. I would have known which way to spell his first name, but I might just have put a "u" instead of an "e" in his last.

I dreaded the sitting not only because his appearance combines several ingredients (glasses, beard, bald head) which make it so much more difficult for me to do a drawing, but also because, though we have met relatively few times (barely half a dozen), a resistance on both sides, amounting sometimes almost to a friction, has existed from the start.

I still remember the night in 1966 when he and Peter Orlovsky came to a dinner party at 145 and Allen (it still feels unnatural to call him by his first name) put a tape recorder on the dining room table and began asking Chris questions about Virginia Woolf and London literary life. He had intentionally waited until after dinner when Chris was half-drunk and, he hoped, loose-mouthed. Later that evening Orlovsky, as though expecting to shock some bourgeois fags, had stood

up in the living room and ritually lowered his trousers to expose himself to us and our other guests.

On that same occasion Allen had asked to see my work and, when I took him out to my studio and showed him a drawing of Brian Bedford I'd done that day, asked me how many times I had used an eraser. From the tone of his question, I knew that he automatically assumed that I could not have done such a precise drawing without relying heavily on an eraser, an instrument he clearly regarded as a symbol of weakness and a betrayal of spontaneity (so do I!). But, when I truthfully pointed out the three minute erasures I'd made, he neither admitted his mistake nor praised my accuracy. Ever since I have been on my guard whenever we meet.

Nevertheless, on Saturday, when Chris and I went to the house where Allen is staying as the guest of Vijali [an ex-monastic Vedantist Chris and I had known slightly for many years] and her psychiatrist-husband, Oscar Janiger, I had decided in advance to suggest a sitting. When I did, Allen quickly, eagerly agreed and placed himself at my disposal. Yesterday he even said that he'd been intending to suggest the idea to me. I realize that he has been wondering why I'd never asked him before. He is at his most dangerous in his humble-modest aspect.

We worked through both drawings almost without speaking to each other. Early in the first drawing, after I'd asked him to look me in the eye, he wanted to know if I minded his "looking into space" rather than at me. He made it sound as though he had been looking through me. If so, I hadn't noticed and so said, Go right ahead. Later it did seem that he was slightly looking past me, but the reflection from his glasses made it hard for me to be sure. Toward the end of the first drawing, he broke into prayer and for a minute or two repeated aloud what sounded like an English translation of a Sanskrit prayer.

After the first drawing, which took about two and a quarter hours, Allen himself suggested that we do another. In case I might

think that he was getting entranced by the experience of being looked at, he told me that he welcomed the opportunity to meditate, his first since he'd started traveling four days before. It was a beautiful day, and I'd planned to get to the beach for a swim, but I was glad to go on working, despite the nervous twitching in my empty, over-coffeed stomach. I'm glad now, too, because the second drawing is better than the first, and much more like him.

While I was doing the first drawing, Allen had loosened his belt and partially opened his trousers to facilitate, he told me later, proper breathing during his meditation. I proceeded to draw his trousers open and realized as I did so that their looseness helped to emphasize his pot belly. He saw what I was drawing, I knew, but he made no objection nor any move to protect himself. Most sitters would have immediately tightened and buttoned belt and trousers, whether or not doing so might cause me to spoil the drawing. When Allen looked at the finished drawing, he commented on the open belt but said nothing disparaging. Very much on his best behavior, he commended the "delicate" and "careful" drawing of the head and praised particularly the way I'd incorporated the reflections of his glasses into the drawing of his eyes.

The drawing doesn't seem like him to me now, or only generally like him. It lacks that particularity which I demand from my work. "I don't really know what I look like," he said when I asked if the drawing was a good likeness, but he seemed to approve of the version of him I'd presented. Maybe he approved *because* it wasn't really like him, though he did praise the "good likeness" of the second drawing. He also said that he saw in its face the pain he was experiencing from staring at the ocean's bright reflection of the afternoon sun. For the second drawing I moved his chair to give him a better view of the ocean, and myself a different view of him. I started with Allen looking away from me, but, after I'd drawn his right eye, he turned his head to look more directly at me and I had to ask him to put it back to where it had

Sitting in a house over Santa Monica Canyon,
breathing like an ant under the blue noon sky,
am I an indestructible soul or a mad small old geezer?

September 14, 1982 : Allen Ginsberg

been. I would have preferred to draw him looking at me again, but, when he turned toward me, the reflection of light off his glasses was so complete that I could see almost nothing of his eyes.

During both drawings I sensed his continual movement, but it was subtle enough that I could not properly catch him at it. Though his demeanor suggested total concentration and cooperation, he was really giving me only a facsimile of each. Despite the basic barrier which still existed between us, however, we became closer and more relaxed with each other, if only because of the amount of time we spent together. I had fetched him at ten-thirty that morning, and he didn't leave my studio until four-thirty.

He spent a good half-hour looking at two albums of photographs of my drawings of writers, musicians, and artists, then at some recent paintings I showed him. "You give everybody a bull-neck," he said while looking at a painting of Chris. He'd earlier accused me of enlarging William Burroughs's jaw in my drawing of him. Though these criticisms were minor, they expressed a lingering doubt in his attitude to my work. When he cited my "diligence," he seemed to be stressing my application rather than my talent, my performance as an operator and organizer rather than as an artist.

The albums impressed him to an extent, but that might merely have been due to the number of drawings and their subjects, most of whom he recognized, particularly the poets—John Ashbery, Marianne Moore, and, someone few people have known, Barbara Guest. Though he paused significantly over my drawings of [James] Merrill and [Thom] Gunn, he made no comment on either. "Oh, you knew Frank," he said, when he came upon my drawing of Frank O'Hara. Rather than as a talented poet, he praised him as "a shrewd tastemaker with an ability to discover the right people." He then mentioned a foursome he and Peter Orlovsky had once had with Frank and "whatever lover Frank had at the time." His one bit of description of the encounter—"Frank had a thing about Peter"—was revealing of himself.

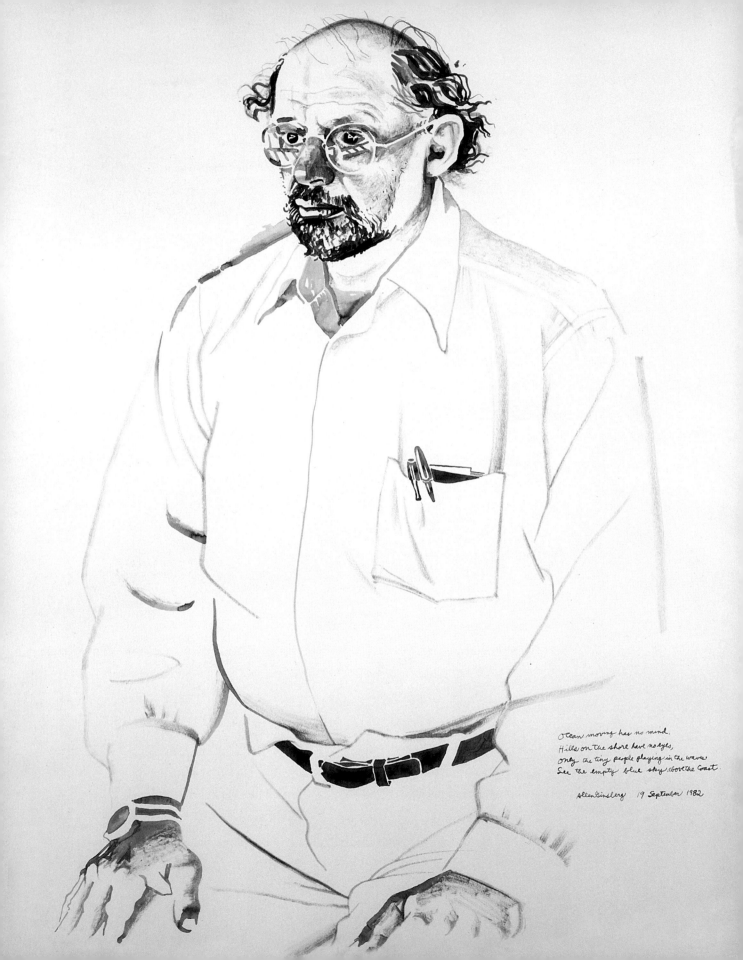

Ocean moving has no mind,
Hills on the shore have no eyes,
only the tiny people playing in the waves
See the empty blue sky above the Coast.

Allen Ginsberg   19 September 1982

With both pride and rue, the self-loathing outsider had observed his lover worshipped by a rival, goy poet.

Allen came briefly into the house soon after he'd arrived and said that he remembered it being "smaller." He kissed Chris, and they exchanged a few words, but, unexpectedly, he made no further attempt to contact him that day, as though he really had come to devote his attention to me. Guarded and tentative with Allen, Chris senses his sado-masochistic drive to cross-examine, embarrass, or expose him in some way, anything to make contact. Chris's subsequent reticence and discomfort with him only whet Allen's appetite. In addition, Chris's awareness of his own failing powers, his susceptibility to what he calls "confusion," makes him all the more uneasy with Allen. Chris said to me, purposefully in front of Allen, that we should leave the house that evening a good half-hour before we needed to. He wanted to ensure that Allen wouldn't hang around too long.

At the end of the sitting, Allen took away with him a joint he had placed on my drawing bench soon after he arrived in my studio. Without telling him that I never smoke grass when I work, I had thanked him and put it aside with the intention of smoking it later. I guess it was mine only on condition that I smoked it with him.

Allen chose to return to the Janigers on foot and used the pathway below the house. We kissed on parting, and this time our lips met with a mutual recognition of contact. At the Janigers' the day before, there had been a hesitant will-we-or-won't-we awkwardness when, after Chris and he had exchanged a kiss, Allen and I fumbled with each other. I had managed only to place a somewhat awry peck on his bearded cheek.

When I went into the house after Allen had left, Chris said of him, "He's such an egomaniac. A total egomaniac." "But one who doesn't like himself," I added. "You don't have to like yourself to be an egomaniac," Chris answered. "Self-loathing is just another form of egomania."

# Jack Nicholson

## 18 November 1982, Santa Monica

At two o'clock on Tuesday, I arrived at Jack Nicholson's house to draw him. I had wanted our sitting to begin earlier because at this time of year the light fades early, but Ann Marshall, Jack's right-hand woman who arranged the sitting, told me over the phone that he doesn't even get up until noon or later.

Jack's house is on Mulholland Drive. Its unspectacular view of the Beverly Hills side of Coldwater Canyon consists mostly of hills, treetops, and other houses. The ranch-style house itself is modest. I would guess that it was built in the late forties and that the rectangular pool at the back of the house was added later.

Ann came out of the back of the house to show me where to park and then led me through the small, old-fashioned kitchen to a stone-floored dining area which opened directly onto a low-ceilinged, thick-carpeted living room. Its darkness, even in the early afternoon, was increased by somber purple sofas and low-slung upholstered chairs. New versions of thirties-modern furniture, they looked like large, soft building blocks. Only a rounded, bright green velvet chair, Jack's choice to sit in for the drawing, interrupted the gloomy mauves and plums of the rest of the furniture.

Coming from upstairs, Jack was soon moving through the living room to greet me. Wearing a black shirt and dark blue jeans, he was even darker than the furniture. He was friendly, but something sub-dued and unfocused about him suggested that his thoughts were else-where. His abstracted air might be his method, conscious or uncon-scious, of covering his shyness.

I remarked on a stylized painting of a mannish woman from the

twenties, and he told me that it was by Tamara de Lempicka. Recognizing her work, I pretended more interest in it than I felt. This prompted Jack to take me on a brief tour of the living room and small entry room, which contained two more de Lempickas, one of another woman and a larger painting which looked like an abstraction of a gray cityscape. When held to the light, Jack told me, it revealed an underpainting of a woman's face. I said that I, too, often painted over earlier paintings.

Jack then gave me my choice of a place to work. I chose the dining area because of its stone floor (in case I spilled some ink), and also because it would provide him with the canyon view through the sliding glass door and me with the most light the overcast afternoon had to offer. I began setting up my drawing bench while Jack chose from his collection of tapes for some music to play while we worked. For my bottles of ink, brushes, and pen, I decided on a low, Oriental lacquered table in a corner of the living room. Without removing a small, round green ashtray which rested on it, I picked up the table to bring it to a position beside my bench. I did not reckon on the extreme slickness of the table's lacquered surface, and, as I was moving the table over the slate-colored stone floor, the ashtray slipped off. Hitting the floor with a dull clunk, it broke into three thick chunks.

Ann was the first to answer my cry of dismay and was joined a moment later by Jack as she picked up the pieces of the ashtray. After turning them delicately in her hands, she made her disapproval plain by her silent, abrupt exit to the kitchen. Her frank display made it easier for Jack to play down the importance of the damage. Telling me in the next moment that the ashtray had been designed by a Keith Murray who had done work with Wedgwood in England, he then went upstairs to bring down a pale blue jug also designed by Murray.

The ashtray had looked to me like a mass-produced dime store item, and, when it first hit the floor, my immediate reaction had been relief that nothing of value had been broken. Once I saw the undeni-

ably handsome jug in Jack's hand, I realized that they were collectors' pieces, probably from the thirties or earlier, and that Jack was a connoisseur of sorts.

Jack's unperturbed manner was not meant to punish me, but the more he made light of the event, the more I suffered. Ann returned from the kitchen in search of two small fragments which were missing because I had quickly picked them up and flung them into the grate of a small indoor barbecue. Later, when I was alone, I lifted the grate and retrieved the two bits and took them into the kitchen, where Ann, as though soothing it, was holding the broken ashtray together in her hands. I was hoping that my act would suggest to her that I had searched doggedly on all fours to find the missing pieces.

*Not* the best prelude to beginning a drawing of *anybody*, let alone a world-famous movie star. Luckily, my nerves, though taut, were under control, and my hand was not shaking. Once our eyes made contact, however, the tension between Jack and me was excruciating. It was a battle of wills between two determined contestants in an acting competition. For a few brief moments I had a slight advantage in that I had played my part before, but when Jack zeroed in on me with that devilish, demented look in his eyes, I relived his long, staring closeup in *The Shining* while a shudder tingled my spine.

It had been a long time since I'd tackled a movie star personality, and I had almost forgotten the extreme, almost exquisite torment of the experience, that feeling that I must justify not only my presence in his house and my demand for his valuable time, but my very self as an artist. Knowing as well that my success depends almost totally on the unpredictable cooperation of my sitter, I feel myself to be, and am, in a completely vulnerable position.

It occurs to me now that, in a way, part of my strength is derived from my vulnerability. Am I not putting my faith in a mysterious, unpredictable power, as others, also for strength and guidance, put their faith in God? To me Jack Nicholson is a perfectly adequate embodi-

236

ment of God. August and revered, he is austere by virtue of his lonely eminence and, within his realm at least, all-powerful. I beseech Him, and then, trusting that He will recognize the sincerity of my entreaty and be merciful, I accept His will.

Fortunately for me, Jack Nicholson is a kind and understanding God. I instinctively knew before I started work that, like Larry [Olivier], he must give his best to whatever it is that he says he will do, so I was not surprised when he looked at me with keen, unbroken concentration for a good half-hour. It was another hour before he called a break and, moving from his chair for the first time, got up to stretch for a few minutes before returning to sit.

While we worked we listened to subtle, sinuous jazz, some of it featuring a guitar. Occasionally he surrendered to its syncopation and moved his head in rhythm, but without moving his eyes from mine. When we were fifteen or twenty minutes into the drawing, he suddenly broke into a long, wicked grin which seemed to acknowledge the absurdity of our mute, intense seriousness without damaging the validity of its purpose. He has a sense of humor, even about himself.

After the first hour we spoke occasionally. I asked what he'd been dubbing last week (Ann had postponed our first date for a sitting because of it), and Jack told me it was the censored version of *The Shining* for its television premiere. The work had been distasteful to him, and, as an example of it, he gave me a censored line from the movie and then the line which he had dubbed to replace it. He admitted that he hates television and, as evidence to justify his cynical attitude, indicated the considerable sum he had been paid for the dubbing.

I mentioned that Chris and I had seen *The Last Detail* at UCLA the night before, and I described a wordless scene of his at the skating rink which had made us laugh. (Randy Quaid is on skates and being watched by Jack, who suddenly turns and gives a quick appreciative glance at what, though she doesn't appear on camera, is obviously a pretty girl skating past him. He then returns his prosaic attention to

Quaid.) Of his performance in that movie Jack said, "That was the beginning of something, the first time I freed up."

I mentioned that I would like to see again *Drive, He Said* [a 1972 movie he directed]. "Not long ago I saw it for the first time since I did it," Jack said. "It's not bad, if I do say so myself."

We also talked of his early films with Monte Hellman. I praised Hellman's unusual talent as a director and said that I had especially liked *China 9, Liberty 37* [1978]. He agreed with my praise of Hellman, but a coolness in his manner made me think that something had estranged them. Jack told me that he owns *Flight to Fury* [a 1966 movie directed by Hellman and written by Jack, who also plays a role in it].

We started work around two-twenty, and I finished the drawing about four-fifteen, almost exactly the two hours I had asked for. Jack said he liked the drawing and studied it closely for several minutes, then returned to it a while later. Though his praise was in no way excessive, he signed it without hesitation. With neither surprise nor involvement, he appeared to accept the drawing as a given fact. Pointing to the area under the chin in the drawing, he then tilted up his own chin and, making his neck taut, lightly placed the back of his right hand under his chin. "This is the only part of me I let them put makeup on," he said. "I get them to darken it."

Rather like his familiar, a youngish, thin blond rail of a girl (Jack told me that she is also an artist) drifted in and out of view throughout the afternoon. She left the roast she was cooking in the kitchen to inspect the finished drawing and remarked on my handling of the broken little finger on Jack's right hand. He had shown me the finger when I informed him I was about to draw his hand and had then placed his hand in a position which featured the finger. Jack was pleased that the drawing clearly displays the finger's crookedness, an identifying mark known only among the initiated.

I found out after the sitting that Jack is an early Taurus (27 April). I guess him to be a perfectionist (the little finger is an excep-

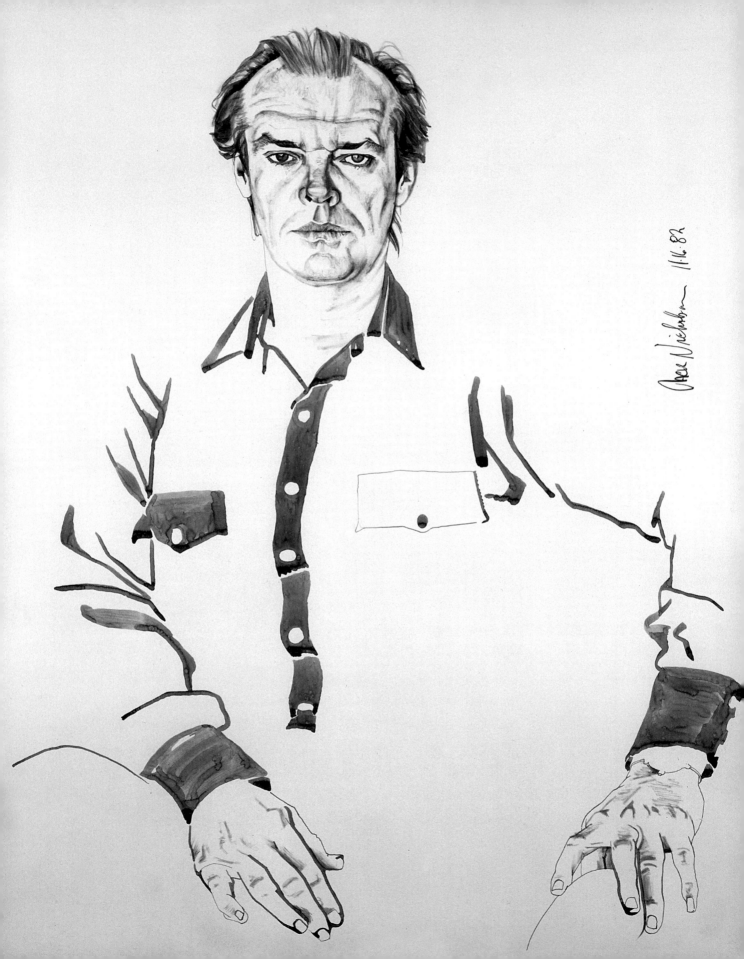

tion to a rule), determined to the point of obstinacy, neat (the house is very ordered, the objects carefully placed and respected). Everything is outwardly controlled, while within a fire rages silently with only occasional eruptions of violent, noisy temper.

Shortly before I left the house, Jack greeted a telephone call from Anjelica Huston with "How you doing, Big?" He ended it with "Have a nice rest of the afternoon," and followed his words with a simulated kiss.

[A few days later I made a telephone call to New York to ask my longtime friend, Peter Schlesinger, who is a sculptor and collector of ceramics, if he had ever heard of a designer named Keith Murray. Indeed he had and, when I described to him Jack's green ashtray, said that he had occasionally seen such ashtrays of Murray's for sale in shops or offered at auctions. Peter even knew the proper name for its color, "celadon." After explaining the situation to him, I asked him to keep an eye open and, if he found one which was not overpriced, please to let me know.

About a year and a half later Peter called me from New York to tell me that he'd found the Keith Murray ashtray that I was looking for at a price he thought fair (about $250). I asked him to buy it for me, and, since he was making a trip to Los Angeles the following week, he brought the ashtray with him. I paid him for it. It was an exact replica of the one I'd broken, and I sent it to Jack. I never heard from him, but months later ran into Ann Marshall at a party. When I asked if Jack had ever received the ashtray I'd sent, she told me yes and said Jack had been pleased. She also told me that they had managed to repair the broken one so successfully that one could not tell that it had been damaged. So now Jack has a matching pair of celadon ashtrays. I wish that I had been given the repaired ashtray as a memento for my efforts. It would have made a nice conversation piece for the cocktail table.]

# Helmut Newton

## *30 December 1982, Santa Monica*

Helmut Newton came to 145 on Monday morning to photograph Chris's bed for a dumb-sounding *Vogue* article revealing the unmade beds of the famous. It was nearly three hours before Newton was finished, and this only at the insistence of Chris, who was anxious to get back to work. And I was hanging around waiting to draw Newton. When the date was made for him to come to the house to photograph, he also agreed to sit for me when he'd finished. At first he said it would be an honor, but a few days later, when we met at Dagny [Janss Grant]'s big Christmas party, he was asking, "How long will I have to sit? How still will I have to be?" When I told him not longer than two hours and maybe less, he made a lugubrious face at the prospect of such an ordeal. "You know I had a heart attack," he told me. "I'm not supposed to sit too long." My anticipation of the sitting, not keen to begin with, lessened considerably. I guessed that his wife, June [the photographer Alice Springs], who sat for me a couple of years ago and, I think, felt my drawing of her was harsh, had been warning him against me.

Still, though both Chris and I dreaded Monday, we were in no way prepared for Newton's charmless, rude behavior. "He has all the bad characteristics of a dreary German," Chris declared after Newton had finally gone. "And so thick-skinned," I agreed heartily. Before he could sit for me, he needed "to take a pee." Then: "Is there some place around here I can get a hamburger?" (The kitchen cupboards were nearly bare, but I fixed some cheese and crackers for him.) "A beer. Have you got a beer?" Then: "A cigarette. I must have a cigarette. Have

242

you a match? Have you an ashtray? A comb. I need a comb. I always part my hair on the side. Have you a comb?"

It was his peremptory tone which was so disagreeable, and his heavy, humorless voice, the cadence of his speech even more German than his thick accent. The pronounced form of his male self-indulgence makes it clear that he spends most of his time with women. Only a very masochistic or cynical woman would endure him. Self-respecting fags don't tolerate such behavior from a man.

While I was drawing him, he told me that he had had his portrait done only once before, when he was a child, a portrait in pastels commissioned by his parents. When I asked if he still had it, he said, "Oh no, it was lost in all that—." He finished his statement with a gesture which told me that that old holocaust was too familiar and too tired to go into yet again.

I've often repeated my claim that I can't draw anyone I actively don't like, that my dislike stymies the whole process. Maybe I'm just a prima donna whose negative feelings, to use a phrase from Emily Dickinson, "close the valves of her attention like stone," but if I can't find some way of liking or at least forgiving my sitter, my ability to identify with him withers and my drawing hand freezes. Newton was a real challenge to me. Though I was just able to finish my drawing, while working with him I came as close as I've come to not liking my sitter and had consciously to withdraw my thoughts from the impressions I'd got of him that morning. Instead, I dwelt in mental commiseration with his poor wife and felt deep gratitude for not being married to him myself.

I guess he sat fairly well, at least compared with what I was expecting. I couldn't even bear asking him to look at me. I worked about an hour and a half. It's an indifferent drawing but a marvel of accomplishment considering the circumstances.

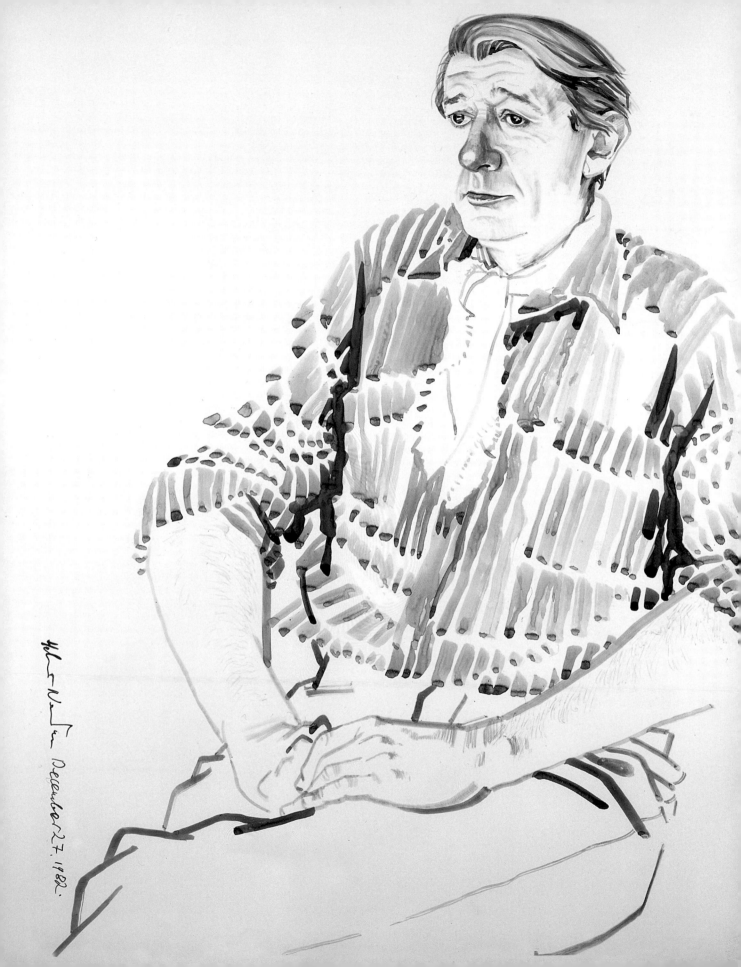

# Jerry Brown

## 9 October 1983, Santa Monica

I did two drawings of Jerry Brown yesterday afternoon. I was more apprehensive about this sitting than any other in many months. When Brown's assistant, Jessica Hanson, called to make the appointment for one o'clock, she asked if I would do Brown the favor of letting him, after a run along San Vicente Boulevard, come to 145 half an hour early so that he could shower and change into his suit. Of course I agreed, but it was already one before she called yesterday to say he was "running twenty minutes late," but not down San Vicente Boulevard. She told me that he'd done a long run in Laurel Canyon early that morning and, not needing our bathroom, would arrive ready to sit.

Wearing a dark gray suit and tie and a white shirt, he showed up at five minutes to two, with Jessica behind him carrying, on a hanger, another suit of a lighter gray in case I preferred that. His suits and trousers are too big for him, he was pleased to tell me, because he's lost weight. He may have lost some, but not enough. His face looks all right, but he has a thick waist and a big rumble seat.

Jessica tactfully excused herself and said that she'd be back between four and four-thirty. I asked Brown if he wanted anything to drink, and, instead of his usual glass of water, he asked for a cup of coffee and followed me into the kitchen. "I only drink coffee for the caffeine," he said after making sure that our freeze-dried coffee wasn't decaffeinated. I spoke my sincere agreement but hid my surprise at his open support for a stimulant known to be a health hazard. It seemed out of character for him to need a fix.

Chris did not emerge from the back of the house, and I was anx-

245

ious to get started, so I took Brown directly to the studio, where we briefly discussed his clothes. My frank lack of interest in them dismayed him. I didn't care which suit he wore, whether or not its jacket fitted perfectly, or even whether it was buttoned or unbuttoned. "You decide," I kept saying, "it doesn't matter to me."

Brown's defensiveness makes him aggressively wary, and he insisted on knowing what my intentions were. We've had three or four meetings now, but to trust me as an artist and friend did not occur to him. Was I aware of the pitfalls that threaten a public figure such as he? Would I protect him? I think he was worried that, either maliciously or sadistically, I would endanger his dignity. Perhaps anxiety and suspicion keep a politician on his toes, but they torment a sitter, and can infect his portraitist, too.

Though a success, the sitting was an ordeal for us both and made me wish that I could find a way to get my kicks without suffering such stress.

I took chances in the execution of the two drawings and used a lot of dark wash and a big brush. Brown sat fairly well for the first and badly for the less flattering but more interesting second drawing. That I mastered myself matters most to me. Despite Brown's qualms, and his physical and psychological resistance, I did the two drawings I set out to do in the time I asked for—we started shortly after two and finished at four-thirty-five, just before Jessica returned.

Studying the finished drawings, Brown worried that in the first his head is too little compared with the size of his hands. He wasn't much reassured by my explanation that, because I insist on closeness to my subject, some foreshortening in my work is unavoidable, but I was firm. Afraid his criticism might offend me, Brown soon searched for positive comments.

During the first drawing he complained of the glare, so I moved him away from the sliding glass window to a lower, upholstered chair

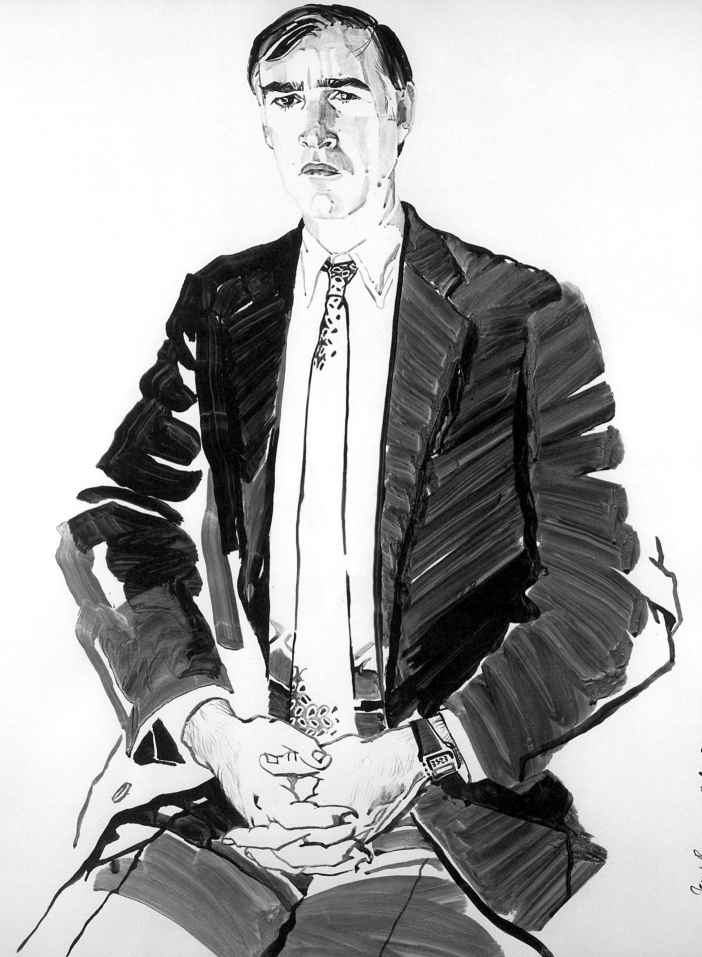

Jerry Brown, October 8, 1987

and almost immediately suggested we start on a second drawing. He understood my challenge and matched his professionalism to mine.

Confident after a reasonably good first drawing, I felt exhilarated and resolved to do something much better. Alas, only a few minutes into the second drawing, Brown's concentration began to dissipate, and soon his head was wandering. To help him re-establish its axis, I several times held my hand up at an angle approximating the tilt of his head when I'd started the drawing. Though he followed my directions, soon the angle of his head changed again. He was visibly tripping and no longer truly with me. I persisted, but it was uphill all the way.

Considering the difficulties, it's a wonder the drawing turned out as well as it did. I expected him to call it unflattering, but, saying nothing critical, he only gave it his silent, intense inspection.

I asked him to sign the drawings, and he agreed without hesitation. He started with the just-completed drawing and asked me the date before signing it. Glancing at my new watch, which also gives the date, I told him the seventh just as the buzzer sounded. When I returned from opening the gate for Jessica, Brown had also signed the first drawing but, I discovered only after he'd gone, dated it the eighth. His wariness had prompted him to check his own watch, and, assuming mine to be wrong, he had written the right date on the first drawing. So the later drawing has an earlier date!

I didn't realize until I was drawing him that Brown dyes his hair. His sideburns are carefully left gray, but the rest of his hair has that overrich, lifeless color of dyed dark hair.

While I was preparing coffee for him soon after his arrival, Brown asked me if I'd seen all the publicity connected with the portrait commission. I said I had and, out of what I thought was modesty, expressed surprise at its extent. My surprise, I reflected later, had been tactless because, by blindly presuming major credit for the publicity, I was denying him the star status that he takes for granted. Without

Jerry Brown, October 7, 1983

attempting to cover his satisfaction he noted, "I always seem to make news whatever I do."

## 19 November 1983

Around ten-thirty on Thursday night, Jerry Brown opened our front door, and he and his assistant, Jessica, came into the living room just as we and our guests were about to leave the dinner table. He'd sat for me that morning and had shown great interest in the possibility of meeting Stephen [Spender, our guest of honor at dinner that night], so I'd invited him. He had said that he had a speaking engagement downtown but might come by later. I didn't think that he would and, when he appeared, was further surprised by his open expectation to be fed. There was only Natalie's portion of stew left [Natalie Leavitt was our cook and cleaning lady], a bit of salad, and a poached pear already wrapped for the journey to her house. Nearly overcome, however, by the distinction of serving an ex-governor, Natalie more than gladly sacrificed her dinner.

Brown came to the dining room table, and I introduced him as everyone stood. He already knew Billy Al [Bengston] and Joan and John [Didion and Dunne]. Unwilling to give the impression that Jessica might be his date, Brown made no effort to include her. She held herself back in the living room in shy modesty, and I had to insist that she join the table. Despite her refusal to have anything to eat, I gave her my chair and put a chair for Brown between Chris and Stephen. As is his wont, Brown took the spotlight and began with his concern over the nuclear arms race. He delivered his words partly to the table at large but most specifically to Stephen, who returned Brown's occasional invitation for corroboration with worldly wise ease and aptness. A veteran of discussions about the welfare of the world, Stephen was authoritative and easily matched each of Brown's serious facial expressions.

After a polite period of indulgence, the perennial earlybirds (Billy Al, the Dunnes, and Jack [Larson, actor, playwright, and librettist] and Jim [Bridges, writer and director of movies and plays]) took their leave. Stephen and Brown carried on another fifteen or twenty minutes. Because Jessica had just risen to go to the bathroom, I was standing when Brown looked at me and said, "I know what that means." He then stood and said I had given him "a deadline." At our sitting I had said that he could arrive as late as eleven but had not stipulated any exit hour. It was after twelve, however, and time to end the evening. Stephen and Bryan [Obst, a young friend of Spender, an ornithologist and a student-teacher at UCLA] stayed on a moment to let Brown get away.

Without an excess of substance, the encounter had been significant enough, and respectful and friendly. But I was tired. I'd done all the marketing and then stood at the stove for over two hours preparing the stew and pears, and that after more than two and a half hours standing at my easel, struggling to paint Brown as though he were one of my everyday sitters. Exactly as in our first sitting, his behavior was fairly cooperative for the first hour and then, once I was warmed up and ready to go, nearly impossible. I did two paintings, my first of him in color, on Gatorfoam boards, one 48 by 32 and the other 32 by 24 inches. Brown made no objection to either painting, mildly apologized for squirming the last hour, and appeared surprised and apprehensive at the prospect of three more sittings, though from the start I had asked for five.

I wasted too much time on the second painting. It's no good, but the first, although very much "a preliminary work," has something.

Considering his lack of real cooperation, it's perfectly natural that I am liking Brown less. He is arrogant, selfish, profoundly vain, and insensitive to people as individuals. To him they are political units. But my respect for him as a politician is not diminished—much.

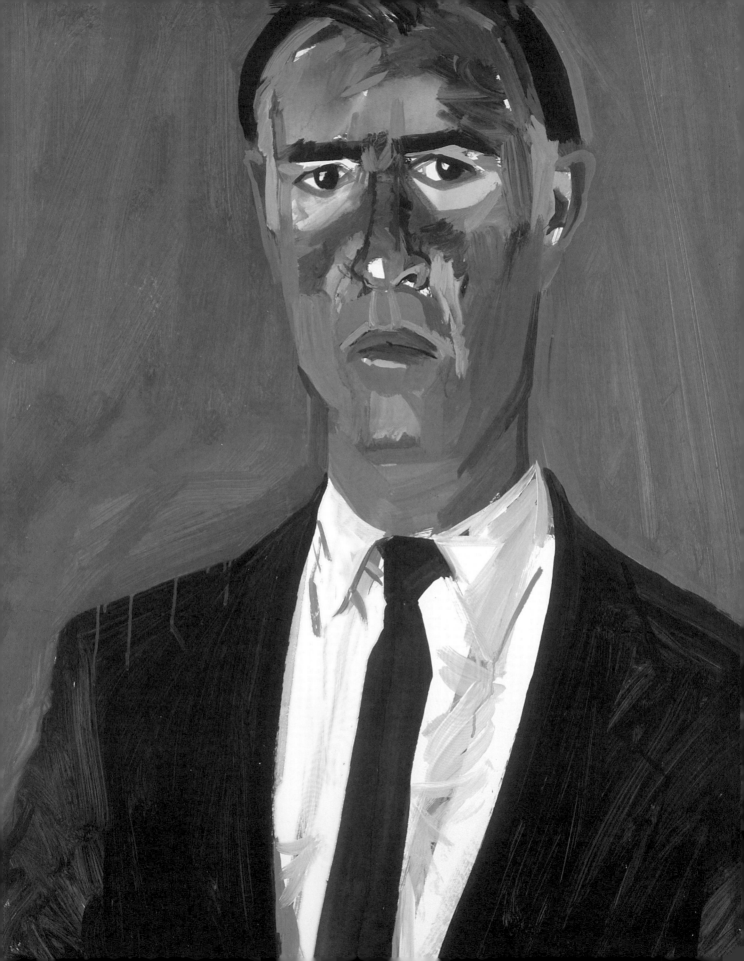

## 3 December 1983

A tough, really tough, sitting with Brown (I call him Jerry but think of him as Brown) on Thursday the first of December. It seemed tougher not because of any increase in Brown's restlessness—how *could* that be worse?—but because of the added pressure on me, applied largely by myself because I believe that no one will like the kind of painting I really want to do.

Somewhere in this ordeal with Brown, this mighty official commission, there lurks my salvation. It could take one of several forms. If my triumph of the will occurs, I will do the painting of him I want to do. If not, I might decide, as often contemplated, that in future I will renounce all claim to being a portraitist. The live human face and form will always be my subject matter, and I will always work from life. (A painting which is not a record of a direct experience, such as what I get from my sitter, could never satisfy me.) But, if the crux of my work continues to rest merely on whether or not a likeness is judged accurate, flattering, or distinguished enough, my frustration might become intolerable. The decisive sitting may be with Brown.

For encouragement I repeat to myself Billy Al's words to me at our dinner for Stephen on the seventeenth of November. "Don't worry if it's not your best. Give them the best you can do under the circumstances, and let them take it or leave it. Your second or third best is still better than what anyone else could do, and better than they deserve. You define what the painting should be. Please yourself as best you can, then tell them they can do with it what they want—once you've been paid."

I know Billy's right. He is practical and sound, and his help when I need it most is good of him, and dear to me. Though Billy's style defies imitation, his example continues to inspire me.

Brown's performance was the same as before. Fair cooperation for the first hour, ninety minutes at best, then he was lost to me. I did

my first canvas of him in just under an hour and a half. I quit it as mere preliminary work and switched to the smaller Gatorfoam work done in the last hours of the second sitting. Repainting more than half of it, I made it more like him but at the expense of the quality of the painting. Only in consideration of the meager help I got from Brown is the painting an accomplishment.

I was so rattled afterward that when I came into the house and started to describe the sitting to Chris, I turned to scolding him for not answering my telephone, as I'd only half-suggested he might do if he was in the vicinity. When it rang eight or nine times early in the sitting, then stopped, then immediately began again, Brown suggested that I pull out the plug, which I did. Why, I wonder, has such a simple remedy never occurred to me?

Though Brown did not seem as doubtful as he has in the past, he declared both paintings "sad," and he always questions me about my plans for the different versions of him I've done. "Why do I keep doing a new painting each time?" The paintings are "for reference," I lie, "I can work from them," or use them "for color notes." Finally I admitted that they are essentially my means of getting used to working with him. (I'm also getting used to my *dread* of working with him!) But, my words sounding hollow even to me, I indicated that "next time" the culminating work would hatch itself. Of course, instead of reassuring him, I just piled more pressure onto myself. I suffer at my own hands only. *I* am my tormentor.

## 27 January 1984

I have done it! I did a painting of Jerry Brown yesterday morning and I am willing to stand beside, behind or under it, to protect and defend it as long as we both shall live. It's not great. It's crude, in fact, in some respects. But its crudeness is part of its style and strength. After all, it *was* done from life, and in no more than two hours and fifteen min-

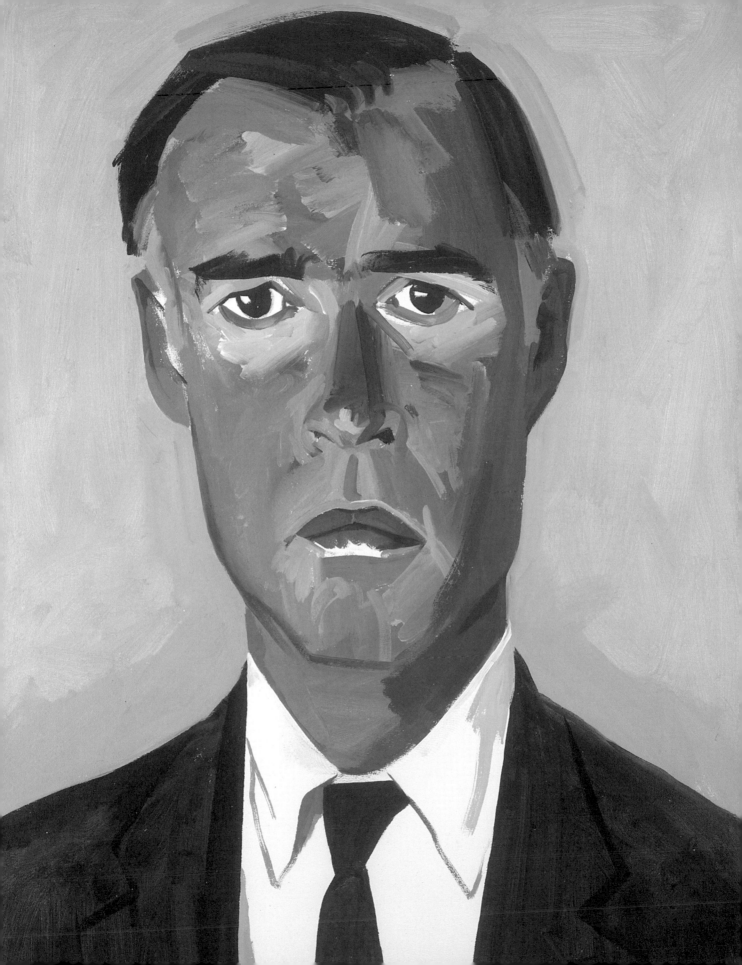

256

utes, and with only one short break to allow Brown a quick pee. It is like him, too, and its troubled look, neither unflattering nor misleading, *could* be taken for seriousness. And the painting is on a stretched canvas exactly the size of those of his father and of Ronald Reagan in the State Capitol Building.

The sitting was agony in contemplation and pretty much that in execution, though, about an hour and fifteen minutes into it, I must confess that, despite the awful strain, I did take pleasure in the work. My awareness of pleasure didn't last long, but I *did* have it.

## 28 January 1984

On the evening after the Brown sitting, I took Chris out to the studio to see the painting. The other paintings of Brown were still propped against the wall where, after the sitting, I'd put them to show Brown and Jessica for the purpose of comparison. I was a bit disappointed that Chris, though he praised the new painting, said the canvas from the previous sitting was "really like him." The painting Chris preferred is cruder, unfinished-looking, and much less flattering, but, in a way, I know what he means. I trust his eye. He's never wrong about my work, or anything else for that matter.

While we were in the studio, we looked again at the canvas I'd painted of Chris on 25 January, the day before Brown sat for my second canvas of him. Done as a warmup for Brown, the painting of Chris is my best of him on canvas. I like its color and brisk, fresh brushwork, and the light but viscous consistency of the paint. The likeness is good, too, especially the eyes. About the mouth Chris commented, "It looks like a slot in a mailbox where there isn't going to be any more delivery."

Showing Chris my work after a good day is one of my most enjoyable experiences.

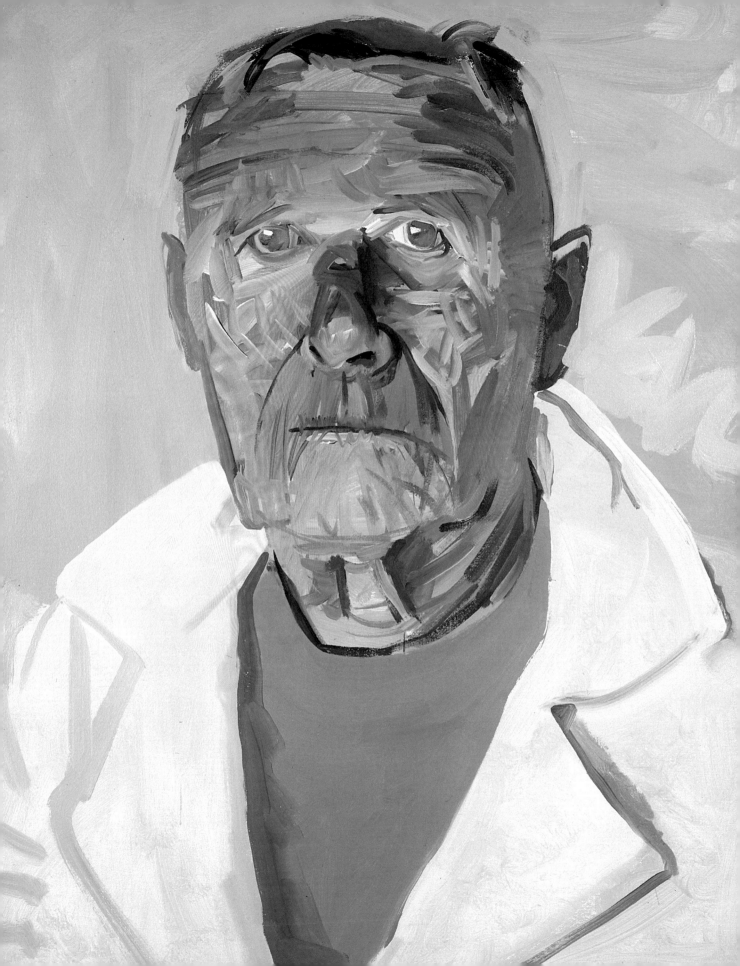

## 31 January 1984

I've not yet recorded anything about last week's session, my fourth, with Brown. Perhaps he was a little less restless, but only a little. He makes much of the rigors of sitting, as though I should find it encouraging to know about them. When I finished it, there was a long deliberation about the kind of image the painting projected. Was it too sad, too serious, too big, too straightforward, too something or other? I realized that he could go on for hours examining his personality and looks, particularly in terms of their effect on the public.

We were soon joined in this discussion by Jessica, who has been programmed to support his concern with how people react to him. She herself had two irritating criticisms of the painting. The first one, that Brown's mouth in the painting was too red, made even Brown impatient. He said that such an idea hadn't occurred to him and almost told her to shut up. Her other criticism, that his hair on the right side of the painting looked "too chopped," as though he'd had "a bowl haircut," didn't bother him as much. But when Jessica accused him of not washing his hair that morning, he turned on her with a petulant, "I did too!" She then suggested that it might be his gray sideburns which made his hair look odd. I kept to myself my own explanation, which is, of course, that he dyes his hair. The dye destroys the vitality of his hair and makes it hang unnaturally.

When Brown invited Jessica to give her opinion of the painting, he shocked me by defining her viewpoint as "the epitome of the average." On that basis only, he implied, could it be of interest to us. Clearly accustomed to sadistic treatment from him, Jessica neither objected nor showed any sign of resentment. She took it like a dog.

## 3 February 1984

"He has no charm but somehow I like him," said Chris this morning in the kitchen. He was referring to Jerry Brown, who had come for

our fifth and last sitting yesterday morning. He arrived an hour late. Jessica had called at ten to say they were just leaving.

Brown and I worked till after three, with only two brief breaks. Without exaggeration, it was as difficult a sitting as any I have done. For the first two and a half hours, he was at least as restless and as unconcentrated as he had ever been. No, he was really worse. I gave up the first canvas after more than an hour and started on the other. (Two custom-stretched canvases, each 59 by 39 ½ inches, were delivered at nine yesterday morning. I'd ordered them especially for the occasion. They cost $66 each!) By one-thirty I had roughed in the second canvas as best I could, and, though it was totally unsatisfactory, it was still better than the first. Only slightly more attuned to his restlessness than I had been at the start of the sitting, I almost despaired.

Aware of the imminent arrival of Jessica to pick him up, I nevertheless resumed work on the first canvas. About ten minutes into my reworking of it and still having trouble with Brown, I had the impulse to engage him in conversation as a ploy to gain his attention. Without any premeditation, I soon found myself telling him, "Since we started, your head hasn't been in the same place for more than a few seconds at a time." "Oh, you mean it's my fault," he retorted. "No, it's my fault," I said, "for insisting on working from life. I shouldn't then complain when life doesn't correspond to my demands. I should, I must, go with it. I'm just telling you that you're making it very difficult for me. There's no way I can do this thing without your help."

As no other sitter of mine has done, Brown then changed his entire attitude to the sitting and began to sit with real stillness and attention. My surprise at his sudden turnabout was so great that it nearly unnerved me.

With his real cooperation at last, I had a slim zero-hour chance to do something good. But the morning's anxious effort had tired me, and I felt daunted by that most difficult of technical problems, saving a bad start. The paint, on my canvas and on my palette, was already

too built-up and my colors, overmixed with white, were neutralized by their opaqueness. My spirit, like my brushes, was sodden. All I had was my determination not to stop unless Brown's concentration failed, or Jessica came and insisted on carting him off.

His concentration didn't fail, and, when Jessica buzzed, Chris ushered her into the house. She made no further intrusion. Beyond belief in myself and almost beyond caring, I worked in a trance, and the painting seemed to paint itself.

Did I create the masterpiece before the light failed? I don't know. I haven't even glanced at the painting since I finished it nearly two days ago. When it was done I invited Chris and Jessica to the studio, and both firmly stated that it was the best of the lot. It is crude and unfinished-looking. Brown's head lists to one side and runs off the top, and he looks older, heavier, and harried. But the painting has intensity and is the best I've done of him. Maybe it will do. I will look at it this afternoon. After it was finished, I looked again at the painting of the previous week, which had pleased and relieved me so much at the time, and thought it bland and superficial by comparison. Also, I discovered by checking my notes that the earlier painting is quite a bit bigger than the paintings of Brown Senior and Reagan in Sacramento, so the last painting is at least more appropriate in size.

After I'd finished work, Brown, uncertain as usual, was avid for discussion and probed the three of us for every reaction to that obsession of his, the Brown persona in all of its manifestations. His appetite for center stage is insatiable.

Because he arrived more than an hour late, he was in the house when Marla Simon, our bookkeeper, arrived. I was pleased to be able to introduce her to him. Marla tried to hide her shyness and awe with a chipper tone. Brown became stately, kindly, almost paternal, and also a bit condescending. But he was august, too, and his beauty heroic. He has the aura of a legendary figure, and knows it, and enjoys

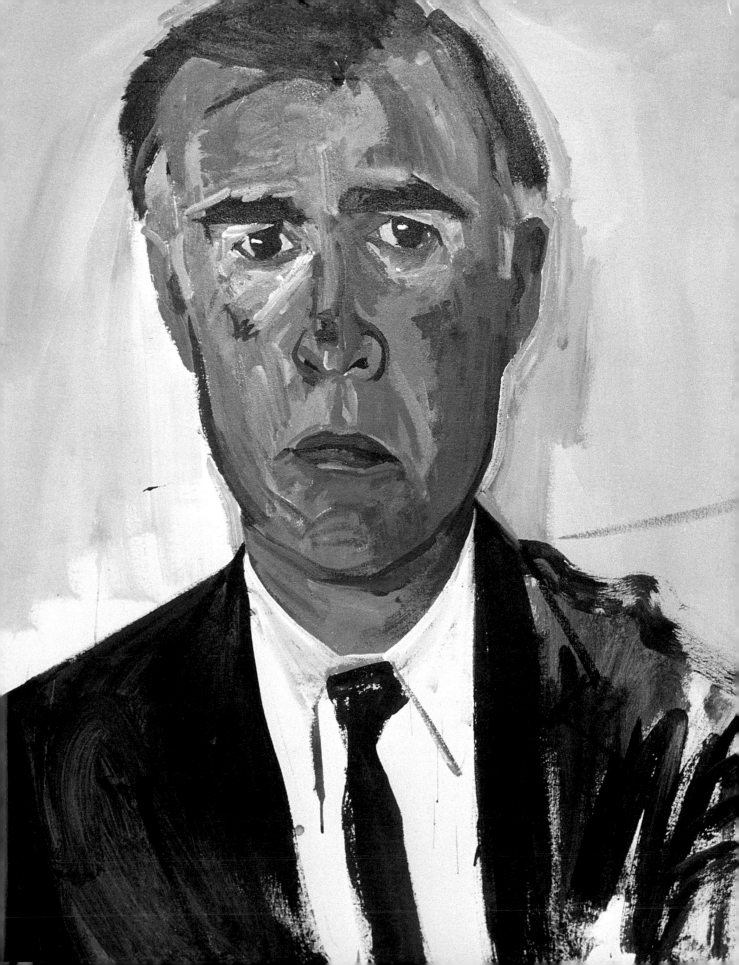

dispensing it. The simple grandeur of their meeting revealed and illuminated them both. I was thrilled to witness it.

## 6 February 1984

Re-reading the above I find that, as so often before, I have left out the point. When I told Brown, just prior to the transformation of his sitting style, that he wasn't helping me, his simple, almost dumbfounded reaction was, "Why didn't you say so?" I didn't know how to answer that question without being offensive. Why didn't you know? was my silent reply. With your intelligence, how could you not realize the importance to me of your stillness and cooperation?

What I wanted to tell him would have gone something like this: For me to play drill sergeant — policeman—Attention! Don't do that, do this—would be an acknowledgment of my failure at psychological and emotional communication with you. Also, I didn't say anything because I didn't think it would do any good, and would only add anger to my frustration when you didn't comply. Twenty-five years of experience have taught me to distinguish those who have the capacity to sit still and attend from those who don't.

Well, I was wrong. Brown proved the folly of my ways and made me feel a fool for wasting nearly all five of our sittings. He merely required direct instructions from me. Once he received them, he carried them out without further ado. What a lesson, and irrefutable evidence of my inborn determination to do things the hard way.